DVD Included

# PICTURE YOURSELF
## Getting the Most Out of Your
# Digital SLR Camera

Step-by-Step Instruction for
Taking Great Photographs of Your World

James Karney and Terrence Karney

# COURSE TECHNOLOGY
### CENGAGE Learning™

**Picture Yourself Getting the Most Out of Your Digital SLR Camera**
**James Karney and Terrence Karney**

**Publisher and General Manager, Course Technology PTR:**
Stacy L. Hiquet

**Associate Director of Marketing:**
Sarah Panella

**Manager of Editorial Services:**
Heather Talbot

**Marketing Manager:**
Jordan Casey

**Acquisitions Editor:**
Megan Belanger

**Project Editor:**
Dan Foster, Scribe Tribe

**PTR Editorial Services Coordinator:**
Jen Blaney

**Copy Editor:**
Bud Paulding

**Interior Layout:**
Shawn Morningstar

**Cover Designer:**
Mike Tanamachi

**DVD-ROM Producer:**
Brandon Penticuff

**Indexer:**
Lalia R. Wilson

**Proofreader:**
Kate Shoup

**Photographers:** Johan Aucamp, Andrea Blum, Bruno Chalifour, Robert Cieszenski, Cody Clinton and Mike Fulton of TriCoast Photography, Geoff Cronje, Dave Edmondson, Graeme Ewart, Denis Germain, James Karney, Terrence Karney, Peggy Kelsey, Joe McBroom, Nikki McLeod, Michael Sheasby, Kent Smith, and Gary Todoroff.

For product information and technology assistance, contact us at

**Cengage Learning Customer and Sales Support, 1-800-354-9706**

For permission to use material from this text or product, submit all requests online at **cengage.com/permissions**

Further permissions questions can be emailed to **permissionrequest@cengage.com**

Library of Congress Control Number: 2008929223
ISBN-13: 978-1-59863-529-4
ISBN-10: 1-59863-529-8

**Course Technology**
25 Thomson Place
Boston, MA 02210
USA

Cengage Learning is a leading provider of customized learning solutions with office locations around the globe, including Singapore, the United Kingdom, Australia, Mexico, Brazil, and Japan. Locate your local office at:
**international.cengage.com/region**

Cengage Learning products are represented in Canada by Nelson Education, Ltd.

For your lifelong learning solutions, visit **courseptr.com**
Visit our corporate website at **cengage.com**

Printed in the United States of America
1 2 3 4 5 6 7 12 11 10 09

*To the Karney family: my siblings Tim and Annelle,
my son Terrence, and my daughters Shannon, Arywn, and Rhyannon.*

# Acknowledgments

A BOOK IS ALWAYS A PROJECT that comes to the reader's hands only with the help of friends and a professional staff. Thanks to the fellow photographers from around the globe who have shared images and insights. They include: Johan Aucamp, Andrea Blum, Bruno Chalifour, Robert Cieszenski, Cody Clinton and Mike Fulton of TriCoast Photography, Geoff Cronje, Dave Edmondson, Graeme Ewart, Denis Germain, James Karney, Terrence Karney, Peggy Kelsey, Joe McBroom, Nikki McLeod, Michael Sheasby, Kent Smith, and Gary Todoroff.

Terrence Karney authored sections of the text, helped in designing the content, and provided images. We shared the technical editing tasks. My longtime friend and often copy editor, Bud Paulding, brought his dedication, attention to detail, and insightful comments to the mix.

Megan Belanger oversaw the project and helped shape its focus with her keen understanding of the publishing industry. It's always a pleasure to work with her. Thanks also to Dan Foster, Sarah Karney, Kate Shoup, Lalia Wilson, Shawn Morningstar, and Mike Tanamachi, who readied the manuscript for publication, and Brandon Penticuff, who assembled the disc that accompanies the book.

# About the Authors

JAMES KARNEY has more than 30 years of experience as an award-winning professional photographer and teacher. He started as a wedding photographer apprentice in high school and has covered weddings full- and part-time over three decades. He developed and taught the 18-month photography certificate program at South Georgia Tech.

He is an accomplished computer journalist whose work has appeared in *PC Magazine, Windows Magazine, Computer Shopper,* and *Internet World*. His books include *The Official Photodex Guide to ProShow, Mastering Digital Wedding Photography* (named a Book of the Year by *Shutterbug Magazine*), the Golden-Lee bestseller *Upgrade and Maintain Your PC, The Power of CorelDRAW,* and the Microsoft Press *Training Kit for A+ Certification.*

He is a graduate of the U.S. Navy Photographic School and holds a bachelor's degree in communications from Excelsior College as well as a Master of Science degree in computer technology from Nova Southeastern University.

TERRENCE KARNEY started using an SLR in 1985 and has had one close at hand ever since. His work centers on landscapes, book illustration, travel, and documentary photography. He speaks English, Russian, French, and American Sign Language; and he has traveled to Scotland, Germany, Ukraine, Korea, and Iraq. "Travel changes how one sees things; learning a language changes it more. All of it affects how one takes pictures," he notes.

# Table of Contents

# Introduction

WELCOME TO *Picture Yourself Getting the Most Out of Your Digital SLR Camera.* Perhaps you are just starting to take pictures; perhaps you are moving up to a more advanced camera. Either way, this book is here to help you get the most from your camera. I've been enthralled by the magic of photography since I was given my first camera at age eight. The camera is an amazing tool. In the right hands, it becomes more than a recording device. It can capture a fleeting moment and let us share not only what we saw, but, with skill, *how* we saw it. Developing that skill requires taking control of the camera and the photographic process.

Becoming a good photographer has never been easier. In the following chapters we'll explore how to get the full benefit of the DSLR's technology, and how to move from taking snapshots to making exceptional pictures. Mastering the basics is a bit like learning to drive a car. At first all the controls and "rules" can be confusing. With a little practice the technical aspects become almost automatic, and with our new skills we gain a sense of freedom. As a professional photographer and educator, I've had the pleasure of introducing others to the rewards of this wonderful activity. This book provides a way to share my insights and experience with a wider audience.

## How to Use This Book

If you are new to photography or just got your first "real" camera, consider working through the book from the beginning. If you are a bit more experienced, feel free to pick and choose the topics that will extend your skills and offer a creative challenge. While each chapter is focused primarily on specific skills and topics, I've used a holistic approach to the material. That allowed me to review key points and reinforce earlier lessons. The illustrations are more than just pretty pictures. We examine the how and why of the techniques used to create them. Either way, the book is designed to be used *with* your camera. Follow along and take pictures!

The first three chapters are an introduction to digital photography and an explanation of how your camera works. They demystify the dials, buttons, connections, menus, and readouts. We cover the basics of how to set the camera's options, the basics of how to obtain good exposures, and the basics of handling the DSLR properly to keep it in good operating order and get good pictures. We also explore the technology and learn the terms used in the rest of the book.

Chapters 4 through 6 are a trilogy on the basic camera controls—part tutorial, part workshop. Chapter 4 centers on mastering the art of exposure, both with and without using the camera's lightmeter. We'll learn how to adjust the settings to capture detail in shadows or in our pictures, and how to keep bright objects from showing as pure white. Chapter 5 covers creative lens use, how to selectively focus only part of a picture, working with wide-angle and telephoto lenses, and controlling perspective, and explains what those strange f/stop numbers really mean. Chapter 6 brings action into the picture, as we learn how to use the shutter to freeze motion or add blur.

Photography is all about light, and in Chapter 7 we turn our attention to how it shapes the way our pictures look, and how to control lighting as a creative tool. We'll also explore how to use flash and work with multiple light sources. Chapter 8 rounds out our discussion as we add composition to the picture and explore how to use light, exposure, and camera technique to create mood and visual impact.

Many events in life can't be told in a single picture, and so we have photo essays. Chapter 9 follows a photographer through a wedding event. This provides a perfect showcase for how to handle a variety of lighting, exposure, equipment, and composition challenges.

The last three chapters are all about working with pictures after they are taken. We use programs included on the DVD, along with exercise files and multimedia tutorials to process our pictures, enhance them, and then transform them into slide shows, prints, and albums.

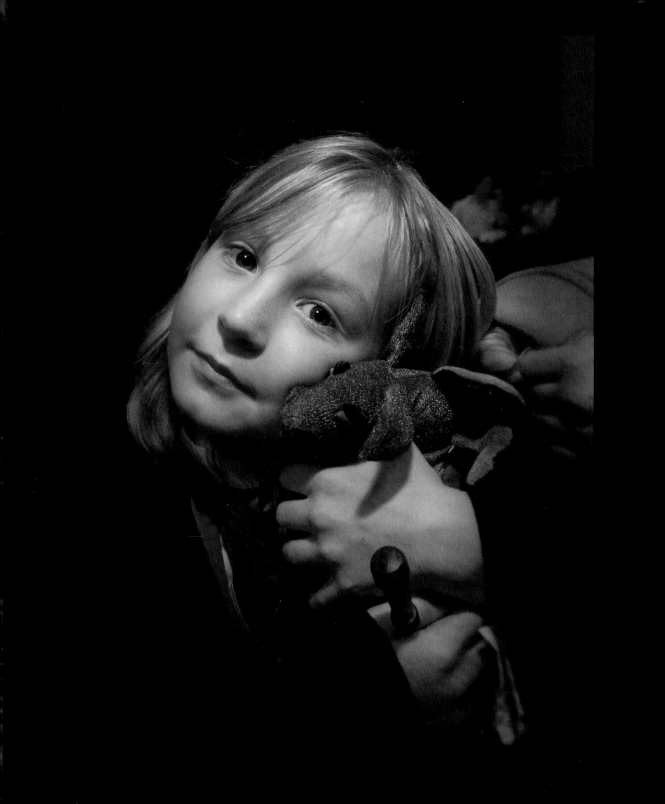

**Figure 1.1a** This picture was taken in a brightly lit store. Light from a flash unit, plus a little post-processing, produced a low-key portrait with almost studio-like effects. (Photograph by James Karney.)

# The Joy of Digital Photography

*"Never have I found the limits of the photographic potential. Every horizon, upon being reached, reveals another beckoning in the distance. Always, I am on the threshold."*

**—W. Eugene Smith**

THIS BOOK IS A GUIDE TO THE photographic adventure and the power of the digital single lens reflex camera (DSLR). It goes beyond the manual, showing you how to take professional-quality pictures. It has never been easier or more rewarding. Even entry-level DSLRs offer features that exceed the professional models of a few years ago. We can see the results at once, and these new cameras come with an incredible array of features and accessories. This chapter is a teaser, demonstrating how much more you can do with a DSLR (and how much better your pictures will be) by simply learning to move beyond the basics.

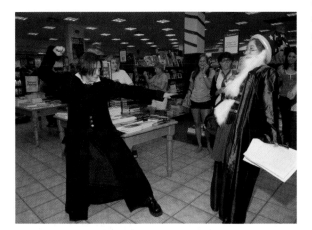

**Figure 1.1b**
This picture of "Professor Snape" and "Headmaster Dumbledore" was taken at the same party as the preceding picture. A change in exposure produced a radically different result from the first photograph. (Photograph by James Karney.)

# The Key to Successful Photographs Is Seeing Both the Light and the Subject—Your Way

MANY NOVICES LEAVE THEIR camera settings on automatic. All those buttons and options can be intimidating. They get acceptable pictures, but miss out on the rewards that a little extra effort provides—the ability to take photographs, rather than mere snapshots—and to capture the essence of the subject and the place, rather than just make a simple record. That impact has always been the lure of the camera.

Right now we won't worry about the buttons, dials, and details that intimidate many new owners. The following chapters use a practical approach, so you can master those skills without any complicated theories. We'll explore both the camera and photography by taking pictures. As we do, the settings will become both familiar and easy to use. Developing those skills is not as hard as some people think, and the process itself is fun. That is why photography is such a popular activity.

The basics of photography have not changed since the first images were taken in the 1800s. The technology has. Early photographers coated glass plates with chemical solutions, and had to make exposures while the glass was still wet. Photographers like Matthew Brady traveled with a pack horse and over 150 pounds of darkroom gear. Film photographers didn't know if their images were even printable until they were developed.

Today we are blessed with instant results, zoom lenses, fast sensors, intelligent flashes, and digital editing. Used properly with a little practice, these tools yield impressive and pleasing results. "Properly" doesn't mean letting the camera make all of the decisions; it's a wise advisor, not the boss. The photographer makes the final call. Let's look at some examples and see what I mean. Don't worry if some of the terms are unfamiliar; they'll be covered in more detail as we progress.

The most popular photographic subjects are family, friends, and travel. Figure 1.1a may look carefully posed, but it wasn't. The location was a brightly lit bookstore during a party for the release of the final Harry Potter book. Rhyannon (my youngest daughter) was resplendent in her new Hogwarts robe, with pocket wand in hand. The stuffed dragon was a prize from a treasure-hunt organized to entertain the waiting throng. It was an irresistible image, and my camera was in hand.

The store was lit with banks of fluorescent lamps. The camera's meter said it was bright enough to take pictures without a flash. Had I stayed with the camera settings, the "properly exposed" image would have showed the crowded background of bookshelves and costumed fans seen in Figure 1.1b. It would have been a boring record of the scene for everyone except a proud parent. So, what happened to the "brightly lit store," the fans, and the bookshelves? I ignored the camera's suggestions—and the normal exposure—and used a flash to illuminate the scene. It was held several inches above the camera, pointing down. The flash was more powerful at close range than the room lights. So the light didn't reach the people and books at full power, placing them in shadow. A few are seen dimly behind her. Her face was framed in the light exactly as I wanted. The result is an interesting study of my subject.

The corners of the picture were darkened a bit more with an editing program called LightZone, and a couple of distracting lights, visible over her head, were removed. The entire process only took a couple of minutes. LightZone is included on the disc in the back of this book. My favorite touch-up tricks are all in Chapter 9, "A Day in the Life: Telling Stories with Pictures."

Figure 1.1b shows the same bookstore, and the same party. Flash was also used for this picture, but in a supporting role. The power was turned down so that it added a bit of extra illumination rather than being the primary light source. This time I let the camera and flash handle all of the exposure details.

The result is a good record of the party-goers and the scene in the store. That was the intent for this image. These two images begin our discussion of the art and craft of photography—for photography is both, plus more than a little science. Art is in the eye of the beholder, and the majority of the science can be left to the experts who design and manufacture our equipment. The craft comes in knowing how to use the equipment to get the result we want.

## Photography Takes Many Forms

The street scene in Figure 1.2 is another example of what we can do by overriding the camera's built-in meter and setting the exposure ourselves. Adjusting the settings can really enhance the mood of an image. This picture was taken just after sunset in Venice. There was still a lot of light in the sky. The camera suggested an exposure that produced a picture that looked more like late afternoon—much brighter than this image. It didn't capture the soft mood of the evening. So I placed the camera in manual mode and experimented. Like most DSLRs, the Nikon D200 used for this picture has an *LCD* preview screen that let's the user closely examine the results to check exposure, focus, and lighting. Taking a couple of quick test images revealed the exact exposure needed for the desired result. Then I waited for the people in the scene to be in the right positions, and snapped the shutter.

The main focus is the restaurant, with its waiter and diners tucked into the corner of the shops. The couple walking by is just a bit darker, though still a part of the scene. The lamps on the wall and above the sign are washed out, but their lights add a warm glow. Above, the cool blue of the soft evening light bounces off the walls and the curtains moving in a gentle breeze.

Venice, like most popular tourist destinations, has quiet times and places that reflect the true nature of its inhabitants and culture. This street (there are no cars on Venice's narrow passageways) was near the tourist-thronged areas of the Rialto bridge. A block away, and the crush of people would have made this type of image impossible.

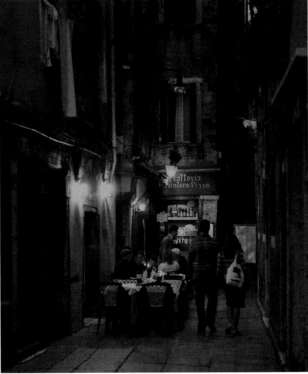

**Figure 1.2**
This travel picture was taken in Venice while dining outside with friends to capture the quiet mood of an early fall evening in a fascinating city. (Photograph by James Karney.)

Getting good pictures requires more than technical skill. It requires a sense of your subject and what you want the viewer to see—taking the time to plan and compose the photograph. That means finding the right physical point of view, and often, stepping slightly off the beaten path. A day of walking the back streets of the city helped me catch the pace and the mood of the Venice that many visitors are too busy to see.

Your contemporary DSLR camera has lots of power, and amazing features well beyond those of professional cameras from a few years ago. But I could have taken both of those pictures with almost any camera that offered manual controls. The real trick was setting the controls effectively, and knowing when and how to press the button. Throughout this book I'll point out not just the technical points at hand, but the creative techniques used to make the images.

Many of the examples will not be mine. Generous photographers from around the world are sharing favorite images to illustrate not only how to take pictures but how to *see* them, and the methods needed to make the final result communicate visually. Let's look more closely.

One of the real benefits of the single-lens reflex is its ability to see, and to show you, exactly what the sensor will record in the viewfinder. That is especially important when working close to a subject. You don't have to travel far to find good subjects. Quiet watching is a tool of the trade for photographers. A day in the yard can yield interesting pictures.

South African photographer Geoff Cronje's lovely close-up of the butterfly in Figure 1.3 is a case in point. Notice how only the butterfly's wings and the flower petals directly below them are in focus. The background is a blur. That is typical when the subject is very close to the lens. So being able to control which areas in the picture are sharp, and how sharp, is very important.

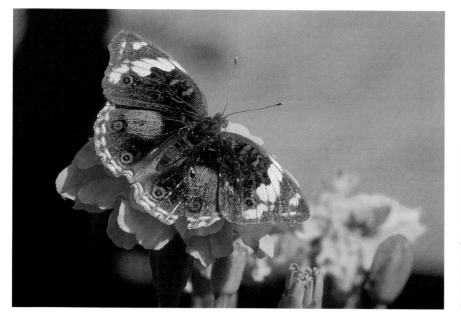

**Figure 1.3**
Sometimes good pictures are right beneath our feet. Not all wildlife images call for travel far from home or long telephoto lenses. They do, however, require the ability to see an opportunity and take advantage of it. (Photograph by Geoff Cronje.)

Geoff used a *macro* lens to take make this image, designed for taking pictures of small objects (hence the name—these lenses let you focus very close to the subject, making it appear bigger in the frame). It can focus much closer than the average lens. The closer to the subject, the better the detail can be captured and the larger the object appears in the picture.

A less-expensive (but more cumbersome) method for working up close is to use a close-up lens. This screws onto the front of the camera lens and works much like a magnifying glass. Close-up photography is fascinating. Later we'll look at ways to make your subjects stand out from their surroundings, and show off the full potential of looking more closely at the smaller world that exists all around us.

As I mentioned, another benefit of DSLR photography is seeing the actual image the camera will record, thus the ability to exactly position or *compose* the key elements in your design. Many point-and-shoot cameras have viewfinders located near the lens. At normal picture-taking distances, the variation in viewpoint between the image the lens captures and the image in the viewfinder is slight; but up close, the difference in perspective (the technical term is *parallax*) between the photographer's eye and that of the lens can result in the subject being too far to one side—or even out of the image altogether.

## The Need for Speed...

Careful framing and timing are also important when working with fast-moving objects. Let's look at another of Geoff's images, this one of a speeding biplane (Figure 1.4). Here he used a *telephoto* lens to make the far-away appear closer. Telephoto lenses and telescopes work the same way; they magnify an image (and narrow the field of view).

Almost all DSLRs accept interchangeable lenses. There are *wide-angle* lens models, which take in panoramic vistas. *Normal* lenses are so named because the area they place on the sensor is about the same as the angle of view of the human eye. *Zoom* lenses can shift their angle of view, going from a wider perspective to a closer one and back again.

The real challenge in Figure 1.4 was stopping the motion. When a picture is taken, the *shutter* (a curtain that blocks light from reaching the sensor, which captures the image) opens so that the focused light forms an image on the sensor. For this picture, Geoff wanted the time of opening to be very brief, to freeze the motion of the biplane. The shutter in the camera he used can slice time as thin as 1/8000th of a second—fast enough to "stop" the plane in the sky.

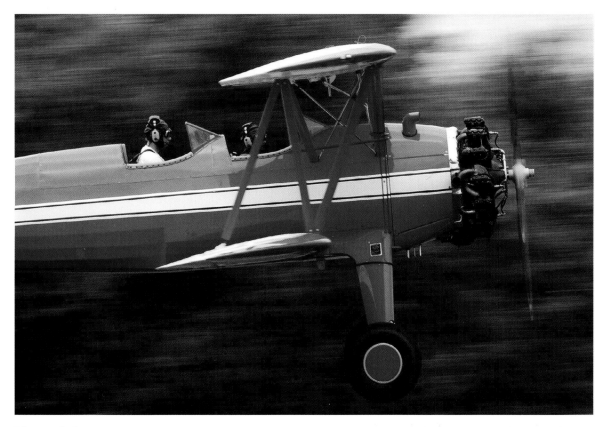

**Figure 1.4**
The plane is sharp, but the trees in the background are blurred in this dramatic action shot of a biplane in flight. Sports and action photographers often pan the camera, holding the principal subject in the same position in the viewfinder while smoothly sweeping the camera, to obtain this effect. (Photograph by Geoff Cronje.)

This image was taken at a much slower speed, only 125th of a second. Normally that would be too slow to stop something moving as fast as the plane. If the camera were held still, the plane would be just a blur, and the trees would be still.

The slow shutter speed, combined with a panning motion, can blur the background while keeping the primary subject sharp. *Panning* is the term used when a photographer tracks the movement of an object so that it stays in the same position in the viewfinder. Do it right and the image object "stands still" on the sensor. The parts of the picture that are not being panned show blur. We'll play with this technique later in the book, when we work with action subjects.

## ...And a Sense of Timing

Both kids at play and sports are worthy subjects, and great chances to practice photographic skills—technical and creative, basic and advanced. Check out the expression and body-English on the young man in Figure 1.5. I'll bet that British photographer Graeme Ewart took quite a few pictures that day to capture this winner! The shutter had to open at *exactly* the right instant. It's hard to be sure an action shot "works" without examining it; but if you do that during the game, you may miss an even better shot! When I was a newspaper photographer, this kind of image was just what the editor wanted, and I'd often take 30 or 40 exposures at each game to get a really good action shot. DSLRs offer the ability to shoot several pictures at a time by holding down the exposure release, but the photographer still needs a sense of timing. Along the way I'd also snap side-line pictures. Not all the "action" is on the field.

The soccer picture was also taken with a telephoto lens. That let Graeme get a good, tight shot of the boys, and let us see their expression from the sidelines. Let me point out some other things that help improve the impact of this image. A *telephoto* (also referred to as a long lens) has a narrower depth of field than a normal or a wide angle (sometimes called a *short* lens). *Depth of field* refers to how much of the picture, from front to back as seen by the camera, will look in reasonable focus. Look closely at the grass near the bottom on the picture, and at the boys and woods in the background.

They are softly out of focus. Compare that effect to the streaked blur of the trees behind the biplane in Figure 1.4.

Consider for a moment the different perspectives on a subject that a wide-angle view, a "normal" view, and a close-up of a scene provide. Motion-picture directors use all three in most scenes in a movie. The wide angle establishes the setting, the normal view is used for conversations, and a close-up lets the filmmaker draw attention to a specific item or reaction. You can do the same when telling a story with your camera.

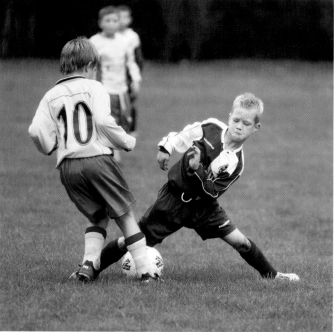

**Figure 1.5**
The expression is as important as the action in most good sports pictures. Here photographer Graeme Ewart captured the peak moment in the play.

## Sun, Shade, and Shadows: About the Quality of Light

When taking pictures, "Some light is more equal than others," to paraphrase George Orwell. In the next chapter we'll be discussing *exposure*, and how different lighting conditions affect the way our pictures look. The face of the boy in Figure 1.5 is virtually shadowless. Look beneath him and you can see a faint shadow. We call this type of lighting *soft* because it produces low-contrast images and soft shadows. Soft light is produced when lighting is very even. In this picture the sun was obscured by clouds, which diffused the light.

Compare the shadows in the soccer picture with the beach scene in Figure 1.6, taken by another talented South African photographer, Johan Aucamp. The beach portion of the image is in *hard* light. The sun was in a cloudless section of sky, producing dark shadows. We can still see some detail in the shadows; a little less exposure and the shadows would have recorded as total black. A bit more exposure and the shadows would have been fainter, but the white paint on the jet-ski would have totally washed out.

**Figure 1.6**
An idyllic beach scene with a dramatic sky provides the elements for a study in light and dark.
(Photograph by Johan Aucamp.)

The dark sky in the background is due to heavy clouds. See how the surface of the ocean in shadow is a deeper shade of blue than the area in bright sun? When we take pictures outdoors, the cloud and shadow conditions can be used to know the exact exposure for a perfect picture. By the time we finish Chapter 4, "Mastering Exposure and Contrast," you'll be able to predict the exact exposure for all outdoor pictures without a meter. It's actually quite simple, and a very valuable skill.

One more thing to mention before we move on. The color of light is affected by sky conditions. Subjects in bright sun are more yellow (*warmer*) than subjects under a cloud (*cooler*), which take on more of a blue cast. Most flash units are designed to produce light that is the same color as the sun.

You can see that softer and cooler light in Figure 1.7. This picture was taken on a foggy day by Florida photographer Joe McBroom. The technical term for the hardness or softness of light is *contrast*. Cooler (more blue) and warmer (more red) light is technically related to the *color temperature* of light. That term comes from the way it measured: by comparing the light to that given off by an object being heated. We'll use both qualities to enhance the appearance of our images.

Let's consider the nature of soft versus hard light a bit more. The fog in Joe's picture scatters the light, so it can't cast a hard shadow. If we use soft light to illuminate a person's face, winkles and lines look softer—helpful if we want to take a picture of someone concerned about having smooth skin in a portrait.

Lighting is the main factor determining contrast. Bright lights create dark shadows. Broad and diffuse light sources produce softer shadows. Secondary light sources (ones in the scene that are not as bright as the primary source) can reduce contrast by lighting up shadow areas.

Color temperature affects the appearance of an image, sometimes for the better. For example, slightly warm images often improve skin tones and make the picture look more "sunny." We'll experiment with both contrast and color throughout the book.

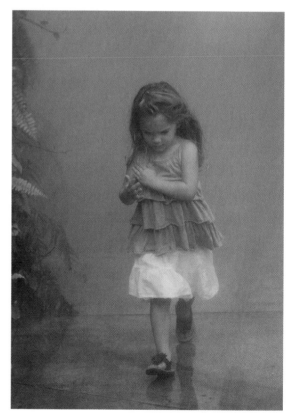

**Figure 1.7**
Foggy conditions produce soft, cool light, as seen in this delightful picture of an intent young lady. (Photograph by Joe McBroom.)

# Equipment Matters—Yes and No, Where and When to Shop

PHOTOGRAPHY IS A WONDERFUL adventure, be it as a professional or an amateur—and the line between the two is often hard to define. Many amateurs have professional-quality skills, and some occasionally sell images. As we explore the craft of taking pictures, I'm not going dwell on the brand of camera used, or its specific features, unless that adds to the discussion at hand. You won't need a bulging gadget bag or top-line DSLR to follow along in succeeding chapters. Figure 1.8 shows a view beneath the skin of a DSLR camera.

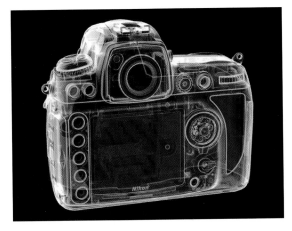

**Figure 1.8**
The modern DSLR is an amazing tool that combines traditional photographic and computer technology. You only need the basic body, lens, and a memory card to get started. Of course, for many photographers, that initial purchase is just the starting point.

I have some tips and tricks about equipment to share before we move on to actually taking pictures. The first is in answer to the common question, "What do you really *need*?" The amount and quality of the hardware does not create skill. The simple fact is, there are many great photographers; some who get paid, and some who don't. Some spend much more money on their camera equipment than do others. Sometimes the hardware does, however, determine what *kind* of pictures you can capture; for example, extreme close-up photography requires macro equipment.

Almost all of the exercises in this book can be handled well with any reasonably current DSLR, no matter the make. The "big two" are Canon and Nikon, the brands that most pros use. A good moderate-wide to telephoto-zoom lens (the kind called a *kit lens*, often bundled with the camera body) will do just fine as the primary accessory. Today the price tag for both is under $500. This book will help those readers who already own such a camera, as well as those who own a somewhat more advanced model.

Of course, you can go fancy. The next step up is the "prosumer" DSLR, which costs about two to three times as much as the entry-level models. Then there are the top-of-the-line professional cameras, with prices in the $5,000-and-up range—plus lenses. The big names offer scores of accessories. I'll introduce some of them as we go through the exercises.

No matter the label or model number, all DSLRs work much the same and require the same basic care for reliable operation. If you already own more gear—perhaps some lenses, an external flash, and a more expensive camera body—that's fine. You are just ahead a bit in developing "Photographer's Acquisition Syndrome—that is, the ongoing desire to acquire a new lens, the latest camera body, a better tripod, etc. The "etc." goes on and on if you really get the bug and spend too much time in camera stores or reading photo magazines. You see an impressive landscape picture taken with a wide-angle lens, or a wildlife image made with an ultra-telephoto lens, or a sports shot captured with a very fast DSLR—and you are inspired and itching to shop for a new toy.

## Good Stores and Shopping Sites

Where and when you buy your equipment can be important. Before we actually start shooting, let me offer some personal advice. For new equipment, buy from a reputable firm, preferably one that specializes in photography. B&H Photo, Calumet, and Adorama are well-known and trusted names. Add *.com* to the name in a Web browser, go to their site, and you are shopping.

While you can find amateur and prosumer cameras in big-box and electronics chain stores, their staff can offer little in the way of knowledge or support. For the most support and expert advice, see a local professional camera store, or visit one like Atlanta's Showcase Photographic on the Web (www.showcaseinc.com). They charge a bit more, but really provide the service to make it a worthwhile investment. They know their gear and the needs of their customers. The wedding in Figure 1.9 was shot with both new and used gear.

There is a thriving market in quality used photo equipment. My favorite is KEH in Atlanta (keh.com). You can try an item for two weeks, risk-free. When buying a major piece of equipment, there is one item of information that is very important to know—*where it was licensed to be sold*. The major camera makers offer outstanding warranty and technical support through national franchises. That adds about five to ten percent to the cost of the product. The item will carry a sticker and have a serial number that proves it is eligible for full support. You can obtain "gray market" imported products that are slightly cheaper, but don't have the proper serial number or documentation. It is a penny-wise and pound-foolish way to shop. If you ever need assistance, the warranty won't be honored and you usually can't get the maker to handle repairs.

Also, check your manual before shopping for memory cards and camera batteries. Make sure the brand you buy is approved for your camera. Buy both only from reputable stores. There are "bargains" out there that are really counterfeit, and may or may not work.

Get a good padded case for your gear and keep the bag and the camera free from dust and dirt. Getting either on the sensor will produce spots on your images and require careful cleaning (often by a repair person). Buy a UV or skylight filter for your lens (for each lens if you have several) and keep it on at all times. These filters are almost clear optical glass that will improve image clarity and protect the front of the lens from dust, grime, and scratches. It's a lot cheaper to replace a $20 filter than a $200+ lens.

**Figure 1.9**
Something old and something new. The camera used for this picture was purchased brand new from Showcase Photographic, a professional camera store. The lens was obtained used from KEH Camera Brokers. Careful shopping saves money without compromising quality. (Photograph by James Karney.)

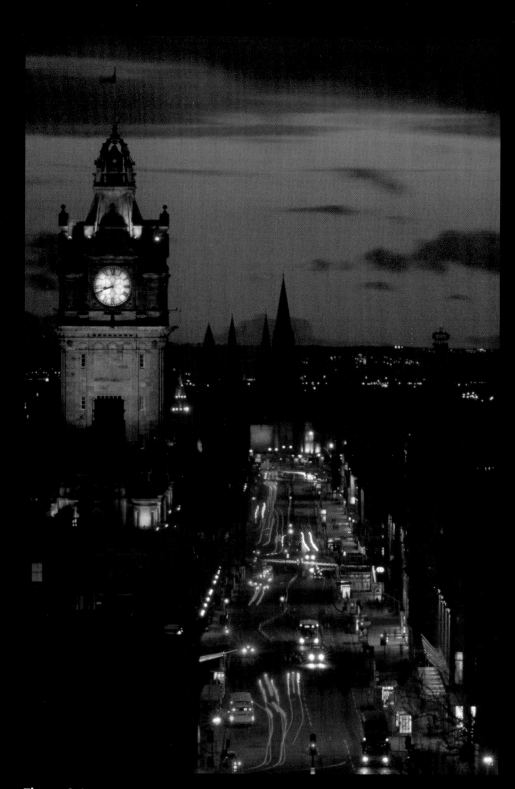

**Figure 2.1a** Edinburgh, Scotland by night. (Photograph by Dave Edmondson.)

# The Digital SLR: Demystifying the Magic Black Box

# 2

B OTH OF THIS CHAPTER'S OPENING pictures hint at mystery. The dark of night and a camera's black box technology keep secrets from the average passerby. Scottish photographer Dave Edmondson showed his understanding of both in capturing the darkened sky, lighted building, and the traffic on Edinburgh's Prince Street in Figure 2.1a.

The modern DSLR is a black box, both literally and figuratively. We let light in, and pictures come out. The workings are hidden away in a sturdy inner case, shown "bare" in Figure 2.1b. Learning how to control—and sometimes ignore—the camera's array of buttons, dials, menus, and readouts is the key to mastering the camera and creating great images.

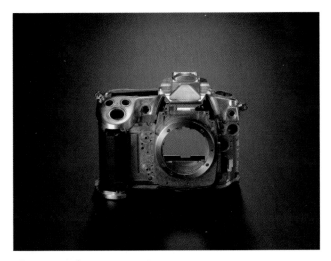

This is just as true today as in the days of film. In this chapter, we explore how the camera works, its major systems, and see how to take control over the camera-computer and become creative photographers rather than passive picture-takers.

**Figure 2.1b**
The unwrapped body of a modern DSLR, the Nikon D300.

# The Basic Black Box: Light Control and Capture

THE FUNDAMENTAL OPERATION of a camera hasn't changed from the very first pinhole model to today's most modern DSLR. The camera is a dark box that totally controls how light falls onto a light-sensitive surface (film or sensor), which records the image projected onto it. Creative photographers play the way the light falls on the sensor plate, the same way a musician plays an instrument. The first step in mastery is in understanding how the process works. Here is the no-math, no-physics, version.

Each DSLR camera has its own particular set of features and controls; however, they all share the same basic functions and construction, and they all make use of basic photographic technology to make pictures. That's what we'll explore in this chapter, to make sure we all understand the primary components, their functions, and some basic photographic concepts for later discussions. We'll save the technical details for later, when you can see your own results, as well as read about the concepts. If you are already familiar with the basic operation of your DSLR and its primary parts, feel free to skip ahead to Chapter 4, "Mastering Exposure and Contrast."

Don't worry if these product pictures don't look exactly the same as your brand or model, or if the buttons are in different locations, or if your manual uses slightly different terms. The fundamental controls are identical, and so is the basic operation.

Figure 2.2 shows the light path as it travels through your camera, depicting the major controls and components. The process is virtually the same for all DSLR cameras (and film SLRs for that matter). Light enters at the front of the lens and travels into the body of the DSLR. The optical design of the lens causes an image of the scene being photographed to form, in focus, at a specific point called the *focal plane*.

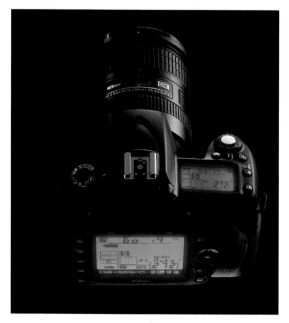

**Figure 2.1c**
The Nikon D90, showing its buttons and control panels.

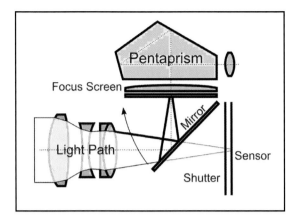

**Figure 2.2**
A cut-away drawing of a DSLR, with labels showing the light path.

Most of the time, light is reflected by a mirror into a *pentaprism*, shown in Figure 2.3. It flips the image over and around for the preview; otherwise, the image would appear upside down and backwards. Some less-expensive cameras use a set of mirrors instead of a pentaprism to cut cost—at the expense of preview quality and brightness.

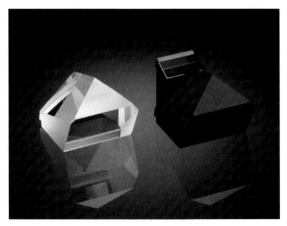

**Figure 2.3**
A DSLR pentaprism. This five-sided object manipulates the upside-down and backward image that is formed by the lens, so that it appears normal to the photographer.

The mirror quickly moves up and out of the way when you push the shutter button to take a picture. Then the shutter opens to let the light pass through and form the image on the sensor. Next, the data is recorded in the camera's memory and saved as a unique file that can be edited and printed.

Just like your eye, the sensor has a limited range of sensitivity. There is an ideal intensity of illumination that will produce the best picture. Too dark, and the sensor can't form the image— just as you can't make out detail unless there is light; too much light and it will be temporarily "blinded," just as your eyes are when you emerge into bright sun from a movie theater.

## The Sensor and the Shutter

There are two factors that control how much light—its *intensity*—falls onto the sensor: the brightness and the time duration of the light allowed to fall on it. The intensity is controlled by the *diaphragm*. This is an adjustable circular collar that can partially close or open as the picture is taken. The amount of time the sensor is exposed to the light is managed by a curtain, called the *shutter*. This slides out of the way for a precisely-controlled amount of time. The combination of the intensity and duration is called the *exposure*. We'll cover how to choose and use the correct exposure in Chapter 4.

A DSLR sensor is a light-sensitive plate attached to the camera's internal computer via a series of thin wires. (See Figure 2.4.) Not all sensors are created equal. They vary in several ways: in size; in how well they capture an image in low-light conditions; in how fast they can do their job; and in the materials used to construct them. The cost and quality of the sensor, its supporting computer circuits, and its imaging ability are three major factors in a camera's price.

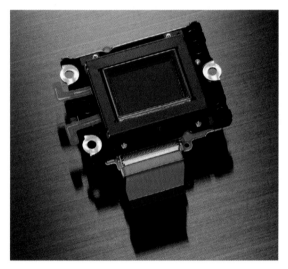

**Figure 2.4**
A DSLR sensor and its data lines.

Digital images are made up of many dots, called *pixels*. The word comes from the term PICture ELement. A sensor is made up of many tiny pixel-point receptors (called *diodes*) that measure the light striking it. These values, representing light intensity and color, are recorded each time you take a picture, and are stored in a unique computer file. The more dots, the better the detail in the image, and the bigger print you can make from it. (This explains why high definition TV looks better because it has more pixels than regular TV.)

The shutter is a mechanical curtain that keeps light from reaching the sensor until the moment of exposure. (See Figure 2.5.) Just as with sensors, not all shutters are created equal. The faster the shutter can open and close, the better the photographer can stop action, and the more pictures that can be taken in a short period of time. The faster DSLRs can record nine pictures per second (called the *frame rate*), with shutters that can slice the interval to 1/8000th of a second. Of course, both the sensor and the data-recording capability must work quickly, in order to make lots of images quickly. This kind of performance is only needed for action photography, like sports. A more modest three to four frames (i.e., *exposures*) per second and shutter speeds of 1/1000th of a second will handle most high-speed situations. For general photography, speeds up to 1/250th of a second are all we need.

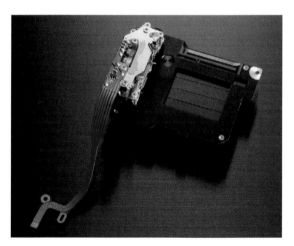

**Figure 2.5**
A DSLR shutter assembly.

At the other end of the shutter-speed spectrum are the common T (time) and B (bulb) camera settings (although not all DSLRs offer a T setting). The time keeps the shutter open until the button is pressed a second time, while the bulb setting holds it open while the button is being pushed. This feature allows for taking pictures, like the one in Figure 2.1a, which require long exposures. Not all cameras will offer both (or even one) of these shutter speeds.

## Sensor Resolution and Image Size

Sensors come in a variety of shapes and with different levels of quality. There are several ways to evaluate sensor quality. These include its sensitivity to light, how quickly it can record an image, and how well it records fine detail and color. You have probably come across the term *megapixel* by now, which means one million pixels. A 10-megapixel camera has a sensor that contains 10 million pixel-points. Some vendors tout the number of megapixels a camera has as if that was the primary measure of sensor quality. It isn't.

It's actually a combination of the *size* of the pixels as well as the number. In general, a big sensor with smaller pixels will yield higher-quality pictures. The camera will need more computer power and memory to maintain acceptable performance. Cell-phone cameras use very small sensors. Sensor in point-and-shoot digital cameras are somewhat bigger, and those in DSLR cameras can be much bigger still. The actual size of a sensor varies from about the size of a letter M in a small headline to the size of a large postage stamp, as shown in Figure 2.6.

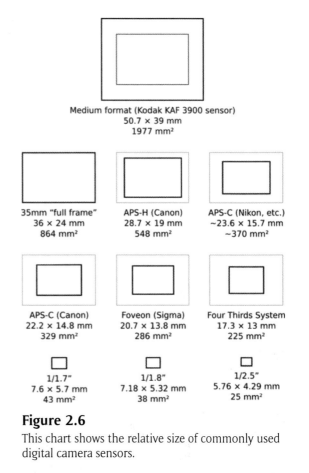

**Figure 2.6**
This chart shows the relative size of commonly used digital camera sensors.

Consider sensors—with the same number of pixels—from all three types of camera. The DSLR will have larger sensors with much larger pixels; the ones in the cell phone will be very tiny. The DSLR image will have much better detail. You will be able to perform more editing magic, and make bigger prints with better quality, with a larger sensor. The point-and-shoot results will look better than those from the cell phone, but not as good as those from the DSLR.

Even within the DSLR category there are different-sized sensors, or *formats*. The "full-frame" format is a sensor the same size as the negative in a 35mm film camera. The APS-H and APS-C formats are smaller, but have the same basic rectangular shape. The "four-thirds" format (also used in most cell-phone cameras) has a shape like that of a standard TV set or computer monitor, with a 4:3 aspect ratio. (Hence the name.)

Larger sensors offer additional benefits (assuming overall quality of design). These include faster and more accurate auto-focusing, more accurate meter readings, and less signal noise. Noise occurs in clear and darker areas of an image when the sensor has to work at the limits of its ability to record data (as in a dark room). See Figure 2.7.

The organ pipes in Figure 2.7 are a small part of a picture taken on a cloudy day inside the Dom Cathedral in Cologne, Germany. I had to use a very slow exposure and push the sensor to its highest speed (more about that topic in Chapter 3, "Basic Camera Technique for DSLRs"). See the fine colored dots that make up a pattern? That effect is *signal noise*, most often just referred to as *noise*. There are ways to control noise by adjusting the exposure, lighting, and processing of a picture. In very dark conditions, like the one in the example, noise is unavoidable. The better and larger the sensor, the fewer problems with noise.

**Figure 2.7**
Sensor noise looks much like the grain seen on film, appearing as colored dots in darker areas of images taken using high ISO values.

# The Eye of Your Camera: Its Lens Assembly

INTERCHANGEABLE LENSES are one of the major advantages of the SLR design (both film and digital models). A push of a button and a quick twist of the wrist, and your camera has a different lens on it. Photographic lenses are like eyeglasses on steroids. Curved surfaces bend light to adjust the way it shapes the scene in front of it, projecting the resulting image onto the sensor. Vendors make an amazing variety of lenses to suit two criteria—shooting conditions and budgets, as you can see from the array provided by Nikon, pictured in Figure 2.8.

The lens on a typical entry-level DSLR may only add $150 or $200 to the cost. Individual professional-quality lenses often run well over $1,000 each. Some exotic models cost more than $10,000! (They also hold their value very well.

I recently sold one of mine after 12 years of ownership and got all of my original investment back.) Lenses tend to have all kinds of exotic numbers and labels in their names. We'll save the details for later, and stick to generic terms for now.

The average digital lens contains at least four (usually more) pieces of glass (each one is called an *element*). Just as with eyeglasses, the lens is designed and ground to "bend" light and adjust its path. The lens also controls the degree of magnification of the image as it is projected onto the sensor. The design also includes focusing gears (and often a focusing motor), and electronic circuits that let the camera and lens communicate. Some DSLR lenses have additional mechanical and computer components to dampen the vibration from the photographer's hands and ensure sharp images.

**Figure 2.8**
The current lens collection available for Nikon cameras.

Figure 2.9 shows an example of a *prime* lens. Prime lenses are designed to offer a fixed angle of view. The *angle of view* determines how wide (or narrow) a portion of the scene in front of a camera is included in the image formed on the sensor. The human eye normally provides about a 45-degree angle of view. The example in Figure 2.9 is an extreme wide-angle design that can actually capture a 180-degree area—a full half-circle. With this lens, the photographer must be careful to avoid having his feet in the picture. (I have one of these lenses, and it has happened!)

**Figure 2.9**
The "fisheye" design of this 10.5mm extreme wide-angle prime lens allows it to capture pictures with a 180-degree angle of view.

Notice the five silver-colored connections at the very back of the lens, to the right in Figure 2.9. These are contacts for the lens and the camera to communicate for focusing, exposure, and data-recording purposes.

Zoom lenses like the one in Figure 2.10 use a more complicated design, with an adjustable angle of view. The photographer can choose the degree of magnification within the lens's range by rotating the zoom ring. This zoom lens is a telephoto design that provides an angle of view from 8 to 34 degrees, depending on the focal length.

**Figure 2.10**
A high-performance 70-200mm telephoto zoom lens with vibration-reducing technology.

Most consumer-level DSLR models are available in kits that include a mid-range (mild telephoto to mild wide-angle) zoom lens. These are often an excellent choice for new and/or budget-minded photographers.

Zooms tend to be bigger and heaver, with more complicated designs, than prime lenses. For example, a 200mm prime telephoto has eight elements (individual glass components) and weighs one pound, ten ounces. The professional-quality 70-200mm zoom in Figure 2.10 has 15 elements and tips the scale at over three pounds. The average consumer-grade zooms are not as ruggedly designed or as high-performance. The Nikon 24-85mm zoom, for example, weighs a little over one pound and has 15 elements.

## Using Lenses: Wide-Angle, Normal, Telephoto, and Zoom

There is no perfect lens for all conditions, no matter how well-designed or expensive. There are always trade-offs. Prime lenses tend to be sharper than zoom models, and are generally lighter and less expensive to produce. I said "generally" because there are always exceptions when it comes to optical design.

That said, there are still good and affordable "walk-around lenses" that do very well at handling most situations. These are zooms that range from mild wide-angle to moderate tele-photo. The most important part of a lens description is its *focal length.* Simply put, that's the distance from the optical center of the lens to the sensor, with the lens focused on infinity. It is usually measured in millimeters (mm). A normal lens (about a 45-degree angle of view) used with a full-frame sensor has a focal length of 50mm. Smaller focal-length numbers and a wider angle of view indicate a wide–angle. Bigger focal-length numbers and a narrower angle of view indicate a telephoto. If the sensor is smaller, then so is the "normal" number. On an APS-format sensor, a 35mm lens is considered normal; smaller than that is a wide-angle lens, larger is a telephoto or long lens.

Wide-angles are great for working up close to your subject or showing panoramic views. The doorway in Figure 2.11 presented challenges that were best solved with a wide-angle lens—and it shows the more common difficulties with using one. The doorway to the Cologne Cathedral was too tall and narrow to allow the full door to fit into a single picture with a normal lens, or even with a moderate wide-angle. I used a 10.5mm fisheye lens to capture the entire door and its design.

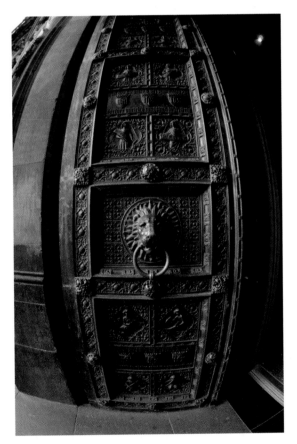

**Figure 2.11**
Extreme wide-angle lenses are very handy in tight spaces, and when having everything in a scene in focus is important. (Photograph by James Karney.)

As you can see, the entire door is in the picture, and in reasonable focus. Not bad, given that I was standing less than three feet away from the 12-foot-tall door. But look at the unnatural way the sides of the door curve, and the center seems to bow out. This is called *barrel distortion*. The central portion of the image looks normal, and the distortion becomes more pronounced toward the edges. Extreme wide-angle lenses are prone to this problem due to their optical design. All lenses involve trade-offs between optical quality and overall performance. When we discuss taking pictures in Chapters 4 through 8, I'll show you how to minimize such issues. We'll also explore how to use processing software to reduce optical distortions in the final picture in the final chapters.

The scene in Figure 2.12 was taken with a 17-55mm zoom lens, a moderate wide-angle-to-telephoto design. It was set to 35mm, basically a normal angle of view, on my camera. This is my favorite "walking around" lens. The picture was taken in dim lighting conditions without a flash. I had to open the diaphragm of the lens wide to let in as much light as possible, and still use a slow shutter speed, to obtain a good exposure.

We don't see the barrel distortion found in the wide-angle example. Now look at the how the background of the scene and the objects near the camera are out of focus. That is because a normal lens does not have the same depth of field as a wide-angle; the area that will be in focus becomes ever narrower as the lens diaphragm is opened more. That can be a good thing.

Experienced photographers often use a shallow depth of field (a picture with a narrow in-focus range to draw attention to the most important areas of an image.). The main subject is placed in sharp focus and the remainder of the image in soft focus.

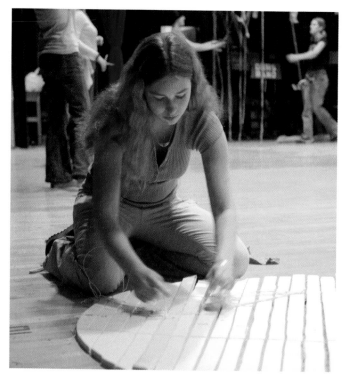

**Figure 2.12**

This picture, showing set production for a play, was taken with zoom set to a normal angle of view. (Photograph by James Karney.)

The final thing to point out is why the subject's hands are blurred. That's because the shutter speed was too slow to freeze the action. Action photography has its own challenges. Chapter 6, "Capturing the Moment: Shutter Speed and Focus," uses that topic to explore how to control the way motion is seen in your pictures.

The bird in Figure 2.13 was not about to stop and pose; I used a telephoto to get the flying gull to nearly fill the frame, and a fast shutter speed to freeze its motion. Taking the shot just as the bird started to slow down helped, too. Telephotos have an even more limited depth of field than normal lenses. Here, you can see how the bird behind the main subject lacks distinct features due to this effect, as do the clouds in the background.

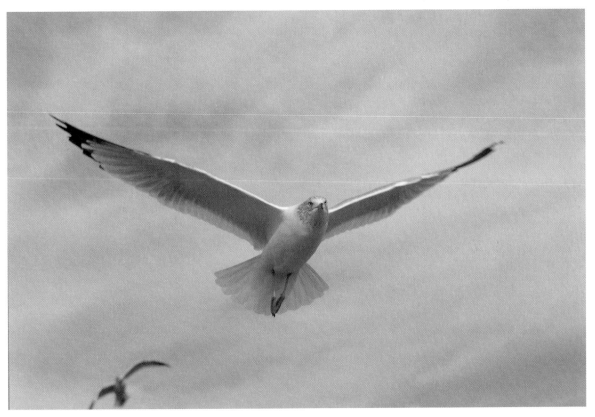

**Figure 2.13**
A telephoto lens is great for capturing subjects that are difficult or impossible to approach. (Photograph by James Karney.)

# Getting Subjects in Focus and Well-Exposed

THE MODERN DSLR IS A WONDER. Advanced computers automatically set a workable exposure, and tracking technology can focus a lens faster than a human eye and finger reflexes. (The camera did help me with focusing the sea gull picture in the preceding section.) The ability to fire several frames a second improves the ability to capture action. Still, difficult lighting conditions and fast-moving subjects pose problems for the photographer, which even the most advanced cameras can't reliably handle. So finally, I chose my own exposure. Meters can't decide which parts of the picture are the most important. Cameras can't guess which soccer player, dancer, child, or flower is really the one you want in perfect focus.

Geoff Cronje's image of the kayaker in Figure 2.14 is a good example. The afternoon sun on the water can easily fool a meter into underexposing an image. He used a fast shutter speed of 1/1250th of a second to freeze both the subject and the water flowing off the paddle. In situations like this there is often little time to consider the proper exposure, and we often have to take pictures without the aid of a flash unit or controlled lighting.

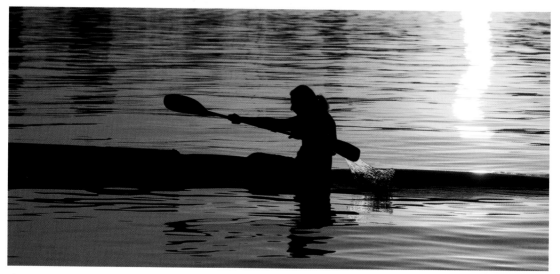

**Figure 2.14**
A master photographer handles a difficult exposure situation beautifully in this picture of a kayaker just before sunset. (Photograph by Geoff Cronje.)

With a little practice it's not difficult to estimate a workable exposure. I often take a reading using the camera's meter and then override its suggested exposure, allowing my total control of the process. Manual exposure may seem daunting. It isn't. The basic formulas are easy to master, and we can still get an "opinion" from the camera's computer. We'll go into much more detail about this in Chapter 4.

Auto-focusing technology has really advanced since it was first introduced in the 1970s. The first implementations were challenged by the slightest movement, and could be confused by shadows and low contrast in a scene. Depending on the model, today's cameras have from three to over 50 motion sensors, often combined with a sophisticated tracking computer. We can pinpoint an area in the image and let the camera bring a stationary target into crisp focus.

Advanced DSLR cameras use 3-D tracking and computerized motion prediction to adjust the focus to where a moving object *will be* when the shutter is fully open and the picture is taken! Andrea Blum used that technology with her Nikon D3 to freeze the skateboarder in Figure 2.15.

Nevertheless, there are limitations. Photographers have to take the time to learn the operation (and the quirks) of their focusing systems. Most DSLRs offer more than one mode of operation, depending on whether a subject is moving or stationary, and whether the active focusing area may need to be repositioned, or a different one selected, while the subject is being tracked or the picture is being composed. Some lenses provide computerized vibration-reduction technology to reduce the effects of camera shake on image sharpness.

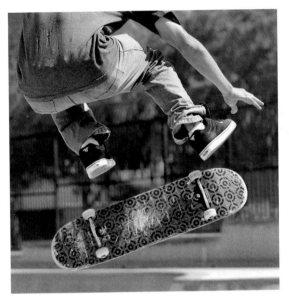

**Figure 2.15**
This skateboarder was captured in mid-air in a 1/1600th of a second. (Photograph by Andrea Blum.)

The woodland picture in Figure 2.16 is another good example of why computers will never completely replace photographers when it comes to setting up a shot. Art requires subjective and selective control that a logic circuit just can't duplicate.

Notice how the water in the scene is softly blurred. That's due to a one-second exposure. The camera's suggestion was probably closer to 1/30th of a second, too fast to allow for that soft, flowing look. To accept that faster shutter speed, Johan would also have had to accept less depth of field than he needed to keep the entire scene in focus. He also had to carefully choose the principal point of focus to keep everything sharp. The camera would have had no way of automatically gauging the proper point to use.

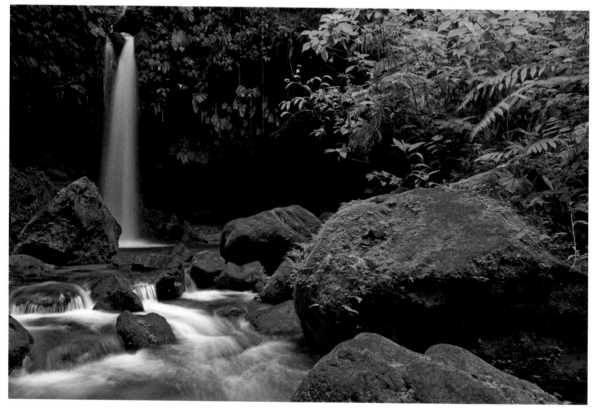

**Figure 2.16**
Only manual exposure and focusing can produce a picture like this one, its "soft" water due to a slow shutter speed. (Photograph by Johan Aucamp.)

# In-Camera Processing and Previews

THERE WAS A TIME, not all that long ago, when it was possible to teach modern photography without the need to even mention batteries, computers, and software. Those days are gone. Your DSLR has far more computer power than early PCs, even the network servers of that era. Figure 2.17 shows the primary circuit board of the Nikon D3.

Many of the computer functions replace or augment the mechanical parts found in film cameras and lenses. These include shutter timing and aperture controls, metering, and sequential picture taking (that once required a motor drive to advance the film). They also add new features, like histogram displays (see Figure 2.18) for evaluating images stored in the camera; intelligent flash metering and control; in-camera image enhancement; wireless capability; customized settings; and the ability to automatically record information about each exposure.

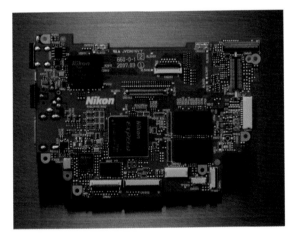

**Figure 2.17**
Part of the on-board computing hardware found in a Nikon D3 DSLR.

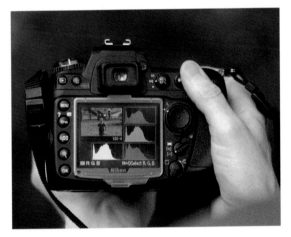

**Figure 2.18**
The LCD display on most DSLR cameras is a valuable exposure-evaluation tool, which allows the photographer to make sure the image is recording the important details in a scene. This model can show both the preview and graph the light levels of the color channels using a histogram.

Consider the challenge that faced Johan Aucamp when taking the picture in Figure 2.19. He wanted to capture both the feel of twilight and to record detail in both the shadow areas and the sky—not to mention the rainbow and the snow on the mountain tops. This range of tones pushes the limits of the sensor's recording ability.

This is where the histogram comes in handy. The photographer can make a test exposure, and then examine the image directly and with the graph the histogram provides. A histogram and the highlight reports lets us pinpoint the optimum exposure, and be sure that it captures fine detail in the picture.

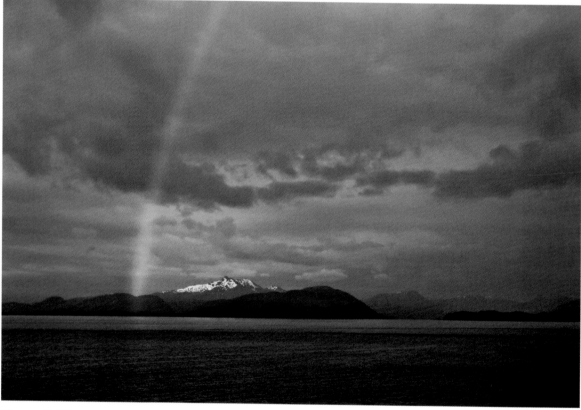

**Figure 2.19**
Twilight and a rainbow offer interesting light, and difficult exposure challenges. (Photograph by Johan Aucamp.)

The preview window on most DSLRs provides a wealth of information about an image. You can quickly inspect focus, evaluate color balance (that is, determine whether the colors look normal or have a cast, check composition, and look for detail in the shadows and highlights. Figure 2.20, by Joe McBroom, is another example of a tricky exposure problem. This picture required careful planning, precise exposure, and skilled processing.

This kind of image would have been much more difficult to create using film. With a DSLR, the photographer can decide how effective a particular exposure is by seeing the results right then.

We can even combine two or more separate exposures into a single image: one image can capture the darker portions of the scene (the shadows) and the other the highlights (bright and almost-white areas). Then the two images can be combined using an editing program.

Now that we have had the "naming of names" and teased you with the creative potential of your DSLR, it's time to begin taking pictures and building skills. We'll start with getting the right camera-handling techniques in Chapter 3 and then explain the art of exposure and the use of light in Chapter 4.

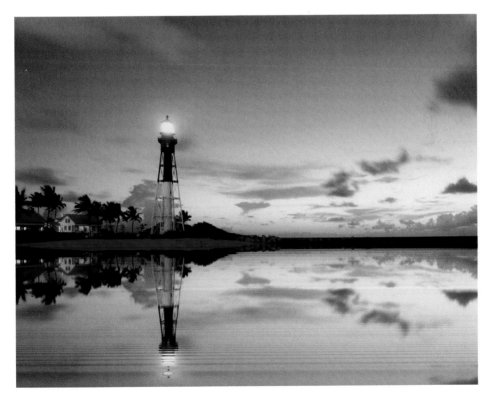

**Figure 2.20**
This twilight seascape demanded precise exposure to hold the detail in shadows and highlights. (Photograph by Joe McBroom.)

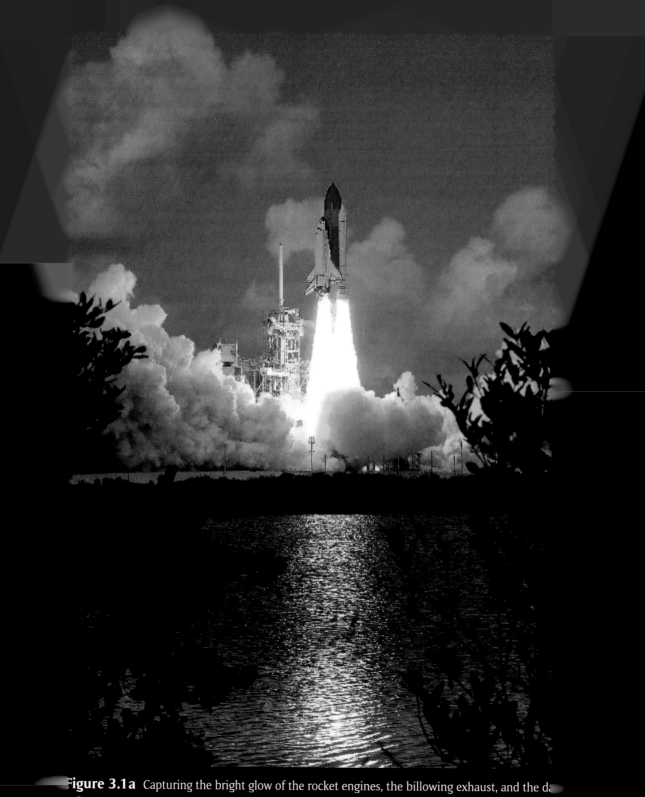

**Figure 3.1a** Capturing the bright glow of the rocket engines, the billowing exhaust, and the da
eflections in the water required careful exposure and precisely timing when to take the picture.

# Basic Camera Technique for DSLRs

## 3

CAMERA TECHNIQUE IS THE CRAFT OF CONTROLLING the photographic process right up to the moment of capture. Your DSLR is a wonderful picture-taking machine that can be configured for almost any type of photography. It is chock full of features, buttons, and probably a complicated menu system. They can help get the picture, but they can also get in the way if used improperly. The good news is that most of the options can be left alone until they add something to your picture-taking ability and style.

In this chapter we are going focus on the primary skills of how to configure basic settings, how to handle your camera to avoid common problems, and how to keep it working reliably—no matter the brand or model. We'll get into topics like setting ISO speed, white balance, and basic camera handling. We'll save advanced techniques, like exposure and focus controls, for later. Have your DSLR and its manual handy as you read.

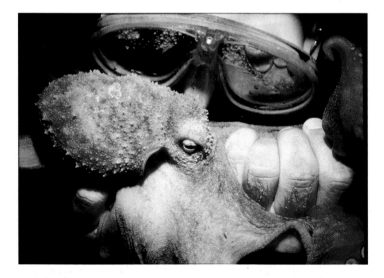

**Figure 3.1b**
This picture was taken under dramatically different conditions from the space-shuttle launch in Figure 3.1a.
While the basic photographic principles were the same, the camera technique was adjusted for the watery situation.
(Photo by James Karney.)

# Your Camera as a Picture-Taking Platform

CONSIDER THE FIRST THREE pictures in this chapter. Bob Cieszenski used a long telephoto lens, a tripod, and a carefully chosen exposure to capture the space-shuttle launch at twilight (Figure 3.1a). He had plenty of time to plan his shot and set up his equipment before the engines started. My picture of the octopus (Figure 3.1b) took place on a night dive in the Cayman Islands, and the octopus was only in the diver's hand for a minute or so. The picture-taking was almost instinctive. I had to rely on the existing camera settings and lens.

The baseball action in Figure 3.2 took place on a sunny spring day, and I used a fast shutter speed to stop the action (including the ball in flight) and careful focusing to keep both the players and the umpire sharp in the final print.

In taking all three of these pictures we relied on basic camera technique—configuring our equipment to match the conditions, choosing the best camera position, and knowing how to use the camera to get the desired result. All the details, except the final exposure, were determined and set beforehand. Camera technique has to be tailored to the situation at hand, and it has a major impact on the quality of the final result.

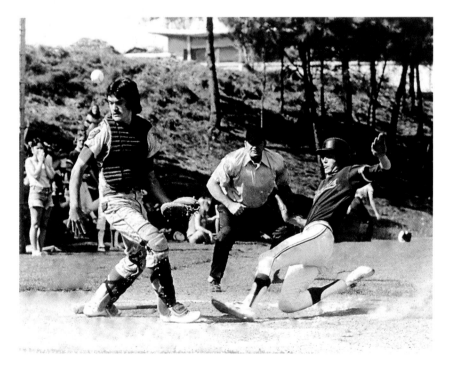

**Figure 3.2**
The basics of camera technique don't change. This image was taken on film during my days as a new photographer. I would have used the same lens, ISO rating, and exposure combination with my latest DSLR to freeze the action and ensure good tonal range and contrast. (Photograph by James Karney.)

# Customizing the Basic Shooting Settings

THE SUGGESTIONS IN THIS chapter are basic settings and safe-handling procedures that apply to virtually any DSLR, so they won't be detailed step by-step instructions on how to adjust menus or use buttons. Your camera's manual is the source for specifics about where particular settings are.

Figure 3.3 shows a basic shooting menu for a typical entry-level DSLR. The organization of the settings varies from camera to camera. The basic image-sensor and file-capture options are fundamental to picture quality, so the choices you make here have a direct bearing on every picture you take. It's good that these options are among the easiest to understand and use correctly. As with all options, there are trade-offs to consider. The following list is in a functional order, so it doesn't follow the menu in the figure, and may or may not match that for the one in your camera.

**Figure 3.3**
The Shooting Menu options for an entry-level DSLR.

## A Simple Menu Choice—RAW or Processed?

Every time you take a picture, your camera creates a data file containing the raw unprocessed data from the scan. Most DSLRs give you the option of saving that file (called a RAW file) or letting it process the data into a standard image format—like a JPEG—and erasing the original data. You may also have the option of saving both the RAW file and a processed version. The first three settings in Figure 3.3 all deal with those options.

RAW files can be large, about 12MB for a 12-megapixel camera. That's just under 300 images on a 8GB memory card. The same card in the same camera can hold 2,800 high-quality JPEGs capable of making a good 8x10-inch print. Even so, I still shoot almost all of my pictures in RAW format. The reason is simple. I like to do my own processing. The RAW file has the most quality and editing potential that that image will ever have. Not only that, RAW lets you go back and modify several critical shooting options during editing with no loss in quality.

You can't do that with JPEG files that are automatically processed in the camera. The resulting file modifications and compression removes data and editing options. For now I suggest you set your camera to RAW unless you really need to save storage space.

If you do choose to capture in JPEG format, you must also choose an image-quality setting. The options will vary depending on the size of your sensor, so you should check your camera's manual for details. It's generally best to use the highest quality available, unless you have limited in-camera storage space. You never know when a wonderful picture opportunity will present itself.

## ISO Sensitivity—Less Is More

One of the major advantages of digital over film photography is the ability to adjust the sensor's sensitivity to light at any time, even for just one picture. Figure 3.4 was taken in a school auditorium. The lighting wasn't very bright, and the little cheerleader was moving fast. I needed a fast shutter speed to freeze her motion, so I used almost the fastest ISO setting my camera offered.

The ISO number is based on how much light energy is needed to take a picture. We'll cover the details more thoroughly in the next chapter. Right now it suffices to say is that the ISO number indicates the sensor's sensitivity to light. The higher the number, the less light is needed to create a workable image. That means we can take pictures under dimming lighting conditions. Doubling the ISO number from its current value doubles the sensitivity of the sensor; cutting it in half reduces the light-gathering ability by half. A shift from 100 to 200 doubles the speed, and to double it again, you raise it from 200 to 400. Most DSLRs have a base number of 100 or 200 ISO, and can go up to 3200 or more.

**Figure 3.4**
A high ISO setting was required to freeze the motion of the cheerleader in this picture due to the low available light levels, and the fact that flash was not allowed during the performance. (Photograph by James Karney.)

There is a trade-off between quality and speed. Pushing up the ISO is asking more from the technology. When we boost the number, the sensor develops *signal noise* (usually just called *noise*). It manifests as little colored dots that degrade the fine detail in the image, and is worse in low-contrast areas having even color and tone. I tend to leave my ISO number as low as possible unless the lighting conditions demand raising it, and suggest you do the same. The actual working numbers for the lowest and highest ISO settings vary from camera to camera.

Many cameras offer some form of built-in noise reduction. I usually leave it turned off, but that's because I have editing software that does an excellent job of minimizing the appearance of noise, as you can see in Figures 3.5a and 3.5b. (We'll use that software in Chapter 10, "Images into Pictures: Processing and Printing Your Files," when we discuss image processing. There is a trial version on the disc in the back of the book.)

The image in Figure 3.5a shows an untreated picture from the cheerleading event without any noise reduction; the one on the right, Figure 3.5b, has been treated during processing. Noise reduction is more effective when editing RAW images, another reason to choose that file format for your pictures.

**Figures 3.5a and 3.5b**
The portion of the picture on the left shows untreated sensor noise, and the one on the right, the results of applying a noise-reduction filter.

# White Balance: Not All Light Is Created Equal

The first three pictures in this chapter were taken under radically different lighting conditions, both in light intensity and white balance. ISO settings can compensate for low light levels, but we also have to deal with the color of the light striking the scene. Different light sources and conditions can dramatically alter the color of our pictures. That's because different illumination sources produce light with varying amounts of color.

Consider the warm reddish-yellow color of a full harvest moon hanging low in the sky, and compare it to the bluish-white color it has riding high at midnight. That's an example of differing *white-balance* conditions. The harvest moon gets its warmer color from the way light, reflected from the sun, is filtered by the Earth's atmosphere. It removes its blue and green hues and leaves mostly red. The result is close to the color of light from a typical tungsten light-bulb. The cooler midnight moon in a clear sky casts the same color light as the mid-day sun. The low-lying harvest moon has a reddish cast similar to a fading sunset.

*Cast* is the operative word. The color quality of the light cast on our subject will alter the apparent color of objects in the picture, especially white ones. Your camera has several standard white-balance settings, matching the most typical light sources (full sun, cloudy, shade, etc.). The actual names may vary from manufacturer to manufacturer. Choose the one closest to the actual source, and the camera will adjust the color balance to neutralize the color cast and produce pure whites.

The three versions of the picture in Figures 3.6a, 3.6b, and 3.6c show just how much difference the white-balance (WB) setting makes. Figure 3.6b has the proper flash setting, matching the actual lighting used. A tungsten setting was used for Figure 3.6a. The resulting blue cast is from the unneeded compensation added by the WB to overcome the reddish-yellow cast common to traditional light bulbs. The version in Figure 3.6c has a fluorescent WB. Magenta is added to overcome the normally green tint in that type of illumination.

Your DSLR probably offers an automatic WB option that measures the color of the light source and uses the closest value. That's a good default setting. If you are taking a number of pictures in a predicable lighting environment, then you can adjust the option to prevailing conditions for that session. You can also shift the white balance to create an effect. For example, using the cloudy setting in bright sun adds a warm tone that may enhance skin tones.

**With RAW files you can apply a new white-balance setting at any time during processing, and it will have the same effect as if it had been the actual setting when the exposure was made—another reason to use RAW as the default capture mode. If you use in-camera processing and save only a JPEG or TIFF version, some color detail will be lost forever if the wrong WB is used. That's because some colors will be neutralized by the color cast, and removed from the generated image file.**

**Figures 3.6a, 3.6b, and 3.6c**
Three versions of the same picture side-by-side. The only difference is the white-balance setting.

## Working in Mixed Lighting Conditions

*Mixed lighting* is the term for a picture with more than one lighting condition. The sea turtle in Figure 3.7 was taken about 60 feet underwater on a bright sunny day. My flash reached the animal, but was not powerful enough to reach the coral below. The background is blue because at that depth all colors but blue are stripped out as the light travels through the water. When dealing with a mixed lighting situation, either choose the white-balance setting that is closest to the type of source illuminating the primary subject, or adjust the composition or lighting to remove the secondary source. Which works best depends on the result you want in the picture.

It's time to start taking pictures. The quickest way to gain a full understanding of white balance and the effects of mixed lighting is by making similar pictures using different WB settings and comparing the results. If you are still getting used to your camera, leave the exposure and focus controls on their automatic settings for now. As mentioned before, consider capturing in RAW mode.

Experiment with a variety of indoor and outdoor situations, in uniform and mixed-light conditions. Keep in mind that an outdoor picture with some areas in full sunlight and some in open shade, or some in full-sun and some under clouds, has mixed lighting. The color of sunlight varies during the day, with extremes at sunrise, sunset, and noon. The typical lovely red at sunset is due to the shift in WB; the differences in natural light can be used as a creative tool, turning a technical challenge into an aesthetic opportunity.

**Figure 3.7**
The blue color of the coral in the background is due to the way water strips the warmer colors from light with increasing depth. (Photograph by James Karney.)

# Getting a Grip on Things

NOW WE TURN TO THE MOST basic skill of all, holding your camera. There are three primary concerns: not dropping it, keeping it still while taking pictures, and not getting dust on the sensor. All three issues are important and can be minimized with good camera technique. Most DSLRs come with a camera strap. Keeping it around your neck is an excellent habit and an effective way to minimize the risk of dropping your camera. Consider slipping one arm and your neck though the strap so it is over one shoulder, and holding the camera in your hand close to your body, when you are traveling over rough ground or in a crowd. That reduces the risk of it bumping into a hard object or being stolen out of your hands. The latter risk is not great but has been known to happen in some tourist areas and at large events.

## The Basic Hold

DSLRs are in a different weight-class from point-and-shoot models. They tip the scales from two to over seven pounds, depending on the model, the attached lens, and whether a flash and/or a battery pack is being used. A good grip is important, both to reduce camera shake (which really affects how sharp your picture looks) and to avoid dropping it.

Notice how fellow photographer Brian Wagner is holding the camera in Figure 3.8. His left hand is supporting the camera body and lens from underneath. The right hand is carrying part of the weight, while positioned to allow easy adjustment of the controls. The finger on the shutter is relaxed and ready to make an exposure.

**Figure 3.8**
The basic DSLR grip is always two-handed, with one hand supporting the camera body and ready to manipulate the lens settings. The other is positioned to allow easy adjustment of the camera's controls. Both hands are used to hold the camera still.

Avoid using a grip with both hands holding the body of the camera, which does not also support the lens. It is often heaver than the camera. Also, there are usually controls on the lens barrel, like the zoom adjustment, which require frequent manipulation while shooting.

Figure 3.9 shows the same camera being held vertically. Many subjects look better in a vertical composition. Again, the left hand supports most of the weight and the fingers are positioned for easy lens adjustment. The right hand is used to "aim" the camera and hold it still. You want a firm grip, but not so tight that your hand tires or that your finger-press on the shutter is jerky.

**Figure 3.9**
Adjusting the grip for a vertical composition. The basic elements of the hold are the same.

Many DSLR cameras offer an optional battery pack with a second set of controls designed for vertical shooting. Figure 3.10 shows Brian using one with a large telephoto lens. He can hold the camera the same way as for a horizontal composition, which is more stable than the grip used in Figure. 3.9, and the shutter finger is more relaxed.

**Figure 3.10**
Shooting a vertical exposure with a battery pack attached.

Earlier I referred to the camera as a picture-taking platform. Its stability during exposure can be as important as having the proper focus on your subject. And that becomes more important with telephoto lenses and slow shutter speeds.

The basic rule of thumb is that average photographers can hand-hold a camera at shutter speeds equal to or greater than the focal length of the lens. That assumes a good grip and a cooperative subject. If you are using a 24mm wide-angle and photographing a landscape, then 1/25th of a second exposure shouldn't show any blurring from camera motion. The minimum safe shutter speed is 1/200th of a second for a 200mm lens.

# Additional Support: Tripods, Trees, and Knees

EXPERIENCED PHOTOGRAPHERS use a variety of tricks to stabilize their cameras, from body posture to tripods. It a good idea even when the shutter speed is supposedly fast enough to eliminate camera shake. Terrence Karney chose to go low and close to the subject in his picture of the tortoise (Figure 3.11). That placed him in the perfect position to use his body to help reduce camera shake. If you are having trouble holding the camera still, for example, due to using a heavy lens, or if the subject is moving fast (that is a relative term we will define later in the book), then a faster shutter speed or some sort of extra support is required.

Brian is using his knee to brace his arms and camera in Figure 3.12. The basic hold stays the same. The telephoto lens weighs as much as the camera, and his left hand is devoted to supporting it. With the zoom and other controls set, he has modified the grip to allow resting most of the length of the lens barrel on his hand. Another option is to fully kneel or sit on the ground and then brace the camera.

### Figure 3.11
Slow-moving or still subjects allow moving in close and the use of slow shutter speeds, but those conditions require more care to avoid camera shake that can blur the image. (Photograph by Terrence Karney.)

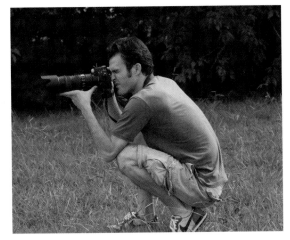

**Figure 3.12**
Using a knee to brace your arms as they hold the camera is a good way to reduce camera shake.

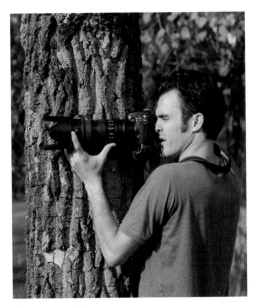

**Figure 3.13**
Leaning into a tree or other solid object is another way to have a stable platform for taking pictures.

Another trick to find an object like a tree, car roof, chair back, or wall to use as a brace. In Figure 3.13, Brian leans into a tree. As you can see, the basic grip is the same. His left hand is pressed against the trunk, and supports the lens. His right hand is pushing forward against the trunk, while still allowing easy access to the camera controls.

Watch for hazards to both yourself and the camera when choosing a structure as a support—before using it. Trees can be home to insects, poison ivy, and sticky resins. Cars can be hot, or move, while doorways are traffic areas.

There are also dedicated camera supports, which range from beanbags that can be placed over objects like a chair, table, rock, or fallen tree, to monopods and tripods.

A *monopod* looks like a high-tech walking stick with a flat plate on top, with a screw for mounting a camera or lens. I'd suggest trying before buying. Some photographers love them, while others find they are less stable than hand-holding. Their use seems to be an acquired skill. I have one, but use it most often to hold an off-camera flash.

There is no doubt about the stability of a *good* tripod. Notice the adjective. The inexpensive light-weight models found near the video cameras in big-box stores don't have the strength to support most DSLRs. Consider a trip to a real camera store when shopping for a tripod, and bring your camera with its largest lens. In addition to stability, weight (you have to carry the tripod when you want to use it), and how high the legs will raise the camera position, you need to try out the head. This is the top part of the tripod (see Figure 3.14) that actually mounts the camera and allows the photographer to move its position on the tripod to frame the picture. Notice how Brian is still using the same grip to control the camera. This is how a tripod is used to capture moving subjects. What he isn't doing, is bracing or holding the camera tightly. The tripod is doing that part of the job. He has adjusted his grip to a very light touch.

If you are taking pictures with a tripod when the subject isn't moving out of the frame, like a landscape or action taking place in a fixed location (like the space-shuttle launch back in Figure 3.1a), you can let go of the tripod and camera—assuming it's stable—and use a *cable release* to make the exposure. That's a remote shutter release. Since you don't have to press the shutter, it reduces the risk of camera shake. Some cameras can lock the focusing mirror up to eliminate the vibration caused when it strikes the top of its housing.

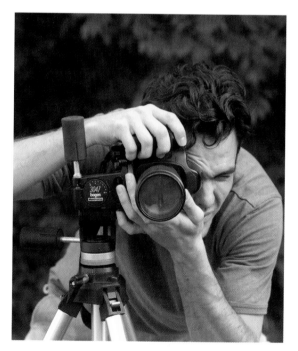

**Figure 3.14**
The basic grip is still handy, even when using a good tripod.

# Keeping Your Gear in Working Order

THERE IS MORE TO KEEPING your camera equipment safe and in good working order than just not dropping it. Dust and dirt on a lens or inside the body can ruin pictures and even cause damage to the hardware. Water, moisture, excessive heat, and mold are some other potential risks. A little care and some preventive measures go a long way to reducing, or even eliminating, them.

## Never Use Force

The components of your camera are designed to work and be handled with a minimum use of force. If a button, knob, or fitting seems too stiff, stuck, or too loose—*never* resort to more than finger-tight pressure. The fitting might be stuck, assembled incorrectly, or have an obstruction. Inspect it first, and if you can't figure it out, ask somebody with experience. I still call my camera-support line when I'm not sure.

Using a tripod requires a few cautions. A couple of them are obvious. You should avoid moving the tripod with the camera attached. It's too easy to have an expensive accident. The adjustable legs and camera mount can slip or fail if not properly secured.

Figure 3.15 shows a typical mounting plate with a knurled knob screw. It is designed as a quick-release device that also makes it easier to attach the camera. A locking clip secures the camera to the tripod, and the lever is used to unhook it. The camera can be quickly un-attached to move the tripod or revert to hand-held shooting.

Now for a less-obvious possible problem: The threads of the mounting screw are usually longer than the depth of the hole in the base of your camera. Screwing it in too hard has been known to actually push the head of the screw inside the base of the camera itself! There are also two different-diameter threads in common use, so make sure that the one on the tripod fitting is the right one for your camera.

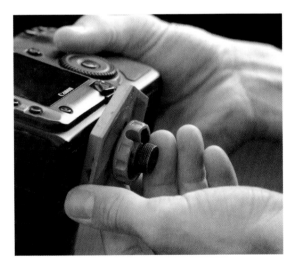

**Figure 3.15**
A typical quick-release tripod attachment device.

## And Be Careful When Handling Glass

"Easy does it" is also the watchword when working with lenses. Of course, you want to be sure to have a firm grip on the lens, and to precisely line up the mount with the camera body when changing from one to another. You also want take care to avoid allowing any dust into the camera when the lens is off.

Figure 3.16 shows an image taken with a speck of dust in one corner. I've circled it and placed an enlarged copy of the spot it created in between two of the flags in the picture. Dust on the sensor can show up on every picture you take. Your camera may have a sensor-cleaning feature, but they don't always work, and you may not notice the dust until it's already ruined several pictures.

There are several things you can do to avoid dust problems. Always keep the front and rear lens caps on all of your lenses when they are not in use. Keep a body cap on the camera when it is without a lens. Don't change a lens in windy or dusty conditions if at all possible. Clean your gear bag of any debris before each photo session.

**Figure 3.16**
The square between the flags is an enlarged copy of the dust spot circled in the upper-right area of the picture. (Photograph by James Karney.)

I use the following routine to minimize dust exposure during a lens exchange. Always check both lenses and the camera body for any debris (lint and hair are even worse than dust) on them before changing lenses. Remove any before removing the caps. Turn your body to shield the equipment from any breeze. Have both lenses ready, and then turn the camera upside down (as shown in Figure 3.17) and remove the current lens. Swap the rear lens cap and place the new lens on the camera. Put the removed lens in a safe location.

**Figure 3.17**
Quickly (but carefully) changing lenses with the camera body opening down helps to minimize dust problems.

Many photographers religiously clean their lenses, but it's not a good habit. The glass used in a modern lens is very soft and even the most gentle cleaning will scuff the surface and leave minute scars. Cleaning solutions often leave a fine haze. The scars and haze reduce the quality of the lens and increase flare. Flare degrades image quality and reduces contrast. (I'll show you an example later in this chapter.)

There is a much better solution for keeping your lenses sparkling clean (pardon the pun). As soon as you get a lens, buy either a skylight or UV filter and keep it on the lens all the time. If it gets dirty, carefully clean it with one of those microfiber cloths designed for cleaning eyeglasses. The filter will protect the front surface of the lens not only from dust and dirt, but also from scratches and the risk of breakage if you bump the glass into something.

## The Gadget Bag and Proper Storage

The final general care tip is to invest in a good padded gear bag, place your camera and its accessories in it, and keep it in a reasonably controlled environment. When you have spent so much on gear that it won't all fit, get a second bag.

I use a LowePro CompuTreck backpack as my primary bag (see Figure 3.18). Peeking out from behind is a 17-inch notebook. Hidden underneath the open flap are a tripod carry pouch and a rain cover compartment. The load balancing is right up there with back-country packs. Most packs like this fit under an airline seat, so you don't have to check your camera gear when you travel.

When it stays in the car on a summer day, I make sure to place the bag out of direct sunlight and park in the shade if at all possible. Once a year the two silicon anti-humidity packets I keep in the bag are replaced. The bag has its own rain cover, and there is a FotoSharp Camera Raincoat (*www.fotosharp.com*) tucked inside to protect the camera and lens if I need to shoot in inclement weather. Many new DSLRs are water-resistant but not waterproof. Mildew can ruin a lens.

A belt pack is another approach if you don't need or want all that carrying capacity. Figure 3.19 shows one with a camera, an attached kit lens, a flash, and basic shooting supplies. It's a good idea to measure your gear when shopping for a bag and consider your "growth plans" for your gear collection. Long lenses, like big zooms or high-powered telephotos, take up a lot of room. On the other hand, they often come with their own carrying cases. They can often be attached to the outside of your primary bag.

**Figure 3.18**
A good bag is a wise investment that not only protects your gear, but also makes it easier to carry and use.

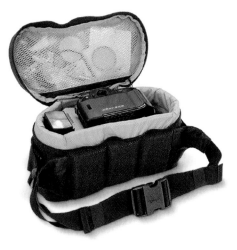

**Figure 3.19**
Belt packs are less roomy than their bigger relations, but are great for carrying a basic digital-photography rig.

# Learning to See

W E HAVE COVERED A LOT of camera fundamentals so far. Now it's time to turn our attention from talking about gear to taking pictures. Before we move on to the next chapter and the mysteries of exposure, there are a couple of additional points to cover about the camera as a platform, good technique, and how to develop an instinctive understanding of the process of taking pictures.

The two pictures seen side by side in Figures 3.20a and 3.20b were taken on the same clear fall morning. The sky and exposure were the same. The soccer game was fast-moving, and I worked both sides of the field that day. The difference in quality is all due to lens flare. See the large slightly hexagonal spot in the upper-left portion of Figure 3.20a? That is the reflection of the sun as its light strikes the filter and front element of the lens. It's pretty hard to miss, and is sometimes called a *halo effect* because it often appears behind a subject photographed against a bright light.

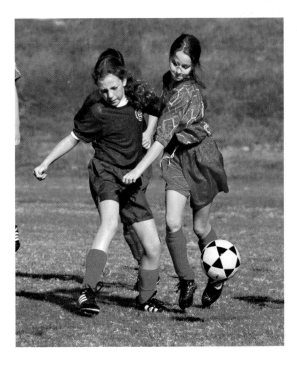

**Figures 3.20a and 3.20b**
The picture on the left was taken with the camera pointing almost directly at the sun, so it suffers from lens flare; the one on the right was taken during the same game from the other side of the field. (Photographs by James Karney.)

Compare the brightness of the colors, the overall contrast, and the apparent sharpness between the two pictures. Figure 3.20b is much superior in all three categories. The flare was caused because the light from the sun fell onto the lens. I was using a lens hood. Using a lens hood is always a good idea. It really cuts down on flare, but it can only do so much.

As soon as I saw the drop in contrast in the viewfinder, I moved to the other side of the field. That's why the rest of pictures are bright and clear. I could have cleaned up the flared image in a program like Adobe Photoshop and made a marginally good picture from it. But I'd rather be shooting pictures than spending time fixing them.

The picture of the bird in Figure 3.21 was also shot almost directly into the sun. I saw the glare striking the lens and shifted position into the shade of a tree. As with the picture of the octopus, the opportunity only lasted long enough for one picture. I saw the bird, and adjusted the exposure while raising the camera and dropping onto one knee. Luckily, I already had a good telephoto on the camera. Before I could take a second shot the bird flew off.

**Figure 3.21**
Shooting into the sun can also be used as a creative tool. Here the light of the sun turns water spray into an instant backdrop. (Photograph by James Karney.)

The shade controlled the flare. Another trick is to shade the lens with a hand or a card, held so it blocks the sun without being seen in the picture. (Be sure that you can hold the camera steadily and safely with one hand.) The sunlight did cause flare that you can see, but in the spray of water that forms the background. That was what first caught my eye. The solitary bird in just the right location produced almost a reflective response in taking the picture.

This is a wonderful time to be taking up photography. The instant feedback of your DSLR lets you examine the results without having to wait for processing. The camera records all the information needed to review your settings. That makes it very easy to see problems, and solve them on the spot.

The advanced metering and auto-focus features let you start taking pictures without having to understand the finer points of exposure and lens design. Take some time to experiment with lens flare. Shoot into the sun and indoor lights. Move around and look at your subject from different angles. What does the way the light falls on the subject do to the way the pictures look? Practice holding the camera for exposures with slow shutter speeds.

These closing images point out valuable lessons on technique. Technique is an acquired skill. Over time and with practice, a photographer's intuition and powers of observation become well-honed. It develops one picture at a time and at the expense of many marginal pictures. It is also the fruit of self-assignments and enjoying the process—both of taking pictures and learning.

**Figure 4.1a**

This soft, high-key portrait was taken within one minute of Figure 4.1b. The dramatic difference is strictly due to the exposure used. Both pictures required knowing how a

# Mastering Exposure and Contrast

**4**

THE FIRST TWO FIGURES IN THIS CHAPTER are a perfect example of how exposure changes an image. They are of the same couple, in exactly the same location, with the same lighting, using the same camera, and taken within a minute of each other. The slight adjustment in camera position did not alter anything other than the composition. The dramatic difference was achieved simply by changing the exposure.

This chapter covers the fundamental skill that separates the photographer from the picture-taker: controlling the way the camera records light. The light meter in your DSLR is a very sophisticated tool, but it has no idea what you are trying to photograph or how you want the picture to look.

**Figure 4.1b**
The meter said this silhouette was underexposed and that Figure 4.1a was overexposed. The lighting was identical for both images. (Photograph by James Karney.)

# The Myth of the Perfect Exposure

PROPER EXPOSURE IS one of the most critical—and elusive—skills the aspiring photographer must master. If the exposure is a little off, important details may be lost. Even the best exposure meter is just a guide. The "perfect" exposure is in eye of the photographer. The light falling on the subject, and the exposure settings, are the two most important elements in any picture. That learning process is a perfect time to develop the basics of camera technique—how to handle your camera to get the highest quality images, and ensure that the camera keeps working properly.

In Figure 4.1a, I deliberately overexposed from the meter reading to reduce the shadow areas of the picture and increase the "lightness." In Figure 4.1b, I matched the exposure for the outdoor sunlight, underexposing the couple and rendering them as a silhouette. Figure 4.2 shows another couple, photographed by my friends Mike Fulton and Cody Clinton at TriCoast Photography, exposed normally for the existing light conditions and showing a full range of tones.

A meter can determine the "correct" exposure for a picture, one that *usually* produces an image file with reasonable middle tones. But, meters can be fooled—the "correct" result may not have the appearance the photographer wants.

**Figure 4.2**
The overcast sky on this rainy day (see the wet sidewalk in the background) helped soften the light falling on the couple. (Photograph by TriCoast Photography.)

The "perfect" exposure produces the image matching the *photographer's vision* of the scene, not the meter's. The "right" exposure can freeze motion, blur parts of the picture—or keep the entire scene as sharp as possible. In short, the exposure setting is part of the creative process. To master it we have to learn more about what exposure is and how meters work.

# ISO, Going Outdoors, and the Sweet-16 Rule

LIGHT IS ENERGY. The photographic sensor in your camera can record the energy levels striking the individual dots, called *pixels*, on its surface to form an image. All photographic exposures have four components: the amount of light energy in the scene, the sensitivity of the recording device (in this case the sensor), the intensity of the light that strikes the sensor, and for how long the light is allowed to strike the sensor.

Three of those components can be controlled using camera settings. (The light falling on the subject is the exception.) The ISO setting is a number that determines how sensitive the sensor is to light. The higher the number, the more sensitive the sensor is, and less exposure is required. At very high numbers, there is a noticeable loss of image quality. (We'll cover ISO in more detail shortly.)

The lens diaphragm, or aperture opening, of the lens (commonly called the *f/stop*) works like the pupil of your eye; it controls the intensity of the light that strikes the sensor. Here, bigger numbers mean a smaller-size opening. (For example, f/3.5 is a larger opening than f/4.) When the aperture is opened wide, more light is allowed in; when it is closed down, the light intensity is decreased. (We'll cover f/stops and lenses in detail in Chapter 5, "Lenses and Perspective: A Photographer's Point of View.")

The third variable is shutter speed—how long the shutter is open. It is measured in fractions of a second. (Long exposures are given in seconds.) Fast shutter speeds can freeze a moving subject in the picture. The amount of light needed to properly record an image is a set value based on the sensitivity of the sensor, the size of the aperture, and the shutter speed.

Let's use an analogy: getting a suntan. (We'll ignore the health issues for purposes of illustration.) The potential for tanning depends on the intensity of the light source and the sensitivity of the skin. The tanning light source is like the light available in a scene we are taking a picture of, and the skin sensitivity is like the ISO number of the sensor. It takes a set amount of radiation—light is radiant energy—to get a certain amount of tan under those conditions.

When we are tanning, we can use sunscreen and time in the sun to control the amount of exposure. The camera offers two controls at the moment of exposure: f/stop and shutter speed. The shutter speed is like how long a person stays in the sun, and the f/stop is like sunscreen. The more sunscreen, the longer we can stay out without overexposure. The shorter the time, the less sunscreen needed.

The sun on a white sand beach is twice as bright as on a grassy yard because the sand reflects the light. For that reason, you need to either reduce the time in the sun by half, or double the sunscreen to get the same amount of tanning and protect against burn. Let's say that one hour of sandy beach exposure is just the right amount of tanning for someone's skin and call it a "tan unit." So two hours on grass is also one tan unit. If we apply a sunscreen that cuts the intensity in half and sit on the beach for two hours, we also have one tan unit. The amount of energy and tanning is the same. In effect, we have used time and intensity to control exposure.

That same principle is used in photography to define the *exposure value,* or EV. We start with the light intensity of the scene and the selected ISO setting. Then we choose an f/stop and shutter-speed combination that allows the correct amount of exposure to reach the sensor. We can use a fast shutter speed and a more open f/stop to freeze motion, or close the lens aperture more and increase the amount of the picture that is in sharp focus. (More on how that works later.)

The camera controls are designed so that when we adjust either the shutter or the lens aperture one full stop, we change the exposure by one exposure value, depending on which way we move the setting. That's because we either double or cut in half the amount of light reaching the sensor. For example, going from f/16 at 1/50th of a second to 1/100th cuts the exposure in half; going from 1/50th to 1/25th doubles it.

So the EV has been doubled or halved. Now, if we increase the f/stop opening (say, from f/16 to f/11) and also reduce shutter speed one stop (say, from 1/100th to 1/50th), we have kept the same EV. The amount of exposure is the same.

Figure 4.3 shows a couple walking on a beach on a beautiful day. I didn't take the picture, but I can tell you the correct exposure just by looking at it. It's easy to manually set exposure outdoors if you know the "Sweet 16" method. That's because there is a basic formula that uses the light intensity of a bright sunny day as a basic value. You don't need to do any fancy math to make it work. Like our tan unit, it's based on the sky condition and shadows cast by the sun.

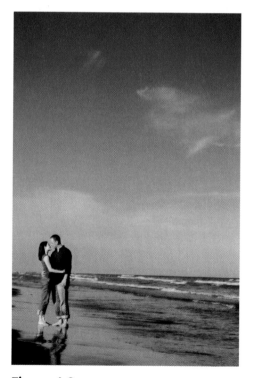

**Figure 4.3**
The proper exposure for this picture was based on both the light in the sky and the reflected light from sea and sand. (Photograph by TriCoast Photography.)

That same principle is used in photography to define exposure value, or EV. The degree (ratio) of change in light intensity recorded by adjusting *either* the shutter *or* the lens aperture one full stop is 2:1—it either doubles or cuts in half the amount of energy, depending on which way we move the setting. For example, going from f/16 at 1/50th of a second to 1/100th cuts the exposure in half; going from 1/50th to 1/25th doubles it. So the EV has been doubled or halved. Now, if we increase the f/stop opening (say, from f/16 to f/11) and also reduce shutter speed one stop (say, from 1/100th to 1/50th), we have kept the same EV. The amount of exposure is the same.

The way to really learn about exposure and metering is by taking pictures under controlled conditions without using the meter. Then use the understanding gained about the basic process to use the meter as a tool, rather than an autopilot.

While the ISO number is based on a standard, there are variations in how different camera makers interpret it, and photographers have personal preferences. In the days of film, all of my new photography students got the same first assignment. They had to go outside and test the real ISO for their equipment the way they used it. In doing so, they learned about exposure without a meter (and it makes learning to use a meter really easy). We are going to do the same thing with the DSLR and its sensor. While you can just read along, doing this exercise is highly recommended. You might want to bring the camera's manual. We'll be adjusting the options and settings as we take pictures.

## Understanding Sky Conditions and Light Levels

We are going to use the sky condition and the camera's ISO setting to determine the correct exposure without the meter. Before the days of the ever-present light meter, photographers had to use *exposure tables* to determine a good baseline for taking a picture. They still work. We are going to use the "Sweet 16" rule to explore exposure without a meter. Then learning to properly use a meter will be a snap. Exposure tables all work the same. The ISO speed is paired with a standard lighting condition to determine a suggested exposure.

Bright, noon-day sunlight on a cloudless day has a set intensity level that is constant enough to use as a reference. Add some white sand or snow to the scene, and the reflected light and the light level just about doubles. Add a few clouds, and that light level drops in half. If the clouds cover more of the sky and darken it, the light level is halved again. We can tell how much the light has changed by looking at the shadows.

If the sunlight in the scene is muted due to clouds, fog, or shade, then we have to increase the amount of exposure to get the same amount of light to the sensor. Consider the broken bicycles assembled on the Amsterdam street shown in Figure 4.4. This was an overcast day and I took the picture in late morning. Notice the faint shadows cast by the bike wheels, and how much softer the light is? That is due to the shade of the buildings, which prevents most of the sunlight from directly reaching the bikes.

**Figure 4.4**
The shadows cast in this street scene were between cloudy bright and cloudy dull. The bicycles were in the shade of the building that also reflected the sunlight of a bright sunny morning. (Photograph by James Karney.)

Let's review. The average human eye can distinguish when the light intensity in a scene doubles or is cut in half. This amount of change is equal to moving the lens aperture or shutter speed one *full stop*—for example, changing the lens aperture from f/11 to f/16, or the shutter setting from 1/25th of a second to 1/50th.

With a little practice the Sweet-16 system can be customized for your camera and shooting style. This skill frees you from relying on the meter and your camera's automatic settings. You'll know how to tweak the meter reading, and be able to tell when it is not accurate. You can also deliberately manipulate the exposure for artistic effects or to compensate for special situations (more on that later).

Let's take some pictures. The first thing is to set the camera metering system to manual mode. There is often a dedicated button or dial that controls this. Be sure that any exposure compensation (plus or minus from the actual exposure setting) is set to a zero value, or turned off. Set your camera to ISO 400 and the lens aperture (f/stop) to f/16. That's the 16 in Sweet-16. Next, set the shutter speed to 1/400th of a second. The basic exposure using this method is set by matching the shutter speed to the ISO number at f/16 (here, 400 and 400), when taking a picture in full sunlight on a cloudless day, like the conditions shown in Figure 4.5.

Go outside at least two hours after sunrise, and at least two hours before sunset, and take some pictures of subjects in open lighting (not shaded by a tree or building) using the settings described in the following list, manually adjusting the exposure. Then take another copy of the same picture using the camera's auto-exposure mode. The early-morning and late-day sunlight do not have the full intensity the system requires for reasonable exposures.

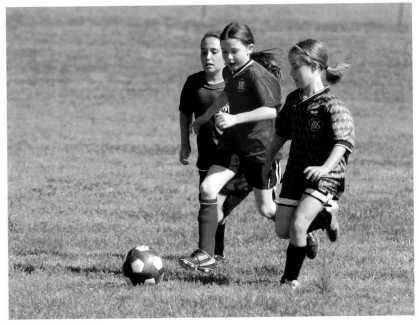

**Figure 4.5**

This picture was taken on a bright sunny day. There were no clouds in the sky and the girls cast dark shadows on the ground. The exposure was 1000th of a second at f/4.5 at ISO 200, the same EV as f/16 at 1/200th of a second with an ISO of 200. (Photograph by James Karney.)

### The Sweet-16 Exposure Levels

*Bright sun with no clouds in the sky and distinct shadows:* 1/ISO number at f/16 (basic Sweet 16)

*Bright sun on light sand, snow, or reflecting off a bright surface:* 1/ISO at f/22. (Decrease one EV from f/16). This is a very contrasty type of lighting that produces very dark shadows and bright whites.

*Hazy sun, a few clouds in the sky causing soft shadows, or very light fog:* 1/ISO number at f/8 (increase one f/stop from f/11)

*Cloudy bright with no shadows:* 1/ISO number at f/5.6 (increase two f/stops from f/16). This is when the sky is mostly cloudy over the scene, but with areas of bight sun adding to the overall illumination.

*Cloudy dull:* 1/ISO number at f/4 (increase three f/stops from f/16). The sky has a complete cloud cover, but sunlight filters through the clouds.

*Cloudy dark:* 1/ISO number at f/2.8 (increase four f/stops from f/16). This is what we see when a thunderstorm approaches or during a fall rainstorm.

When setting exposures using the Sweet-16 reference points, changes are made in full f/stop increments (either doubling the amount of light reaching the sensor or cutting it in half). Experienced photographers also often use the term *full stop* when referring to adjusting the shutter speed or ISO by that amount. The list below gives the range of full stops for all three exposure variables (aperture, shutter speed, and ISO) for you to use. Almost all DSLRs offer the ability to make smaller adjustments. Please use only full stops matching the Sweet-16 rule for right now.

Here is the range of traditional full f/stops: f/2.8, f/4, f/5.6, f/8, f/11, f/16, f/22.

Remember that smaller numbers let in more light, so increasing two stops from f/8 would mean using f/4.

The range of shutter speeds in full stops (arranged from letting in the most light to the least) is 1/25, 1/50, 1/100, 1/200, 1/400, 1/800, 1/1600. Your camera will probably only show the number to the right of the slash mark.

Full-stop ISO numbers also double or halve: 25, 50, 100, 200, 400, 800, 1600.

You may want to adjust the ISO or shutter speed to compensate for a lens that does not offer the proper f/stop. Many lenses don't offer a setting of f/22 or f/2.8. Let's use an example to make the options easier to understand. If your subject is near or on a large reflective surface, you can adjust the exposure by either increasing the shutter speed to 1/800th of a second or making the f/stop one stop smaller to f/22. If your lens doesn't close that much, cut the ISO number in half.

One "full stop" lower adjustment of any one setting reduces the total light energy recorded—the exposure—in half. Many lenses don't have a setting smaller than f/16. (As the numbers get bigger, the opening gets smaller. I'll explain why in the next chapter, along with what those arcane numbers mean.)

Perhaps you want a faster or slower shutter speed than the one dictated by the ISO number, or a larger or smaller lens aperture (f/stop), but want the same amount of light to reach the sensor. In that case, you adjust two variables to record the same intensity. For example, f/16 at 1/200th of a second at ISO 100 is the same as f/8 at 1/100th of a second at ISO 100, and as 1/400th of a second at f/16 at ISO 200.

To really gain an understanding of both exposure and how different lighting conditions affect the way a scene appears, experiment with the same scene under different sky conditions over several days and compare the results. Notice how well the standard settings work with your camera. Do the results look over- or underexposed? Are the highlights too white, or the shadows too black? If so, some fine-tuning is in order.

# Playing with the Numbers

AS YOU GAIN EXPERIENCE working with full-stop adjustments, start using smaller increments to tweak your results to suit both the subject and what you want to see in the final picture. The Sweet-16 system, like your camera's auto-exposure feature, is basically an educated guess based on statistics. As the saying goes, "local results may vary."

The DSLR gives us instant results that film cameras lack. Use that feature to examine the results, and then add or subtract from the exposure settings to shift the way the image is recorded. Many scenes don't have lighting conditions that nicely fit any formula's pre-defined categories, or fit perfectly into a one-stop formula. Your camera may offer adjustments as fine as a one-third or even a one-quarter stop.

Consider the conditions Geoff Cronje faced with the sky cover in Figure 4.6. We can tell from the dark shadows that the foreground is lit by bright sun. The visible area at the top of the image is cloudy dull, and the storm and lowering clouds seen in background are cloudy dark.

A meter reading wouldn't offer a lot of help in a situation like this. Geoff had to choose how he wanted the land and clouds to appear and base the camera settings on that part of the tonal range. Notice how dark the shadows are under the trees. They are darker than one would expect for a cloudy dull condition. The portion of sky lighting that part of the composition may have been cloudy bright. It is not visible in the image.

**Figure 4.6**
Many pictures don't fit nicely into a single lighting category. This panoramic landscape by Geoff Cronje shows a sky that ranges from cloudy dark under the storm clouds to bright sun in the foreground.

His exposure was 1/750th of a second at f/8 and ISO of 200. That's more than one-and-a-half stops less exposure than the bright sun setting for that ISO. There is a very small triangular portion of the clouds, high and slightly to the right of center, that is pure white. Pure white is recorded when a pixel receives an excessive amount of light. This exposure allows the dark clouds to keep their menace. Increasing the exposure would have lightened the clouds and rendered a larger area pure white.

The picture in Figure 4.7 was taken on a day with light cloud cover and bright sun. Terrence Karney adjusted his exposure to produce a nice blue sky that was darker than the blue of the buildings. His fine-tuning of the exposure let him record detail in the clouds, and keep the highlights in the golden domes from going pure white, while reducing the darkness of the shadows under them.

**Figure 4.7**
This picture was taken on a sunny day with a few clouds using the Sweet-16 table with a slight variation. The exposure was 350th of a second at f/8 and the ISO number of 400. (Photograph by Terrence Karney.)

Remember the rule about reflective surfaces increasing the amount of light? It applies to more than just bright sun conditions. Figure 4.8 isn't art. It was part of a fun afternoon as the set crew moved props for a play from storage to the theater, just after a snow storm. The sun shone weakly through the clouds, and there were no shadows. I estimated the lighting conditions at "brighter than cloudy dull," and added a stop to compensate for for the snow. I wanted to freeze the action of the snowball throw. The resulting exposure was 1/300th of a second at f/9 with an ISO of 320. Notice the snowball, its motion stopped, directly above the girl's head.

**Figure 4.8**
The snow cover in this scene added to the overall light level. The effects of snow and sand are not limited to bright sunny days. (Photograph by James Karney.)

## Working with Light Meters

The goal of our Sweet-16 exercise was to train the eye to evaluate lighting conditions, and be able to estimate a reasonable outdoor exposure. Once you feel comfortable with that, try comparing your opinion with the meter reading. Some times you'll be better, sometimes the meter will, and sometimes neither. Learn what types of lighting fool you both, and you are on the way to being an exposure master. Knowing how meters work will speed the process.

Your DSLR probably offers several programmed exposure modes and metering methods. The latter are usually based on traditional hand-held meters. The most basic is the *averaging meter*. It reads the light striking its sensor, averages the total intensity, and provides a suggested exposure setting. It uses the average reflectance of several common subjects, like a sunny sky (not the sun, just the sky) and green grass. That average level is called "18-percent gray," or "middle gray," since that tone is the reflective grayscale of those objects.

The faces of the statues, and the back of the book the statue in the foreground is holding in Figure 4.9 are reflecting the tone known as 18-percent gray. This picture is the perfect target for an averaging meter system, since it is low-contrast and dominated by middle tones. It was taken on a cloudy day with periods of soft rain.

**Figure 4.9**
The faces of these statues are very close to the 18-percent gray that is the standard shade used by reflective meters to determine a basic exposure setting. (Photograph by James Karney.)

The problem with the basic averaging meter is that many scenes don't have lighting conditions that average to 18-percent gray. Even when they do, the direction of the light in relation to the subject and the camera can cause problems. The challenge is particularly difficult in brightly lit scenes with high-contrast subjects like the one in Figure 4.10.

**Figure 4.10**
The bright light of the sun is coming in from the back-left side of this scene, placing the delightful expressions into shade. An averaging meter would not have been able to determine the proper exposure for this picture. (Photograph by James Karney.)

I wanted the final picture to center on the faces of the children, and still hold detail in the white ring pillow, the flower girl's dress, and even part of the black tux. That is too much to ask either the meter or the camera's sensor to manage. The lighting and the subject had too much contrast for that. The meter's suggested exposure would have underexposed the faces and rendered the brightest-lit areas as pure white.

I "cheated" and used a combination of experience and technology. The highlights are even a little brighter than full sun on snow or sand (it was a bright sunny day with no clouds). So I knew that an exposure two stops above bright sun would hold the highlights, and that the sun falling on the ring-bearer's shoulder would reveal the texture of the black fabric.

The problem was that this exposure, 1/800th of a second at f/16 and an ISO of 200, would have left the faces too dark. I used 1/400th of a second at f/14 and lit their faces with a flash unit that was set to deliver just enough light to soften those shadows on the faces. That did blow out the brightest highlights, and they turned pure white. Since the file was in RAW format, I was able to recover some of that detail during image processing. We'll cover fill-flash technique and processing for highlight recovery later in the book.

## Enter the Matrix

*Matrix-metering* adds computer analysis to the averaging process. Its programming breaks up the scene into regions and then tries to identify the best exposure based on the patterns of intensity. The computer in the camera has a library of standard scenes, like sunsets and portraits. For example, a very bright overall scene with one dark area might be flagged as being backlit. The metering system would then suggest (or automatically adjust) the exposure to give the dark region more light, at the risk of washing out the bright background.

That scenario is a generalization. Matrix-meter programming is the heart of most of the modern DSLR's automatic modes. Each vendor develops its own *algorithms* (computerized mathematical formulas), and the finer points are proprietary secrets. Some cameras come with tens of thousands of resident sample scenes, which the computer uses to arrive at its suggestions. Be sure to study the options and controls available for your built-in meter; each model has its own quirks that can only be understood by using them.

Matrix-metering is a major improvement over the coarse results provided by a basic averaging system. If you wish to rely on either, practicing to the point of familiarity is in order. It's also a good idea to check the results, if the image is important. That is especially true if the picture contains an unusual mix of light and dark areas or has high contrast.

The better DSLRs also offer a *spot meter* mode. This design limits the meter's action to a very small area. Hand-held spot meters can read very small circular areas. The size will depend on the distance from the meter to the subject. In-camera meters vary; the best ones measure about 4mm directly off the sensor. Figure 4.10 shows a picture that I took using a spot meter. The large areas of black, coupled with the very bright stage lights, would have challenged any other metering system.

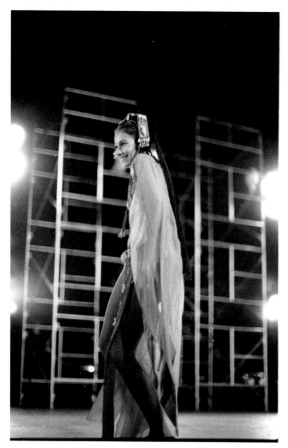

**Figure 4.11**

This image was taken under extremely contrasty lighting conditions; it was exposed, and then processed, to allow the center of interest, the actress, to be presented in normal contrast. (Photograph by James Karney.)

Spot meters, like averaging meters, read the target and assume it is reflecting 18-percent gray. I used a hand-held spot meter when choosing an exposure for Figure 4.11. I pointed it at the actress' tights, which were very close to the right tone. The night was dark, except for the big stage lights, and the exposure was 1/15th of a second at f/1.2 with an ISO of 1600. It helps to practice holding the camera very still.

*Incident meters* still use 18-percent gray as a reference, but they average the light falling on a side of the primary subject facing the camera. Figure 4.12 shows a Sekonic L-758dr incident meter. The translucent dome is over the sensor, which is pointed toward the subject. The total light is averaged and the exposure calculated.

This type of meter is especially handy when photographing a scene with multiple lighting sources. The dome can be aimed at each source to gauge its effect on the exposure, and then at the camera to find the total effect on the picture. The better models, like the Sekonic L-758dr, also can measure flash output. If you decide to get serious with advanced lighting effects, an incident meter is a nice addition to the gadget bag.

**Figure 4.12**

The Sekonic L-758dr incident light meter.

To hone your skills, start taking pictures in more challenging lighting conditions. Use the meter and experiment with its different modes. Your camera should offer a way to rapidly set an *exposure compensation*. This adjusts the effective exposure in small amounts, usually equal to a one-third f/stop value, while leaving the actual exposure-value setting the same. Examine the results, paying particular attention to the way very bright and very dark areas are recorded. The goal is to find the settings that hold the most detail.

## Highlights, Shadows, and Points in Between

Contrast is a major consideration when setting exposure. It's also a powerful composition tool. There are two types of contrast in photography. *Tonal contrast* is the term used to refer to the range of grayscale tones between the darkest black and whitest white in an image. A *high-contrast* scene has mostly black and white with few (sometimes no) shades in between. A black and white checkerboard is an excellent example. A *low-contrast* scene is comprised mostly of middle tones. *Normal-contrast* pictures are in between the two extremes. A normal-contrast scene usually contains some elements that are very light or white, some that are very dark or black, and many tones or colors in between.

*Color contrast,* the second type of contrast, refers to the way colors interact visually in the scene. Colors with opposite characteristics contrast strongly when placed together. Each color accentuates the qualities of the other and makes the color elements stand out dramatically.

Both types of contrast are tools we can use in our photographs to set a mood, pull the viewer into our work, and draw the eye to the main point of interest. They are related to exposure, since exposure affects the way a tone or color is recorded.

Consider how the TriCoast Photography image in Figure 4.13 uses both types. The dark setting has generally low contrast with warm tones. The woman's face and her light-colored scarf and jacket have much more contrast. Her expression, facing directly toward the viewer, accentuates the *film noir* air of mystery.

Cold colors (bluish) and warm colors (reddish) almost always contrast. Light and dark colors contrast against each other, as do very saturated colors against muted shades. Harsh lighting conditions (like bright sun or a spotlight) tend to increase tonal contrast and color intensity, while soft or indirect lighting reduces contrast and increases color saturation.

Setting the exposure for this picture required carefully arranging things so that enough light illuminated the woman without making the floor and background too bright. (This image used carefully controlled lighting.) The lower contrast in the center of the composition increases the color saturation in the brown floor. The exposure was 1/25th of a second at f/2.8 and an ISO of 1250. That means the scene was 10 stops darker than bright sun. The photographer indexed the exposure on the woman. *Indexing* refers to setting the EV used to ensure that detail is held in the most important element of the composition. Her face has more contrast than the rest of the composition.

**Figure 4.13**
The combination of both tonal contrast and well-planned use of color in this picture creates a dynamic tension and an air of mystery. (Photograph by TriCoast Photography.)

Normal tonal contrast and the interplay of light and shadow can be combined with color contrast to produce pleasing compositions. The classical painting masters used all three to add depth and visual texture to their works. Terrence Karney used the same elements in this study of a wharf in Figure 4.14. The effect requires careful attention to exposure, and adjusting it to control the way highlights and shadows are recorded.

## Softer Light, Fewer Shadows, More Saturation

Compare the way color and contrast work together in Figure 4.14 with the portrait in Figure 4.15 by TriCoast photographers Mike Fulton and Cody Clinton. Once again, soft lighting is used to reduce contrast and saturate colors. This exposure is indexed higher on the mid-tone scale by about one-half to three-quarters of an f/stop. This combination of lighting and exposure is often used for portraits of women. The lighting makes the skin appear soft. Boosting the exposure reduces shadows, reducing any lines and "smoothing" the complexion.

**Figure 4.14**
The photographer indexed his exposure to hold highlight detail. (Photograph by Terrence Karney.)

**Figure 4.15**
This image uses soft lighting to decrease tonal contrast and increase color saturation. Notice how the color of the eyes, shirt, and hair work together in this composition. (Photograph by TriCoast Photography.)

To improve your skills even more, try working with light in the shade and even shadows. Experiment with placing subjects next to bright surfaces, in partial shade, and try working with different levels of both tonal and color contrast. Another neat trick is to subtly shift the white balance to add a little warmth (more reddish-yellow) or cooler (shift toward the blue) to the colors in the picture. Most DSLRs have a fine-tuning control. Check the white-balance section of the manual. Keep the increments small, so that the whites still look white. If you shoot RAW files, the white balance can be changed at any time with editing software.

# Almost Another World: Taking Pictures Inside

OUR DISCUSSION SO FAR has centered on using natural lighting from the sun, and (mostly) predicable exposure conditions. Indoors, and outdoors at night, add the complexity of mixed light sources that usually don't have the same intensity as the sun. It takes a lot more practice to develop the ability to judge light intensity and exposure inside.

Contrast levels within areas of a scene can vary dramatically, especially if there are windows in the picture and a bright day outside or if the room contains areas with both bright lights and deep shadows. That combination offers both a challenge and a great opportunity. Bruno Chalifour's working portrait of a guitarist in Figure 4.16 is a case in point. This picture shows real skill, a good eye for color and composition, and the ability to work with available light.

**Figure 4.16**
Dramatic lighting can produce dramatically pleasing results when handled properly.
(Photograph by Bruno Chalifour.)

A spotlight above the musician's left shoulder provides the main light as it falls on the guitar, the hands, and the white jacket. His jacket reflects the light onto his face. The background adds a red accent, lit only by the lights near the ceiling. The contrast in the scene between the white of the jacket and the darkness of almost everything else in the image draws the eye, as does the angle of the instrument.

Consider the way the exposure was chosen. Some of the jacket is recorded as totally white, but most of it shows detail, including the buttons and vertical stripes. So, holding the highlights was the index point, letting the deeper shadows fade to pure black. The spotlight adds warmth to the white balance. The exposure was 1/15th of a second at f/6.3 at ISO 1600. The f/stop choice and the low angle allowed both the guitar and the musician's face to stay in focus. That required a slow shutter speed (and steady hands), even at the high ISO level.

The lighting conditions in Figure 4.17 also came mainly from spotlights. You can see that one lightens the upper-right corner of the picture, and another falls in the corner, a bit lower on the wall. Pointed light sources produce higher contrast than broader ones. That's why the shadows are soft on a cloudy day and harsh in direct sunlight.

I used my camera's matrix-metering mode to read the scene, and then increased the exposure a half-stop to hold detail in the masks, one closest to the upper light and the other one in the lower left near the open door. The final setting was 1/20th of a second at f/2.8 with an ISO of 320.

**Figure 4.17**
This picture was illuminated by two spotlights and an open door. The exposure was indexed to hold tone and detail in the white masks. (Photograph by James Karney.)

An average room illuminated for easy reading with white walls will usually produce a workable image at 1/30th of a second at f/2.8 at ISO 400. If you want to gain the ability to "read" indoor exposures, find the setting that works for a room you use frequently. Then learn to visually use that illumination as a reference, as with the bright sun setting with Sweet-16. Take actual pictures in indoor settings using your estimates, check the results, and adjust the settings if needed.

Not all indoor pictures are taken with indoor lighting. The portrait in Figure 4.18 was illuminated only by a set of large windows about eight feet from the subject. The broad light source produced soft highlights, but was bright enough against the interior of the church to provide some contrast. The face is turned mostly toward the light, producing a nice shadow effect. The exposure settings were only one stop more than open shade, 1/60 of a second at f 4 with an ISO of 200. If he had been standing close to the window, it would have been exactly the same.

**Figure 4.18**

The picture may have been taken indoors, but all the light came from the sun through several large windows. Window light is often a wonderful way to illuminate a portrait. (Photograph by James Karney.)

# Going to Extremes

YOU MAY HAVE NOTICED that many of the pictures in this chapter were exposed to hold detail in the highlights. Many scenes have a wider tonal contrast range than a sensor can record. Human vision tends to be more willing to accept dark shadows than featureless expanses of white. As a result, knowing how to hold the highlights and keep them from "blowing out" into pure white is a good skill to possess.

For our final exercise in this chapter, we'll see just how far the "save" can be pushed. Some scenes offer serious challenges, but the right combination of camera settings and then basic processing can work wonders. I don't mean fancy retouching to add or remove portions of the image in a program like Photoshop, just manipulating the way the exposure settings are used.

Figure 4.19 is the original RAW image taken inside the massive Cologne Cathedral on a rainy fall afternoon. The blue cast is due to the natural sunlight filtered through the stained glass windows. That's the only light used. I let the camera attempt to determine the white balance; the scene looked very blue. By shooting in RAW, I knew I could adjust it later. Let's look at the picture throughout that process.

The image is underexposed and very dark in the shadows. That's because I wanted to keep as much detail and color in the stained glass as possible. The camera's meter reading resulted in a test exposure that turned all but the windows in the far left of the image into panels of pure white. The exposure was 1/20th of a second at f/2.8 at ISO 500. This scene was a lot darker than the church interior in Figure 4.18.

**Figure 4.19**
The original RAW image as recorded by the camera. Significant underexposure was used to hold detail in the stained glass windows. No processing has been done at this point. (Photograph by James Karney.)

## Adjusting the White Balance

My first step was to adjust the white balance. That's critical to success because white balance determines the way colors look and it sets the visual "mood" of the picture. Figure 4.20 shows what a dramatic difference this one changed setting makes. Now the picture has lost the blue cast. This is the way the cathedral looks on a sunny afternoon. The clear portions on the widows now look more white, and the interior of the building has a much more pleasant, warm look. I used Bibble Pro, a RAW editor we will work with later in the book.

The image is still dark and moody, and it's hard to even tell what the objects in the foreground are. It's time to use Bibble Pro's processing tools to boost the exposure in the shadows, and reduce the sensor noise—without losing detail in the stained glass. That's an option because good editing programs let you selectively adjust the highlights, mid tones, and shadows. The results are shown in Figure 4.21.

**Figure 4.21**
The image after processing in Bibble Pro.
(Photograph by James Karney.)

**Figure 4.20**
The image after correcting the white balance.
(Photograph by James Karney.)

Now we can see detail in the lower portion of the picture. Quite a difference, but the woodwork in the center and the statuary on the pillars is still dark. We can fix it with local adjustment. I did that in another program called LightZone. We'll explore it later too. Figure 4.22 shows the final result.

If you look closely (and assuming the printed version looks like the one on my monitor), there is better lighting on the statues, and on the wooden objects in the center of the picture. There is even more detail in the windows. Does this mean that we can simply shoot pictures using a best guess at exposure and white balance? No.

Any enlargement of this picture shows significant sensor noise in the areas that were dark before. And the image is not quite as sharp as it would be without all the manipulation. The final image exposure was a trade-off. I was willing to trade fine-detail quality to hold the stained glass colors. It also took time to edit the file, which would not have been needed had the interior lighting been better and allowed a more reasonable exposure.

There are some other technical flaws that arise from using the lens wide open, adjusted to its fastest f/stop, and from setting the zoom lens to its widest position. There are almost always trade-offs with the settings for any picture. The ones chosen here allowed getting a picture under adverse conditions. That ability came from understanding exposure, and knowing the equipment and how to use it to full advantage. That comes with practice.

Take some pictures indoors that push the limits, under a variety of lighting conditions. Use slow shutter speeds and practice holding the camera still. Then take what you learn back outdoors and see how your abilities have improved.

**Figure 4.22**
The final image after editing in LightZone.
(Photograph by James Karney.)

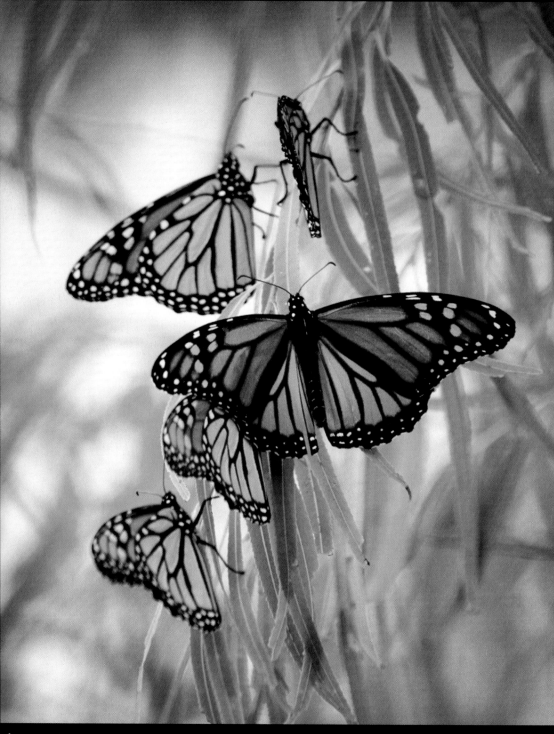

**Figure 5.1a** Some lenses are designed for up-close photography of small things, like these butterflies. (Photograph by TriCoast Photography.)

# Lenses and Perspective: A Photographer's Point of View

<div style="float:right">5</div>

**M**ODERN INTERCHANGEABLE LENSES are as much a technological wonder as your DSLR; and that interchangeability is one of the main features setting a DSLR apart from its lesser point-and-shoot kin. Different lens designs and different lens settings have different "personalities" in the way they bend light to form an image. That affects both the way the picture looks and its impact on the viewer.

Properly used, they can make small objects fill the frame and blur the background, like the butterflies by TriCoast Photography in Figure 5.1a. They can make distant objects seem near and packed close together, like the Blue Angel jets in Figure 5.1b, taken by Gary Todoroff.

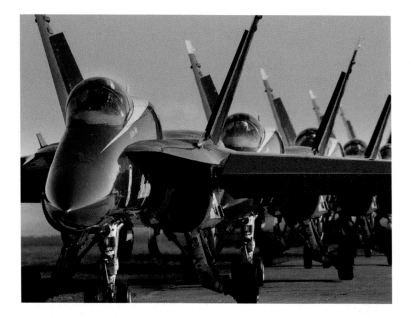

**Figure 5.1b**

Some lenses make far-away things look closer. (Photograph by Gary Todoroff.)

# Lenses: Wide, Normal, Long, and Zoom

A CAMERA LENS HAS TWO PRIMARY tasks: focusing a sharp clear image of the subject you want to photograph, and letting in the proper amount of light. The lens is also the device that controls the view your camera has of the world. That sounds simple, and in practice, it is—if you understand a few basic concepts. This chapter is all about how to choose, use, and care for the glass in front of the camera—and how it sees the world.

The fish-eye lens that Scottish wedding photographer Nikki McLeod used to create the image in Figure 5.2 has a 180-degree angle of view, true panoramic vision. It also induces distortion that can warp straight lines. You can see that in the way the straight roofline and sidewalk are pictured as curved lines. Nikki used that distortion as a design element.

There are some fundamental concepts and terms that have to be understood to able to use lenses to their full advantage, and combine them with exposure as creative tools. In Chapter 3, "Basic Camera Technique for DSLRs," we skipped over the technical details about f/stops and what those strange numbers really mean. It's time to unveil the mystery and explore the world of photographic optics. First, we need to define some terms.

**Figure 5.2**

And some let us really take in the scene. This photo was taken with an extreme wide-angle fisheye lens that offers a panoramic field of view, at the cost of visual distortion. (Photograph by Nikki McLeod.)

Lenses can be divided into three groups—wide-angle, normal, and long or telephoto—based on how much of the scene around the photographer is recorded in the image. The optical center of a lens is its *focal point*. Light reflected from the subject passes through the focal point, and is curved by the glass to create the image on the sensor. The distance from the focal point to the camera's sensor is the lens' *focal length*. It is measured in millimeters.

In effect, the lens is projecting the image onto the sensor. The longer the focal length, the more the lens magnifies the subject being photographed. The more the magnification, the less area in the scene fits onto the sensor. That's what determines the field of view recorded when you take a picture.

Figure 5.3 shows a wide-angle view, with frames inside depicting the reduced area for typical normal and telephoto lenses. A normal lens produces a picture with the same angle of view as human vision, about 44 degrees of a circle. Longer focal lengths produce a narrower field of view and increase magnification—making distant objects seem closer, just like a telescope. Shorter focal lengths paint a wider subject area onto the sensor at reduced magnification. A fisheye lens is an extreme wide-angle. It can "see" 180 degrees, a semi-circle. You actually have to watch out and be sure your feet don't appear in the picture when using one.

**Figure 5.3**
Examples of the visual areas of coverage of wide, normal, and telephoto lenses.

## Normal Is a Relative Term

"Normal" in lenses is a relative term, based on the size of the camera's sensor. Smaller sensors record less of the image projected by the lens, in effect cropping the picture. Figure 5.4 shows a full-frame image based on the traditional 35mm film format, which has an area 36 by 24mm. That's the size of the sensors on high-end DSLRs. Most DSLR sensors are smaller. The frames indicate how much of the scene would be cut off by sensors with different crop factors.

To find out what a normal lens is for your camera, check the user's manual to determine if there is a crop factor. If so, divide 52mm (that focal length has a normal angle of view for a full-frame sensor) by that number. For example, my Nikon D300's sensor has a factor of 1.5. I consider a 35mm lens "normal." since 52 divided by 1.5 equals 34.6mm.

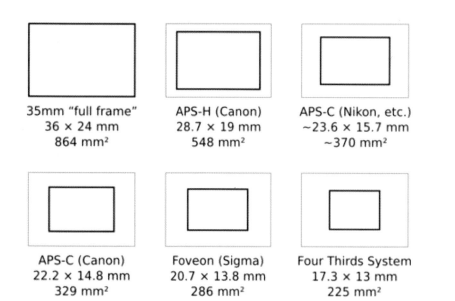

35mm "full frame"
36 × 24 mm
864 mm²

APS-H (Canon)
28.7 × 19 mm
548 mm²

APS-C (Nikon, etc.)
~23.6 × 15.7 mm
~370 mm²

APS-C (Canon)
22.2 × 14.8 mm
329 mm²

Foveon (Sigma)
20.7 × 13.8 mm
286 mm²

Four Thirds System
17.3 × 13 mm
225 mm²

**Figure 5.4**
The inner rectangles in this drawing show the crop factor for common DSLR sensors compared to the traditional "full frame" 35mm camera format. Some DSLRs offer full frame sensors.

Lenses with a fixed focal length are called *prime lenses*. Zoom lenses have a moveable section inside that adjusts to change the effective focal length, and with it the field of view seen by the sensor. Quality prime lenses tend to be sharper and exhibit fewer optical flaws than a zoom covering the same focal length. Modern amateur-quality zooms are great bargains and a wonderful way to experiment with multiple focal lengths without breaking the bank. High-quality zooms come close to rivaling the optical quality and speed of prime lenses.

**Figure 5.5**
Lightweight zoom lenses like this Nikkor 18-105mm offer a good focal-length range from moderate wide-angle to medium telephoto.

# Fun with Focal Lengths and Focus

**W**E CAN USE DIFFERENT FOCAL length lenses to change the way a scene looks in the picture, and control how much of the image is in focus. We are going to look at examples made with different combinations, and discuss how to use those effects creatively. As I offer examples, experiment with your own equipment. If possible, frame the scene using different focal lengths and focusing on different points within the frame. I'll also slip in a few more terms. (No, I haven't forgotten f/stops, but more tech talk can wait.)

## Going Wide While Getting Close

The name *wide-angle lens* may make it sound like this class of optics is designed for landscapes, but they also have a real ability for working close to your subject and giving your viewer an interesting perspective. I took the picture in Figure 5.6 with a 12mm-24mm zoom set to 15mm. Notice how large the horse's head appears compared to everything else, and that everything in the image appears in focus.

The horse's head is large because it is so much closer to the camera than the rest of the picture. Wide-angle lenses let us play tricks like this with visual perspective. It also lets us get very close to a subject and still see its surroundings. If you have a wide-angle lens, or a zoom that goes into the wide-angle range, experiment a bit with framing objects near the edge of the frame and see how it adds perspective to your visual statements.

**Figure 5.6**
Wide-angle lenses let you work close to a subject and still keep distant objects in the in background in focus. (Photograph by James Karney.)

The wide-angle optical design imparts a relatively large depth of field to the image. *Depth of field* refers to the distance near-to-far that appears in acceptable focus in a picture. When we (or maybe our DSLR) focus a picture, a specific point is chosen as the *focus point*. That is the object that will have the finest optical resolution in the recorded image.

Extreme wide-angles lenses can focus extremely close and still have a large depth of field. This lens can focus as close as one foot to a subject. I focused on the bride's hands—not the horse. The church steeple is in reasonable focus too. The smaller the f/stop the larger the depth of field (remember, bigger numbers mean smaller apertures). The sunny day let me use a very small f/stop, f/16. With the lens zoomed to 15mm, everything about 20 inches from the camera to infinity was within the depth of focus range.

I used the words "reasonable" and "about." Only one point in the picture is perfectly in focus. Zoom lenses don't offer a depth of field (DOF) calculator on the barrel, so I am basing the depth of field on what looks sharp in the image. Many prime lenses do have a DOF calculator, like the one on my 10.5 fisheye, pictured in Figure 5.7. Let's use it to look more closely at how DOF works.

**Figure 5.7**
The manual focus and depth of field scale on a Nikkor 10.5 fisheye.

There are three rows on the scale above the name of the lens. See the solid white oval between the two 8s just above the name of the lens? That is the focus-point indicator. Right now, the lens is set to a focus point just under one meter. That means that the sharpest object in the picture, the one in perfect focus, is located 0.3 feet from the focal point located in the middle if the lens. (We won't go into all of the optics involved.)

You do need to know the optical trigonometry symbol for infinity to use the calculator. It looks like a number 8 on its side. You can see it in Figure 5.7 just above the number 22 on the left side of the DOF calculator. This symbol marks the focal point on the distance scale beyond which everything in the scene will appear in focus. That's why it has a symbol rather than a number. (Remember the *focal* point is the optical center of the lens and the *focus* point is the object in the picture you are focusing on.)

There are two points marked with the number 22 on the bottom row. The one on the left marks the farthest point on the distance scale that will be inside the DOF range at f/22. The one on the right marks the nearest point. Everything from seven inches to infinity will look reasonably sharp with this lens when the exposure is made with the f/stop set to f/22. Come in and read the distance markings at the two 16s, and you know the DOF range if you take the picture with the lens set to f/16.

## Perspective: Looking High and Low

The picture in Figure 5.8 was taken with a fisheye lens set to f/8 and focused at just over two feet. That placed everything from 18 inches to infinity in focus. I held the camera up at arm's length and pointed it into the crowd of dancers, very close to the two women in the foreground. The rest looks like I was standing on a ladder due to the same wide-angle perspective that made the horse's head look so big in Figure 5.6.

Let's consider what she allowed for in choosing these settings. She needed to hold detail in the clouds. They would have been very distracting if they recorded as pure white. The sun was shining through the clouds and casting harsh shadows. She let them stay dark to increase the contrast in the scene. The lines of the club, its shadow, and tilting the print all add to the impact of the composition. Then she used a small f/stop to take advantage of the fisheye's deep DOF to keep the club, the men, and the clouds all in good focus.

**Figure 5.8**
This picture was taken with a 10.6mm fisheye held at arm's length above the photographer. The extreme wide-angle perspective makes it look like it was taken from a ladder. (Photograph by James Karney.)

Nikki McLeod used the same wide-angle perspective and extreme DOF when photographing the golfers in Figure 5.9. She got down and close to the golf club. The exposure was 1/750th of a second at f/8 with an ISO of 200 under cloudy bright conditions.

**Figure 5.9**
Using the same wide-angle perspective technique, but this time from a low angle. (Photograph by Nikki McLeod.)

Fisheye designs use a different optical design from moderate wide-angles. That's the reason you see more distortion in the pictures taken with them. They work sort of like the way a map does, when the sphere of the planet is projected as a flat surface. The closer to the edge, the greater the curve; that why the golf club looks so big. If you have access to a wide-angle, take some pictures from different angles of subjects with long straight lines, and see how the perspective and the lines change.

## A Bit of Moderation

Moderate wide-angles let you work close and have good depth of field with little distortion. That's about a 53- to 37-degree *angle of view* (AOV) or 24mm to 40mm focal length lenses on a full frame–format camera. A 53-degree AOV offers good depth of field and the ability to work close to your subjects. There is some wide-angle perspective that enlarges near objects, without the extreme distortion seen in fisheyes. If the subjects are a few feet away, the recorded scene has almost the same perspective as a normal lens. The picture in Figure 5.10 was taken with a 53-degree AOV from a distance of about seven feet.

I used the same focal-length lens for the picture in Figure 5.11. The near-object enlargement is easy to see. Notice how much bigger the right hand holding the candle seems, compared to the left hand on the other side of the cake. Now compare the hands in the background. Allow a bit for the fact that those belong to children. As the focal length gets longer, and the lens is opened wider, the depth of field gets shallower. The lens was wide open, reducing the depth of field.

**Figure 5.10**
This picture was taken with a moderate wide-angle. There is none of the extreme distortion found in the two preceding fisheye images. (Photograph by James Karney.)

There wasn't much decorum when the party moved outside with a food fight on the agenda! I used a 24mm lens to take the picture in Figure 5.12 during the melee. It's a moderate wide-angle on my camera, producing a 53-degree angle of view. That selection was based on three things. My main concern was to avoid having anything wet and/or messy land on the camera, and this lens let me cover the scene without getting too close to the action. The f/6 setting kept the main subjects in focus, and made the background just a little soft (slightly out of focus).

**Figure 5.11**
Comparing the hands ringing the cake in this picture is a good way to see the close-up perspective effect of a moderate wide-angle lens with a 67-degree AOV. (Photograph by James Karney.)

There is a little of the wide-angle perspective that enlarges the subjects in the foreground with this focal length to give depth to the composition, but it is not exaggerated.

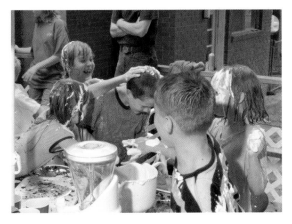

**Figure 5.12**
This picture was taken with a moderate wide-angle field of view. Getting closer would have put the photographer too close to the action. (Photograph by James Karney.)

Normal lenses are the ultimate in moderation. The DOF is not as deep as a wide-angle, but they don't suffer from distortion or radically curved lines. Because of the narrower AOV than their wide-angle kin, objects are rendered larger on the sensor. That can make it easier to produce a sharply cropped area, since the source will be enlarged less. Figure 5.13 shows a two-thirds crop of a picture taken with a zoom set to 40mm, with an exposure of 1/45th of a second at f/3.5 at ISO 1000.

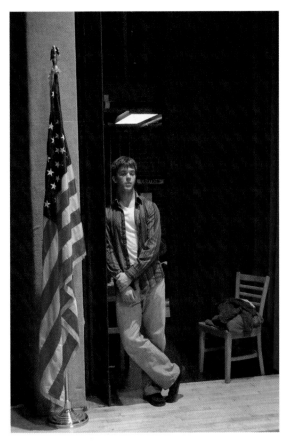

**Figure 5.13**
A normal lens was used to take this picture. This focal length range has less depth of field than wide-angles at the same setting, but less distortion. (Photograph by James Karney.)

# F/Stops: Understanding the Numbers

W E'VE TOUCHED ON THE SUBJECT of f/stops, and seen enough examples to understand that they affect both exposure and depth of field. Now it's time to explain what the numbers mean and how they affect the quality of our pictures and lens design. Then we will talk about how to use them creatively.

Inside a lens is a set of thin metal plates, called the *iris* or *diaphragm*. These create a variable opening in the center of the glass. When the iris is wide open, more light is let in; as it closes, the intensity of the light reaching the sensor is dimmed. The opening itself is called the *lens aperture*. An f/number is the ratio of the focal length of the lens divided by the diameter of the aperture. Don't worry about the math. All we need to know is that the formula can be used to determine the relative intensity of light reaching the sensor.

A "full" f/stop is an aperture opening that cuts the intensity of the light exactly in half (stopping down), or doubles it in intensity (opening up), compared to the next full stop in the series. That's the same change in exposure value as when we halve or double the shutter speed. So we can easily choose an exposure combination to suit our needs. Figure 5.14 shows the f/stop adjustment ring and DOF calculator on a 50mm manual lens. With most new DSLR lenses the f/stops are adjusted using camera controls, so they don't have an f/stop ring.

**Figure 5.14**
The lowest row of numbers on this lens represents its available full f/stops.

## F/Stops, Maximum Aperture, and the Need for Speed

The widest f/stop (smallest number) on a lens is its maximum aperture. The lower the number, the more light it lets in, which can be very important when working in low-light conditions, or when you need to use the fastest shutter speed or the lowest ISO setting possible. Maximum aperture and build quality are major factors in the cost and available features of a lens. They also affect the technical quality of the pictures it takes. Let's look at some extreme examples

The picture in Figure 5.15 was taken with an extremely fast f/1.2 55mm prime lens under marginal shooting conditions. The exposure was 1/5th of a second at f/1.2 with an ISO of 1600. The lens weighs twice what the much less expensive f/1.4 50mm model prime. It also let me get that shot under extremely adverse conditions.

The longer the lens, the more it costs to increase the maximum aperture, and the more it weighs. Both of the lenses in Figure 5.16 are zooms with vibration-reduction technology and offer a maximum 200mm focal length. The one on the left is "only" a 70-200mm lens, but it sports a fast f/2.8 maximum aperture. It weighs 3.25 pounds and costs $1,700. The one on the right is a 55mm-200mm zoom. That's a 15mm increase in range over the other lens, but the maximum aperture varies from f/4.5 at 55mm to f/5.6 at 200mm. It weighs nine ounces, is very compact, and costs $150.

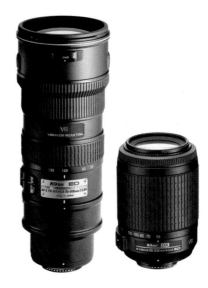

**Figure 5.16**
The lens on the left is only a 70-200mm zoom. It is larger than one on the right, a 55-200mm mode, due to the difference in maximum aperture and area of coverage.

**Figure 5.15**
This picture was taken during an outdoor night performance using a very fast lens, with an exposure of 1/5th of a second at f/1.2 and an ISO of 1600. (Photograph by James Karney.)

The 70-200mm is classed as a professional lens, and is built to a higher standard with more durable construction and a more-developed optical formula that produces sharper images with less distortion. It is also designed to work with full-frame sensors. The 55-200mm lens can be used only with cameras sporting a smaller 1.5 crop-factor sensor.

Is the $1,700 model worth that much more? It depends on what your needs (and desires) are.

I shoot weddings and sports. The 70-200mm is one of my favorite lenses. I've considered buying an inexpensive zoom as a travel lens. They are lighter and easier to pack than faster zooms. There are models for most DSLRs that cover moderate wide-angle to telephoto. An 18-105mm with an f/3.5-f/5.6 aperture range would have been a fine choice for the German street scene in Figure 5.17, which was taken with a zoom set to 35mm. The 50-degree AOV gave the natural perspective of a passer-by.

**Figure 5.17**
I used a zoom set to a normal lens AOV for this picture. The performer is slightly blurred to show motion. It's not from a slow shutter speed. The focus point is the crowd and the cloudy day and low ISO resulted in an f/stop with a shallow depth of field. (Photograph by James Karney.)

## The Sweet Spot and the Art of Stopping Down

There is one more trade-off to mention before leaving the topic of maximum aperture. Figure 5.18 shows two portraits taken of the same person with the same lens and lighting, both by Gary Todoroff. The only real difference was the f/stop he used. The one on the left was taken using the maximum aperture. The second was closed down two stops from f/1.8 to f/2.8. The shutter speed was decreased two stops, providing the same exposure value to the sensor.

**Figure 5.18**

The picture on the left was taken at f/1.8, the one on the right at f/2.8. (Photographs by Gary Todoroff.)

In the enlarged sections in Figure 5.19 it's obvious that the image on the left lacks contrast, and is not as sharp as the one on the right. The difference is due to optical shortcomings in the lens design. There is no perfect lens design. Some are sharper and have better contrast and color fidelity, but they all have issues that limit their ability to perfectly form an image. The differences would not be as noticeable in a picture seen full-frame.

We could detail the various optical aberrations and distortions, but that's way beyond the scope of this book. There is a simple solution that improves image quality, which you can use without learning advanced optics. Whenever possible, shoot as close to two stops down from your maximum aperture as you can. So if your lens is an f/2.8 model, close down to f/5.6. If it is a variable zoom and at 200mm is only an f/5.6, then f/11 is the sweet spot. If the shutter speed was set to 1/100th of a second, move it two stops to 1/25th. Now you know one of the reasons that pros like "fast glass."

Of course, you can still shoot wide-open when needed. But if you know you will need to enlarge the image, consider either closing down the f/stop or using a longer lens.

**Figure 5.19**

Close examination shows the benefits of stopping down the lens to reduce the effects of lens flaws. (Photographs by Gary Todoroff.)

# Going Long with Telephotos

TELEPHOTOS RANGE FROM moderate, with a 30-degree AOV (70mm on a full-frame sensor); to extreme with a two-degree AOV (1,000mm on a full-frame sensor). Moderate telephoto lenses are favorites with pros for shooting portraits. People are more relaxed when you are a little farther away. Longer lenses also improve perspective, making noses and ears look relatively smaller. The TriCoast Photography image in Figure 5.20 was taken with a Canon 5D and a 105mm lens. That's a moderate telephoto with a 19-degree AOV.

## A Bit About Bokeh

The casual study of a child at play in Figure 5.21 was taken with a zoom set to 200mm, producing a fairly tight 6.9-degree AOV, and the exposure of 1/250th second at f/4 resulted in a limited depth of field. (The camera had a 1.5 crop factor.) Notice the way the background starts becoming softly out of focus on the rocks and the reflections on the water are soft and smooth. This out-of-focus effect is called *bokeh*. That's a Japanese word that means "fuzziness."

**Figure 5.20**
Moderate telephotos are well-suited for portrait work. (Photograph by TriCoast Photography.)

**Figure 5.21**
The soft blurring in the background is called *bokeh*, a Japanese word for fuzziness. (Photograph by James Karney.)

When the lens focuses the image on the sensor, the most precise focus is at a plane parallel to the sensor at the focus point. The objects at that point are rendered as very tiny circles. Objects that are not in focus are recorded as larger and less distinct circles. The quality of lens bokeh varies with the optical quality and the shape of the diaphragm. It's generally a good idea to try to keep the objects in the foreground in reasonable focus. Humans tend to accept a fuzzy background, but find an out-of-focus foreground distracting.

Shallow depth of field and bokeh at wide f/stops are natural characteristics of telephotos. They can be used creatively, just like the extended depth of field and sharp background of wide-angle lenses. That's what the TriCoast team did with the image of the organist in Figure 5.22. The Canon EOS 20D coupled with a 200mm lens produces a 6.4-degree AOV, yielding slightly more telephoto effect and even more bokeh because the photographer was closer to the subject and shooting wide open at f/2.8.

See how the edge of the hand and the numbers on the controls to the player's right are in focus? Bokeh has rendered the organ keys in the upper-left corner almost a total blur. The arm starts getting fuzzy as it moves toward the sleeve. This shows something else about depth of field. It tends to be deeper behind the point of focus and not quite as much in front of the primary focus.

That's what optical tests show. The range of depth of field in a wide-angle lens is a ratio of 2:3 to the back of the point of focus and 1:3 toward the front. In other words, the if the total depth of field was three feet, then it would extend one foot in front of the subject in focus and two feet behind it. The difference lessens as the focal length of the lens increases. So does the amount of the depth of field. A 1000mm telephoto has a very shallow depth of field, and it is almost evenly distributed on both sides.

**Figure 5.22**
This picture is a good demonstration of how bokeh is generated with limited depth of field. (Photograph by TriCoast Photography.)

The shallower your depth of field is, and the longer the lens, the greater the bokeh effect. This technique is a very effective way to eliminate a distracting background and draw attention to the primary subject. Johan Aucamp use bokeh to produce a very pleasing background in the picture shown in Figure 5.23. The long lens, coupled with a wide f/stop, produced a very shallow depth of field. The scene behind the bird was blurred into a pattern of color and vague shapes. Increasing the depth of field reduces bokeh, allowing more detail in the background.

**Figure 5.23**
Bokeh can be used to create a soft background. (Photograph by Johan Aucamp.)

# Going with the Action

TELEPHOTOS ARE THE LENS of choice when it comes to getting close to the action. Figure 5.24 was taken with a 80-200mm f/2.8 zoom. I closed the aperture to f/4.5 to minimize lens problems, while still getting some bokeh to soften the woods in the background. To ensure a really sharp image, the camera was mounted on a tripod, and the shutter speed was set to 1/1250th of a second at ISO 400.

When shooting action, focus can be a major problem. Your DSLR probably offers several auto-focus options, and the ability to isolate different points in the viewfinder as focus-point indicators. Some are better suited to static subjects, others to action shooting. The results may vary with contrast, and when several subjects pass through the focus point while you are waiting to press the shutter. Spending some time practicing with different options is a good idea, as is checking the settings and results periodically as you work.

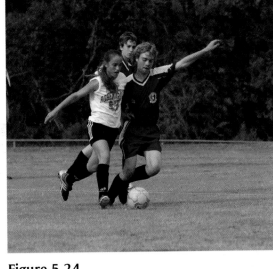

**Figure 5.24**
Freezing the action with a telephoto requires tight focus and a fast shutter speed. Using a tripod helps too. (Photograph by James Karney.)

Figure 5.25 is a case in point. My camera has a predictive-focus mode that anticipates where a fast-moving object will be when the shutter is open. I pressed the shutter when the ball was kneed by the player in red, and the system kept in focus. This skill was honed by tracking birds in flight.

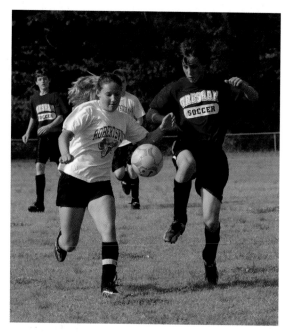

**Figure 5.25**
Don't forget that the camera can be held vertically, even on a tripod. (Photograph by James Karney.)

This picture underscores another point. Don't forget that you can hold the camera vertically as well as horizontally, and so can a tripod. Shifting the orientation may let you frame the image better and get the primary subjects larger in the picture.

# Vibration Reduction and Those Extra Buttons

Once upon a time, the only controls on a lens were its focusing and f/stop rings. Today's full-featured DSLR designs often don't have the f/stop ring, but do have buttons for turning on and off features like vibration reduction and limiting the focus range. The buttons on a 70-200mm zoom are shown in Figure 5.26.

*Vibration reduction* (VR) is a great tool that lets us get sharp images with slow shutter speeds. It takes practice to master VR, and using it drains power from the camera's battery. That's a good trade-off, as long as you don't forget to turn the switch off when not using VR. Leaving it on and placing the camera in your bag can result in a dead battery the next time you go to take a picture.

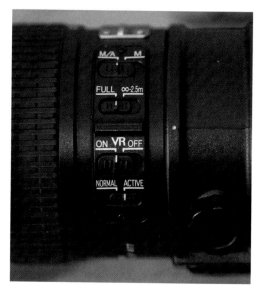

**Figure 5.26**
Making sure power-draining features are turned off when not in use can save you from an unexpected dead battery.

# To Infinity and Beyond

ALL LENSES, EVEN THE LONGEST telephotos, have an infinity setting on their distance scale. When that mark is within the depth of field, all objects from the point of focus back will be sharp (or at least as sharp as the quality of the lens, the atmospheric conditions, and the steadiness of the camera allow). Remember how wide-angle pictures with good depth of field made the distance between objects in the foreground and background look greater that it actually was? Telephotos under the same conditions make things look closer together. The aerial view of downtown Eureka, Oregon by Gary Todoroff shows it well (see Figure 5.27).

You don't have to be at infinity to get this perspective, and you can even get it with relatively short lenses. Just make sure that the objects are close enough to each other to be within the depth of field when the shutter is pressed and that you are not using a lens that induces the wide-angle perspective. That means that the farther away objects are from the lens, and the closer together they are physically, the easier it is to make the space between them seem compressed.

Figure 5.28 is a landscape by Johan Aucamp, taken with an 80mm lens on a camera with a 1.5 crop factor. That's an AOV of 17 degrees, a moderate telephoto. His composition is carefully crafted to turn the peaks in the distance into a series of repeating stacked shapes. The setting sun increases the effect by casting shadows that darken the ridgelines from left to right, and the orange sky adds color contrast. The hazy sky softens the light and adds texture. The placement and reflection of the water complete the scene.

**Figure 5.27**
Telephoto lenses set to infinity tend to make objects look closer together. (Photograph by Gary Todoroff.)

**Figure 5.28**
This landscape combines telephoto compression with other design elements to produce a study in color contrast and repeating shapes. (Photograph by Johan Aucamp.)

## Lens Flare, Lens Shades, and Filters

When the sun (or any other light source) directly strikes the front of a lens, it can cause lens flare, reducing image contrast and sharpness. The best solution is to move into a shaded position. Sometimes you can't. The unedited picture in Figure 5.29 was taken with the sun just above the bride and groom. That was the only location to get the right point of view. I was using a lens shade, which minimized but didn't eliminate the flare. You can see halo effects between the couple and on the groom's tuxedo. I was able to reduce the problems to an acceptable level with a significant bit of retouching.

Always use the proper sun shade on your lenses. Figure 5.30 shows one in use on a 70-200mm zoom. Another good idea is to keep a UV or sky-light filter on all your lenses. They help reduce the impact of aerial haze, and protect the front element of the lens. There are different filters that can be used to modify the light as it enters the lens. We'll look a how they work in Chapter 7, "The Big Picture: Light, Color, and Composition.".

There is one other safety issue to mention. Be careful when the camera is pointed toward the sun. Never look directly at the sun though a lens, especially using a telephoto. Doing so can ruin more than the picture from flare. The condensed and focused rays of the sun have significant amounts of UV radiation that can hurt your eyes. Enough exposure can result in permanent damage.

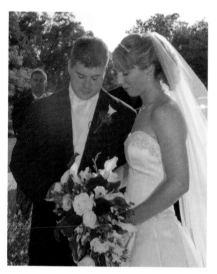

**Figure 5.29**
Bright light striking the lens will cause flare and reduce image quality. (Photograph by James Karney.)

It's also a good idea to not leave a camera out with the lens pointed at the sun. The lens acts like a magnifying glass, and the beam can get very hot. Not good for the inside of the camera or the shutter. Remember that magnifying glasses can be used to start fires with the heat from the sun.

**Figure 5.30**
A lens shade reduces the problems with flare, caused when a light source strikes the front of a lens.

# Getting Close: Macro Photography Tools

Getting close to your subject, and making big pictures of small objects, offers interesting picture possibilities, like the close-up avian portrait by Joe McBroom in Figure 5.31. It also often requires special equipment. Lens manufacturers, like eye doctors, have to deal with trade-offs when designing optical formulas. Most DSLR lenses can't magnify an object larger than 1/10th actual size on the sensor (written as a 1:10 ratio) without developing noticeable distortion. That's why a telephoto lens can't focus as close as a wide-angle or normal lens, but they can all produce an image of a subject with about the same magnification.

Some standard lenses do have limited close-up ability, but they don't offer the results of dedicated designs. There are a variety of options that extend the ability of your DSLR to work close, varying in cost and capability. This section outlines the major macro equipment categories, their features, and how they can (sometimes) be combined.

**Figure 5.31**
Bringing your viewer close to the subject requires careful focusing and, often, special equipment. (Photograph by Joe McBroom.)

*Macro lenses* are designed to allow close focusing, making objects bigger on the sensor than an average lens. Some can render a life-size image on the sensor (a 1:1 ratio), and most can magnify at least to half-size, or a 1:2 ratio. Many macro lenses look very much like a non-macro lens of the same focal length, but with a somewhat longer barrel. They come in normal to moderate-telephoto lengths (50mm, 60mm, 105mm, etc.).

The most exotic (read: expensive) lenses combine macro abilities with *perspective control* (PC), like the lens shown in Figure 5.32. (Note that Nikon labels some of its macro lenses "Micro-Nikkors.") Depth of field at large magnification is very shallow. PC lenses can be adjusted to bend the light and shift the plane of focus. If Joe had had a PC lens for his owl picture, he could have shifted the plane to be the same as the bird's eyes. Of course, that would have made some in-focus portions fuzzy. The depth of field is still small. That's why most macro lenses also offer a very small minimum aperture. The lens in the picture closes down to an exceptionally small f/45.

The focal length of a macro lens doesn't determine the magnification, but rather the working distance. A 50/60mm lens will have a very short working distance (as little as 5 inches). A 200mm lens will have a working distance of between two and three feet. How close the subject is will define the magnification ratio, until the subject is far enough away that normal optics come into play.

**Figure 5.32**
Dedicated macro lenses offer close focusing ability, and some also provide perspective controls. Notice the smooth out-of-focus background, due to the shallow depth of field from using a 105mm macro close to the subject. (Photograph by James Karney.)

There is a noticeable reduction in the amount of light reaching the sensor when a macro lens is focused close enough to produce more than a 1:10 magnification ratio. That requires a change in exposure, so be sure to keep an eye on your meter and check the results in the preview screen.

*Diopter filters* are a bit like reading glasses for your camera. They are placed in front of the lens, and magnify the image placed on the sensor. Focusing past a few feet is impossible while they are on. On the plus side, they don't reduce the exposure like a macro lens. On the negative, they change the behavior of the light on the way to the sensor, and that causes distortion. The better filter makers charge more, but produce products that make better images with less distortion. The filters come in different strengths and can be stacked to get the desired amount of magnification. They can be put in front of macro lenses.

*Extension tubes* are just that: hollow tubes that go behind the lens, allowing the lens to focus closer. As with macro lenses, the amount of light reaching the sensor is reduced. Most also defeat the communication between camera and lens, so you'll have to manually adjust exposure and focus. They can be combined with macro lenses. (Some macros even come with a dedicated extension tube.)

*Teleconverters* are auxiliary lenses placed behind a lens to magnify the image. They come in set magnification factors, like 1.5x and 2x. Some are designed to have a macro function. Newer models allow communication between the lens and camera, so you retain auto-metering. They will, however, degrade the image, some more than others, and they dramatically reduce the light intensity reaching the sensor. Some cut so much light that autofocus features may stop working.

A *bellows* (see Figure 5.33) is a variable extension tube, often with PC capability, and most can focus extremely close. Some photographers use a special ring and reverse the lens on a bellows. (The front of the lens is attached to the front of the bellows.) This may reduce distortion at very close range. Like diopter lenses and extension tubes, they reduce light levels and require increased exposure. They are bulky, rarely allow the lens and camera to communicate, and may require specialized cable releases to use features such as automatic stopping-down.

**Figure 5.33**
A bellows being used to take a macro photograph. (Image by Gary Todoroff.)

# The Craft of Close-Up Photography

THERE ARE SOME BASIC challenges involved when taking close-up and macro pictures, no matter what type of equipment you use. The magnification factor not only enlarges the subject, but also reflects any camera motion. Depth of focus is often reduced to millimeters. Longer lens extensions, and the smaller apertures often used to increase depth of field, mean higher ISOs and/or longer shutter speeds. Animate subjects, like butterflies, tend to move—and don't take direction very well. Even more stationary ones, like flowers, bend with the breeze. There are several tried-and-true techniques that increase our ability to get quality close-ups, some more obvious than others.

## Steady and Smooth

First rule, make the camera as steady as possible. My first choice is a tripod, followed by a beanbag or some form of natural rest. Figure 5.34 shows one of Gary Todoroff's macro images in the making. The 90-250mm f/2.8 zoom is not a lightweight lens. He has added a 1.4 tele-converter, effectively creating a 700mm (35mm equivalent) lens.

**Figure 5.34**
Tripods are recommended for macro work whenever possible. (Photograph by Gary Todoroff.)

A *cable release* is a great accessory any time we use a tripod and a slow shutter speed. This is a gadget that trips the shutter remotely. It reduces the minor camera shake that occurs when we push directly on the camera button. The general rule of thumb for defining "slow" is any speed less than the focal length of the lens, adjusted for the sensor's magnification factor. So "slow" with a 105mm lens on a camera with a 1.5 factor would be about 1/150th of a second. If you don't have a release, the self-timer with a 20- to 30-second delay can accomplish the same result. You can almost totally eliminate shake in still-air conditions, by locking the camera's mirror in the up position before making the exposure.

## Choose the Focus Point and Watch the Background

The image in Figure 5.35 is the resulting photograph taken by Gary using the setup seen in Figure 5.34. Notice how the leaves immediately near the blossoms are in focus, while the ones in the background are blurred by the lens bokeh into a dark pattern. The focus effect is due to the choice of lens and teleconverter, the distance from the subject, the point of focus, and the depth of field. Sounds complicated, but it becomes easy with a bit of practice and use of the viewfinder.

Backgrounds often make or break a close-up photo. Some photographers go to great lengths to adjust the scene, from rearranging nature to constructing complex lighting. In most cases, a bit of selective focus, and adjusting the relative light levels, will do the trick with a minimum of fuss. After all, the subject is usually pretty-well confined to a small area.

Light levels, both on the subject and in the background, can be adjusted with light modifiers like reflectors and shades, as well as flash. On serious wildflower outings, I carry a dark cloth, a small reflector, a stand with clamps, and a pair of flash units. Sometimes the right camera angle will provide a suitable background. Adding light to the subject—which does not fall on the background—will make the background appear darker. The reverse will brighten the relative appearance of the background. Consider how the backgrounds along with the depth of field in Figures 5.36 and 5.37, contribute to the composition.

The photographers each had different situations to contend with in order to get their pictures. We can't always control all the aspects of an image. Many "still" subjects can be moved by wind, especially small and flexible ones like plants. That may require adjusting the shutter speed at the cost of depth of field or the ISO setting. (Bracing the object, out of the camera's view, can help.) Animate objects move, and so make using a tripod impossible.

**Figure 5.35**
The shallow depth of field in macro photography makes it easier to reduce distracting backgrounds. (Photograph by Gary Todoroff.)

The black widow photograph by Terrence Karney in Figure 5.36 was alive and in the open. The advantage was that the spider was interacting with its web. Choosing the location and adjusting the way light entered the scene could be controlled. This picture required patience and care on the part of the photographer not to get too close, or create any movement that would startle the creature. The shutter speed was only 1/10th of second, requiring the wait for the creature be still. The light-colored background contrasts well with the spider's black body. The extremely shallow depth of field blurs the web.

Geoff Cronje's close up of a saurian in Figure 5.37 makes use of a low camera angle to take advantage of a natural rim-lighting effect from the sun. He used a 105mm lens with an exposure of 1/200th of a second at f/5.6 with ISO 200. The result has enough depth of field to keep the animal sharp against a dark, out-of-focus background.

**Figure 5.36**
This image required careful setup and patience, in part due to the nature of the subject, and because of the subject itself. (Photograph by Terrence Karney)

**Figure 5.37**
Choosing the right camera angle and exposure results in color contrast and rim lighting, which separate this saurian visually from its surroundings. (Photograph by Geoff Cronje.)

## Learning to "Look Close"

Close-up and macro photography help develop technical skills by making us work at the limits of our equipment, and require attention to detail. For example, using my underwater housing requires that I choose any macro options before entering the water. The last picture in this chapter was taken on a night dive, with a flash mounted off the camera. I stayed close to the reef and used a dive light to locate subjects.

Figure 5.38 shows a fish fry about the size of a pencil eraser. It was hiding in a small crevasse in the coral and was startled by my light. I waited until he felt safe enough to peek out just a bit, so that the flash would illuminate him, rather than cast a shadow over his home.

**Figure 5.38**
The primary skill in close-up photography is looking closely at the world around us and seeing the picture possibilities. (Photograph by James Karney.)

Looking for subjects in a defined space, like a yard, a meadow, the side of a hill, or even in a single room, improves our ability see picture possibilities. Consider an afternoon self-assignment, either indoors or out, with a single lens that lets you work in macro range. Good pictures may be a lot closer than you realize.

**Figure 6.1a** Stopping a skateboarder in mid-air requires precise focus and a fast shutter-speed. (Photograph by Andrea Blum.)

# Capturing the Moment: Shutter Speed and Focus

**6**

Y OUR CAMERA'S SHUTTER CONTROLS TIME, opening and closing to allow the right amount of light to reach the sensor and record the scene. The duration of that interval affects image sharpness and exposure, and can be used as a creative tool. The shutter speed controls the amount of blur (or lack thereof) of moving objects in the picture.

Andrea Blum's picture (Figure 6.1b) froze the skater and his board in mid-air in 1/1250th of a second. Peggy Kelsey wasn't worried about fast action, but did need to time her shutter-press to record the interaction between the girls in Figure 6.1b at just the right moment. She also had to work with a lot less light than that of a bright sun. Slower shutter speeds let us close the lens aperture down to improve depth of field, or we can open it to isolate the area in sharp focus. The exact speed needed varies with distance and the direction the subject is moving, relative to the camera.

**Figure 6.1b**
Timing and focus are equally important when capturing a fleeting moment of quiet interaction. (Photograph by Peggy Kelsey.)

# Freeze Frame: How Fast Is Fast Enough?

GARY TODOROFF'S PICTURE in Figure 6.2 makes use of shutter speed to blur the bird's wing tips to show their motion. The visual message would have been different if he had used a faster speed to freeze all movement. The "correct" shutter speed depends on what effect the photographer wants to produce. Obtaining that effect requires understanding, and applying, the basic principles of controlling motion with the shutter and your camera technique.

Suppose you are on a train and want to take a picture of someone in a window on another train traveling right next to you. If the trains are both traveling in the same direction, at exactly the same speed, the shutter speed is of little concern. If one is slowly overtaking the other, then a fast speed is needed. If they are coming toward each other at high speed, you may not even be able to react in time to take the picture. Let's look at three examples of the same activity taken at three different angles.

The horse and rider in Figure 6.3 were perpendicular to the camera. Bob Cieszenski was using a 200mm lens (300mm full-frame) and a 1/1000th of a second shutter speed. Had he been closer, or using a longer lens, the speed would have had to have been faster to get the same effect. Consider the timing involved: The horse is moving forward and up; the picture shows the animal completely off the ground and just broaching the obstacle. It takes practice to capture just the *right* 1/1000th of a second.

**Figure 6.2**
The right shutter speed can blur motion to show movement. (Photograph by Gary Todoroff.)

106

**Figure 6.3**
Movement perpendicular to the camera requires a faster shutter speed to freeze than does motion at an angle towards or away from the camera. (Photograph by Robert Cieszenski.)

The minimum shutter speed needed to totally freeze motion varies according to: the speed the subject is traveling, the direction of motion relative to the camera, the distance between the two, and the focal length of the lens used. A subject moving perpendicular to the camera requires twice the shutter speed of one moving at a 45-degree angle, and four times that of one moving directly toward it, if all other factors are equal (velocity, distance, lens). So if the perpendicular speed needed is 1/1000th of a second, the 45-degree is 1/500th, and the head-on is only 1/250th.

If there is enough light, most sports photographers use a speed that will stop motion for any angle with the lens in use at a reasonable working distance.

Figure 6.4 shows another horse and rider, this time at a 45-degree angle. The exposure time is 1/750th of a second and the focal length on the zoom was set to 170mm. That's the same as a 225mm on a full-frame sensor. Since we don't know the exact distance between the camera and subject in the two pictures, it's impossible to compare the relative effect of the shutter speed.

**Figure 6.4**
A 45-degree angle of motion reduces the motion relative to the camera by half from a perpendicular angle—all other factors being equal. (Photograph by Robert Cieszenski.)

Figure 6.5 shows another horse, this time jumping directly at the camera. Horse and rider are both sharply in focus and movement is arrested. The exposure was 1/1000th of a second at f/3.2 with the zoom set to 160mm, the same as a 240mm lens on a full-frame sensor.

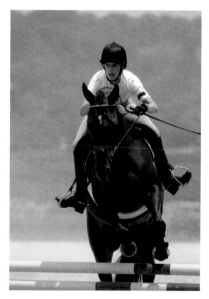

**Figure 6.5**
Head-on angles, or going directly away from the camera, reduce the relative motion to the camera to one-quarter of that in a perpendicular angle—all other factors being equal. (Photograph by Robert Cieszenski.)

Let's look at some comparisons. At 75 feet with a 300mm lens on a full-frame sensor, subjects moving at five to ten miles per hour will appear motionless with a shutter speed of 1/250th of a second, as they are moving toward or away from the camera. You'll need 1/500th of a second for subjects moving at a 45-degree angle, and 1/1000th of a second for perpendicular movement. Move back to 300 feet with the same equipment, and the speeds drop to 1/250th, 1/125th, and a mere 1/60th respectively.

There are tables available that provide suggested shutter speeds for various conditions, but a few basic rules of thumb will handle most situations. Human-powered team sports will all freeze with up to a 300mm telephoto (full-frame) at a 1/1500th of a second. Raise the shutter speed to 1/2500th of a second, and bike races and running horses will stop at the press of a button. Flying birds, baseball swings, and race cars need at least a 1/4000th of a second. If you have a long telephoto—say, over 500mm—then double the numbers.

# Picking the Point and Moment

PHOTOGRAPHERS HAVE TO BE ready and in position to get good action pictures, even with the most advanced DSLRs. Some subjects let you wait for them to enter the picture, like the jumpers in the head-on and 45-degree angle position. This situation, as with the rider coming toward the jump, allows you to set the focus and composition before the subject appears.

Other situations require that you track the subject's movement, adjusting focus and composition as needed until the picture "comes together" and you release the shutter. The three soccer players seen in Figure 6.6 were moving at almost a 45-degree angle, and were about 50 feet away. I was using my camera's continuous-focus capability, and keeping the active point on the player with the ball. As they moved I adjusted my body to keep the players properly composed and in focus in the viewfinder. The 80-200mm zoom let me adjust the focal length to expand the angle of view as they moved closer. The exposure was 1/1250th of a second at f/5.

1/1500th of second would have let me freeze the players, but they were not the fastest object in the picture. When the ball is kicked hard, it can be traveling many times faster than a runner. Also, the action was moving back and forth. So I selected a speed that ensured that all the elements would be motionless. Another advantage to a fast speed is a small f/stop, which reduces the depth of field. A blurred background is less distracting if the main subject is in sharp focus.

**Figure 6.6**
The ball is the fastest-moving object in this picture, and required a faster shutter speed than the players. (Photograph by James Karney.)

Notice how there is open space to the left of the frame? While we want to focus the composition on the action, we also leave room for the implied movement. The players are all moving in that direction. If the frame were cropped right next to them, it would have visually constrained the action.

The same basic principle is applied in Figure 6.7. Here the soccer players have all come together as the ball moves from a head shot. The principal point of focus, both of the players and the composition, is the ball. The photographer has no control over the action in sports photography. That means we have to allow enough room in the frame to crop for good composition. That's easier with a zoom, especially if you are able to position the camera so that the majority of the action takes place in the middle portion of the zoom's range. Another trick is to adjust the exposure (if possible) to have the lens closed down about two stops. This is generally the sharpest aperture in most lens designs. It offers the best contrast and resolution with a minimum of optical distortion. Using a lens shade to reduce glare is also a good habit.

The ball and players in Figure 6.7 didn't require a faster shutter speed than the 1/1250th of a second I used; that's because the players had almost stopped forward movement, and the ball was nearing the top of its arc and slowing before dropping back down. The TriCoast image in Figure 6.8 makes use of the same principle to produce an interesting composition of a bridegroom and his friends.

**Figure 6.7**
The ball is the fastest-moving object in this picture, and required a faster shutter speed than the players. (Photograph by James Karney.)

**Figure 6.8**
What goes up slows before it comes down—offering the perfect point to freeze its motion. (Photograph by TriCoast Photography.)

# Panning for Pictures

**W**HEN A FAST-MOVING SUBJECT is traveling perpendicular to the camera, it's often impossible to capture its picture if we wait for it to enter the frame. That's when we have to track the subject by panning the camera. *Panning* is when we move the camera to keep the image of a moving subject in one position in the viewfinder. I usually try to allow some extra room on either side of the composition and keep the object centered in the viewfinder. This technique requires a high shutter speed if you want to keep the background from blurring. Sometimes a photographer deliberately uses a shutter speed slow enough to blur the background to indicate motion. If available, a tripod really helps. If not, I turn my whole torso and both arms, rather than just head, neck and arms. Figure 6.9 shows the Blue Angels in tight formation. Gary Todoroff used a shutter speed of 1/4000th of a second. The clouds were added later in Photoshop.

Panning was the same technique Johan Aucamp used to capture the beating wings of the bird in flight in Figure 6.10. The shutter speed was 1/2500th of a second at f/5.6 with a lens equal to an 850mm on a full-frame camera. It takes practice and a good understanding of your camera's focusing system to obtain high-quality results. Birds are a great way to practice these skills. Isolate one bird and track it by panning. As a self-assignment, vary the shutter speed, focus methods, and work on developing a smooth panning motion and a gentle release of the button.

**Figure 6.9**
This picture of the Blue Angels was made by panning the camera to follow the movement of the planes. (Photograph by Gary Todoroff.)

Panning can be used with slower subjects, and it isn't limited to perpendicular movement. I used it in the soccer pictures. Geoff Cronje's image of the rower in Figure 6.11 combines panning with timing to create a composition that combines the lines of the boat, the oar, and the water, and adds the splash as the oar breaks the surface.

**Figure 6.10**
It takes practice with panning and maintaining critical focus to capture a close-up portrait of a bird in flight. (Photograph by Johan Aucamp.)

**Figure 6.11**
Panning and timing the shutter release to capture the position of the oar enhanced this composition. (Photograph by Geoff Cronje.)

# Sometimes Blur Is a Good Thing

GEOFF CRONJE USED PANNING another way in Figure 6.12. Here the shutter speed is a mere 1/180th of a second. He kept the plane in the same location in the viewfinder and turned the background into a blur. Since the plane was not moving on the sensor, it stayed sharp. The camera was moving in relation to the background. It's the same effect we see if we fix our vision on the side of a moving vehicle.

I took the picture of the actor rehearsing with the boa in Figure 6.13 under stage lighting. A higher ISO and a faster shutter speed, or using a flash, would have let me freeze the image, but I wanted some blur to add movement. Notice how her face and torso are sharp, as is her left arm. Her right arm is blurred and the boa is a swirl of color.

**Figure 6.12**
The background is blurred, but not the plane, because panning the camera kept the image of the plane fixed in one location on the sensor. (Photograph by Geoff Cronje.)

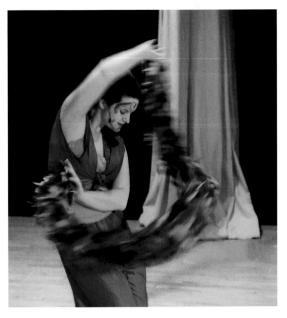

**Figure 6.13**
The blur of motion in this picture was produced by selecting a shutter speed fast enough to freeze the actor, while too slow to arrest the faster movement of the boa. (Photograph by James Karney.)

This effect required timing. Her movements varied as she pivoted around and twirled the boa. As with the groom and his men in Figure 6.8, there was a point at which she was almost still, and the boa was moving quickly. That's when I pressed the shutter. It was open for 1/40th of a second.

The landscape by Johan Aucamp in Figure 6.14 makes use of selective blur as well. Here the exposure was one second at f/7.1. The long exposure turned the moving water into a silky cascade. Cutting that time in half would have blurred the water, but not provided the almost misty effect. A fast exposure would have frozen the waterfall and the flowing stream would have looked clear.

The exact shutter time needed for these water effects will vary from location to location. That's because the distance and direction relative to the camera will change, and so will the speed of the water. In some cases you may want a very slow shutter speed, maybe several seconds. With open sun, or even bright shade, that may require either a polarizing or neutral-density filter to allow that interval. The polarizer is a great tool for water-related photographs. It lets you adjust the highlights of the reflections on the surface.

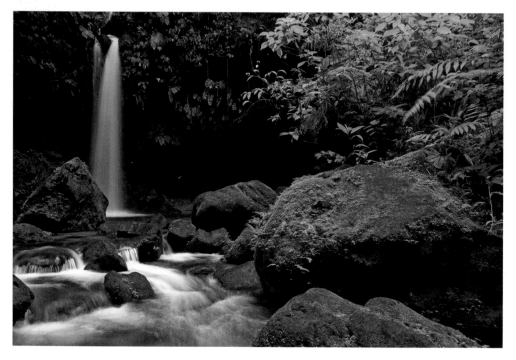

**Figure 6.14**
A long shutter speed can turn fast-moving water into a silky blur. (Photograph by Johan Aucamp.)

## A Note About Flash

The flower petals in Figure 6.15 are suspended in mid-air, and the couple is perfectly sharp, even though the photographer used a slow shutter speed, only 1/15th of a second. Flash can change the rules. Remember that the actual exposure is based on the amount of light reaching the sensor. The flash used for this picture was much brighter than the available light, and flash is very fast. Its duration varies with the model and settings, but it is less than 1/1000th of a second and often much less than that. Some units can fire within 1/25,000th of a second.

As you can see, flash can dominate a weaker light source. Sometimes the ambient light level is close to the power of the flash. Then using a slow shutter speed can result in blurring. If the flash is too powerful, both shadows and the background of the scene will be very dark. It's worth the time to practice using flash with different shutter speeds.

Your DSLR has a flash synchronization (sync) speed. This is the fastest shutter speed that can be used with a flash under normal conditions At speeds faster than the sync speed, the shutter opens to just a narrow slit, and the flash duration is too brief to allow the light to reach the entire surface of the sensor. Your flash may be able to fire a rapid series of bursts during the exposure to allow faster speeds in a special operating mode. It's worth taking the time learn about your camera's sync speed and experiment with high-speed options.

Now that you've been properly introduced to the shutter, consider some self-assignments, and experiment with both freezing motion and inducing blur.

**Figure 6.15**
Flash speed, not shutter speed, froze the flower petals in this picture. (Photograph by TriCoast Photography.)

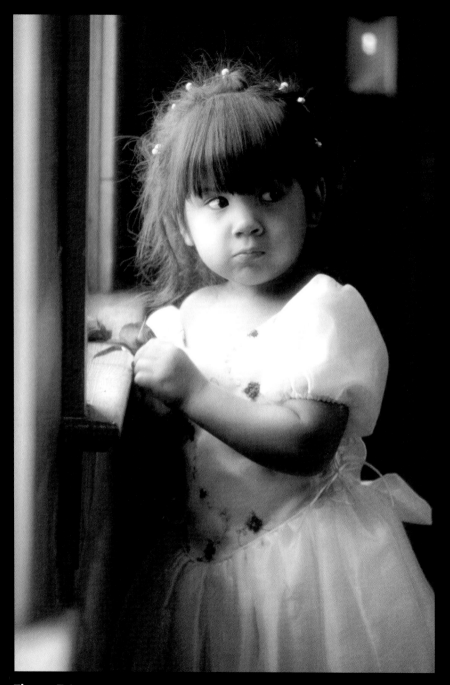

**Figure 7.1a** The soft window light sets just the right tone for this enchanting portrait of a little girl. (Photograph by TriCoast Photography.)

# The Big Picture: Light, Color, and Composition

# 7

THE FIRST THREE PICTURES IN THIS chapter are a study in contrasts. Each was taken using only the available light falling on the subject. The photographer's technique—understanding the quality of the light, selective focus, depth of field, and shutter speed—coupled with the composition, produced the desired image. Learning to see how light shapes the world is the most valuable skill a photographer can develop. This is the chapter where we bring it all together.

The word *photography* literally means "writing with light." Most of our discussions so far have centered on the tools we use to work with the light in a scene—focus, f/stop, shutter speed, lens design, and composition. This chapter looks more closely at how to use the light itself. Light provides the contrast, texture, tone, and color that shapes our images and gives them life. We arrange the picture and use our skills to capture an image that shows the viewer our vision of the scene. We'll start by examining several images, all taken using available outdoor light (the unaltered light falling on a subject), and then discuss how multiple light sources and flash units can give us total control over shadows and highlights.

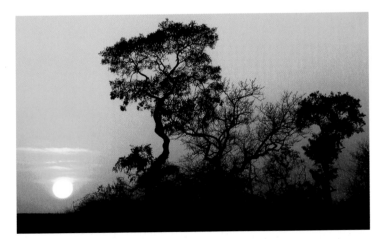

**Figure 7.1b**
The setting sun brings color and contrast to this landscape by Johan Aucamp.

# Observing the Qualities of Light

FIGURE 7.1A WAS TAKEN using window light. The little girl was turned so that the light was coming in from her side, casting a soft shadow. Window light, unless the sun is shining directly in and onto the subject, is soft. *Soft* here means "moderate tonal contrast"; the diffused light does not cast harsh shadows. So we can see detail on the side of her face away from the window and on her white dress.

The window light does not reach the out-of-focus background. That's due to a very shallow depth of field and the fact that very little light reached that portion of the room. The exposure was 1/60th of a second at f/2.8 with an ISO of 400. The photographer rendered the image in black and white; removing any color contrast adds to the soft visual feel of the picture.

Compare that to the landscape in Figure 7.1b. This image has high contrast, bright color, and no shadow detail. The exposure was set to keep tone in the sky. The sun behind the tree was so bright that the exposure rendered the tree as a silhouette. Daylight does not keep the same color or intensity throughout the day. The low position of the sun during the first few and last few hours of the day reduces light levels, because the Earth's atmosphere filters out some of the blue and green color. That's what causes red sunsets, like the one in this picture, and the color of the harvest moon.

The orange glow on the face of the fire-tender in Figure 7.2 is caused by the reflection of the light from the open furnace. Geoff Cronje set his exposure to let that glow become a highlight and add a visual accent in an almost monochromatic scene. Notice how the dark shirt is rimmed with enough light to keep it from blending into the black background. The slow shutter speed induced blur in the man's arm to indicate motion as he stoked the coals.

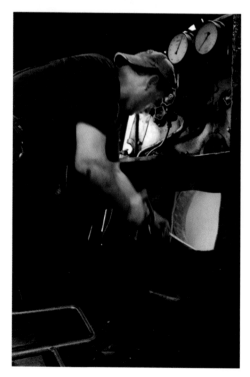

**Figure 7.2**
This picture was exposed to take advantage of the available light and subject motion to capture both the look and feel of the man at work. The orange of the fire adds color contrast to an almost monochrome setting. (Photograph by Geoff Cronje.)

From a photographer's standpoint, the direction, relative intensity, and color of the light sources in a scene are its primary attributes. Carla Hoskins' charming portrait of the little girl in the fountain in Figure 7.3 would have been much less interesting if the sun had been behind the photographer instead of the subject. Here, late-afternoon sun is coming in at a 45-degree angle from the back left of the scene. That position is what produces the highlights on the child's hair and dress. It also brightens the stream of water that arcs over her head.

Carla chose a shutter speed that almost froze the motion of the water, but not quite. That let the spray record as streaks of water rather than dots, and blurred the arc as it broke up and fell into the pool. The f/stop was set to keep the rim of light from going pure white, while holding detail in the girl's face and the front of the dress. They are lit by the fill light from the sky and the fountain.

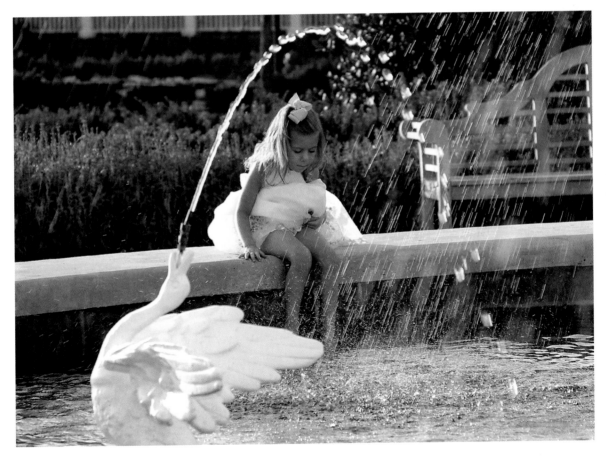

**Figure 7.3**
The angle of the sun and time of day are both critical elements in this composition. (Photograph by Carla Hoskins.)

If this picture had been taken at noon, the sun would have been overhead, and the results *much* different. There would have been harsh downward shadows and no rim lighting. The stream of water would have lost its highlights, and the background would have been brightly lit and distracting. If the sun had been over Carla's shoulder, the lighting on the girl's face would have been flat, and strong shadows would be cast behind the objects in the scene. Late afternoon sun is warmer (unless the sky is overcast or the subject is in the shade) than the light at mid-day.

The image of the couple in Figure 7.4 was taken on a bright, sunny summer day. The sun was still hours from sunset. So why are there no harsh shadows? In fact, there are hardly any shadows visible at all. That's because the picture was taken in open shade. The light was diffuse. The colors are saturated, but not as bright as they appear in full sunlight, more as they would on a cloudy day. It's another example of the effects of direction and intensity.

The photo was taken on the shady side of the mill, so the open sky, not the direct sun, was the light source. That light is softer and cooler (more blue) than direct sun. The exposure was 1/125th of a second at f/4.5 with an ISO of 100. That's about three stops more open than full sunlight.

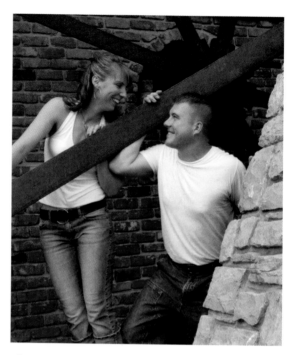

**Figure 7.4**
Open shade produces soft light, low contrast, and increases color saturation. (Photograph by James Karney.)

One more example, then we'll draw some conclusions. Joe Mc Broome's butterfly in Figure 7.5 was taken in full sunlight. We can tell by the sharply defined shadows. The contrast is much higher in this image than in the one in Figure 7.4. Joe used an exposure of 1/1600th of a second at f/5.6 with an ISO of 400. The fast shutter speed ensured that neither camera shake nor subject movement would blur the primary subject. The 200mm lens and close proximity to the butterfly created a very shallow depth of field with pleasing bokeh (soft blur due to a limited depth of field) as a background.

Look closely at the detail in the butterfly's wing. The texture has good definition; that's due to angle of the light and the contrast level. The animal is facing directly into the sun, and the wing is facing the camera directly. From the camera's perspective, the sun is raking across the wing, creating shadows that outline the texture.

With these examples in mind, let's look at the traditional definitions for both the quality and direction of photographic lighting. The positions are always described based on how the light appears to strike the subject from the camera's point of view. It can't record what it can't see.

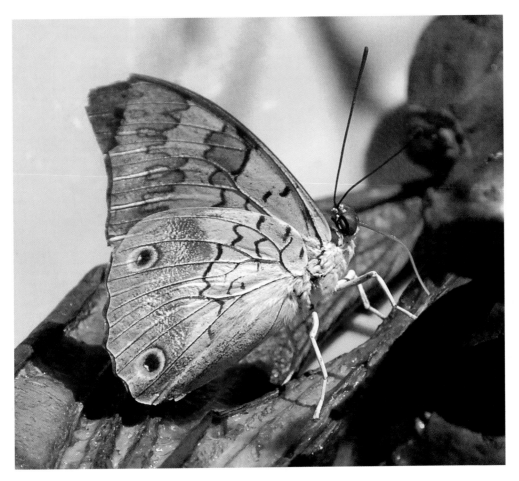

**Figure 7.5**
A fast shutter speed and wide aperture ensured a sharp subject and pleasingly blurred background. (Photograph by Joe McBroom.)

# Intensity, Quality, and Contrast

THERE ARE FOUR PRIMARY attributes used to describe the illumination quality and type of light source. *Intensity* is the simplest attribute to define. It's simply how bright the source is. There is not much control over intensity when we are taking pictures using only available light, other than to adjust the ISO, shutter speed, or f/stop.

The other options include modifying the existing light or waiting for different conditions. Later in this chapter we will look at the use of light modifiers and flash. Waiting for the right conditions may sound extreme, but is not always that difficult—if you have the time. Many professionals time their portrait sessions to coincide with the soft light found in the three hours before sunset.

*Light intensity* is divided into two categories. *Specular light* is generated from a direct bright source point that casts hard shadows. The sun shining in a clear sky is a specular source. So is an unshielded light bulb, a fire, and a spotlight. The picture in Figure 7.6 is an example of a scene lit by specular light. Specular light sources generally produce images with high-to-medium contrast.

**Figure 7.6**

The spotlight illuminating the guitar player is an example of a specular light source and a high-contrast image. (Photograph by Bruno Chalifou.)

*Diffused light* is generated by broad light sources, or specular sources that have been softened and scattered before they reach the subject. Fog, haze, cloud cover, and large reflective surfaces generate diffused light. Diffused light sources generally produce images with softer shadows and lower contrast than specular light sources. The foggy light in Figure 7.7 is an example of diffused light. Keep in mind that most scenes in nature are illuminated with a mix of both specular and diffused light. That's because specular light is reflected off of surfaces, creating secondary illumination.

**Figure 7.7**
Fog-scattered sunlight produces diffused light, reducing both intensity and shadows. (Photograph by Joe McBroom.)

*Contrast* is a term used to define both the range of tones (*tonal contrast*) from lightest to darkest, and/or the way colors in an image relate to each other and the overall composition (*color contrast*). The human eye can distinguish about 256 shades of gray. Tonal contrast is usually divided into three categories, based on the number of shades in the image. *High-contrast* images contain mostly blacks and whites, with few middle tones. *Medium-contrast* (also called *normal contrast*) images have a range of tones from blacks to whites. (Figure 7.1a is a good example of a well-executed medium-tone image.) *Low-contrast* images contain mostly middle tones. Specular light sources, with their hard shadows and bright highlights, tend to produce high contrast in images, while the soft shadows created by diffuse lighting are associated with lower tonal contrast.

*Color contrast* is more subjective. It's the way colors are perceived in relation to each other and the composition. Reddish tones are "warm," while blue is considered "cool." The viewer senses the cool air in the bluish tone imparted by the fog in Figure 7.7, while the orange in Figure 7.2 adds warmth. Cool and warm colors, and complementary colors placed close to each other in a picture, build color contrast. Figure 7.8 shows a color wheel. The smaller wheels on the right of the figure show examples of the various relationships. Colors that are on opposite sides of the wheel are complementary.

**Figure 7.8**
A color wheel with examples of color theory relationships. (Image ©istockphoto.com/Nancy Nehring.)

A color's brightness and the color saturation (which are affected by lighting) modifies its visual contrast. Johan Aucamp contrasted a rainbow and the warmth of a bright golden mountain top with cold blue sky and a dark sea in his landscape seen in Figure 7.9.

Less can be more when creating impact with color contrast. Adding more colors into an image tends to decrease the overall color contrast, and to diminish the visual importance of any one color. In Figure 710, Carla Hoskins isolated one flower and used a shallow depth of field with color contrast to make it stand out in the composition.

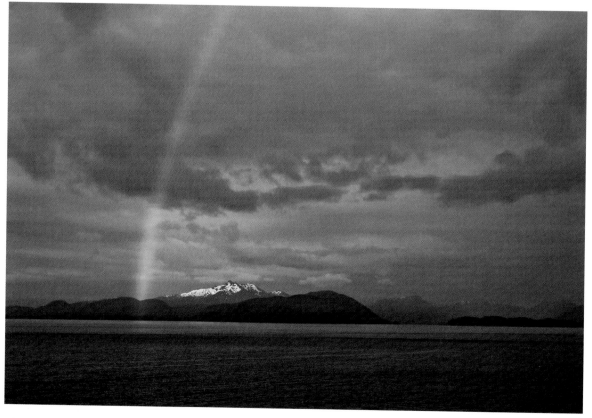

**Figure 7.9**
Less can be more when using color contrast in a composition. (Photograph by Johan Aucamp.)

**Figure 7.10**
Color contrast and shallow depth of field combine to make a single flower the center of interest in this picture.
(Photograph by Carla Hoskins.)

*Color saturation* makes a color appear more intense—that's not the same as *bright*. The glow of the sky at the setting sun in Figure 7.1b is saturated, as are the blues and greens in Figure 7.7. Bright light produces bright, rather than saturated colors, and overexposure can wash the color out of a picture's highlights.

*Color temperature* identifies the color of a light source. Our sun is a yellow star. The atmosphere filters the light, changing its color during the day, and under different weather conditions.

The hour just before sunrise and the one before sunset are very warm. Passing through cloud cover it becomes scattered and increasingly cool.

Artificial light comes in various shades based on the source, from lamps that mimic the sun at noon, to reddish tungsten bulbs, to fluorescent fixtures with a greenish glow. Our brains compensate for the variations; sensors and film do not. So photographers can use color temperature to impart mood to our images.

# Direction, Texture, and Tone

A PHOTOGRAPHER'S MOST powerful creative tools are the eyes and physical movement. Moving to find the right camera position is a step many photographers omit, at the expense of the image. Light falling onto a subject is directional. Changing your camera position changes how the camera sees the interplay of light and shadow on the subject, creates texture, and influences the placement of tones and color in the scene. While the basic names for lighting positions are listed as horizontal locations on a circle around the object, the height of a light source will also change the appearance of the scene. Think of a sphere, not a circle, when evaluating (or placing) lights.

*Front lighting* is the term used when the light source is closely aligned with the camera position, as when the sun is behind the photographer, or a flash is mounted on the camera. It's also called *flat lighting*, because objects then look wider. (Your driver's license was probably taken with flat lighting.) That's because the shadows that are cast fall behind the subject.

Figure 7.11 is a high-key portrait. The lighting was from a broad source near and slightly above the photographer's shoulder. It was designed to eliminate shadows. The setting was an all-white enclosure. The exposure was chosen to just hold details in the highlights, and eliminate any true blacks. The result is a low-contrast image, with saturated colors. High-key lighting often produces low-contrast images, due to the lack of deep shadows in the picture.

**Figure 7.11**
This high-key image was produced by using flat lighting, balanced to reduce shadows. (Photograph by James Karney.)

If the vertical angle of a light source is high and to the front, there will be shadows cast down. This is what causes "raccoon eyes" in those family group pictures when the photographer lines everyone up facing the sun after lunch.

*Full side lighting*, with the light source coming into the frame at a 90-degree angle, dramatically models the subject, adding the impression of three dimensions to the two-dimensional medium of photography. It emphasizes texture and form with the shadows it creates. Gary Todoroff's landscape in Figure 7.12 employs sidelighting to rake the surface of the ocean and reveal the waves. The blending of dark cold tones in the sea and sky with the warmth of the setting sun adds well-placed color contrast to the composition.

Full 90-degree sidelighting adds a dramatic element to landscapes. Controlling contrast with very bright or dim light sources can be tricky. You may have to choose between holding details in the shadows, or highlights in bright sun.

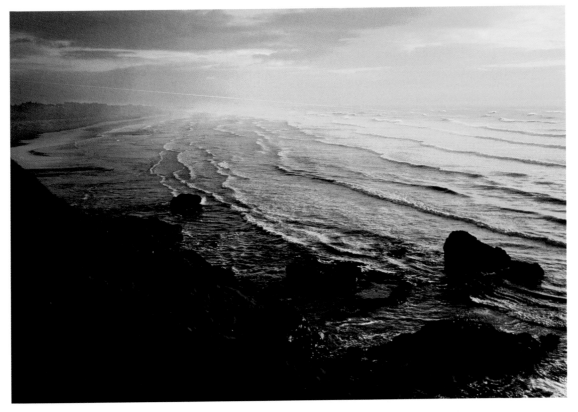

**Figure 7.12**
Sidelighting creates shadows that emphasize texture and create visual depth. (Photograph by Gary Todoroff.)

In controlled-lighting situations, you can use additional light sources to fill in the shadows, as seen in Figure 7.13. This is a low-key picture, and the exposure was set to emphasize the darker end of the tonal range and produce deep blacks. Sidelighting makes faces look a bit narrower than they really are, just as flat lighting makes them look wider. The cooler temperature, the direct gaze of the subject, and the 90-degree sidelighting all increase the impact of the composition.

*45-degree sidelighting* produces a result between frontal and 90-degree sidelighting that reveals texture and adds dimension with moderate contrast. This is very popular for portraits and people pictures, as seen in Figure 7.14 by Nikki McLeod. Her subject is turned lightly toward the light, and the exposure was set to create a soft shadow.

**Figure 7.13**
Sidelighting used in a low-key portrait with fill lighting to keep the shadows from going completely black. (Photograph by James Karney.)

**Figure 7.14**
45-degree lighting is a favorite technique for portraits, because of the way its shadows contour the face. (Photograph by Nikki McLeod.)

Backlighting is rarely used as a primary light source. It is mostly used to create silhouettes (as we saw in Figure 7.1b), or rim the subject with light. Figure 7.15, by TriCoast photographers Mike Fulton and Cody Clinton, shows the rim-light effect on the bride and her veil. This type if lighting requires a careful exposure to avoid totally washing out the highlights and the sky.

Here the sun is in the upper-left corner, so the picture uses the intensity to produce an effect where the sky progresses from brilliant white on the left to a medium blue on the right. Notice the highlights on the bride's arms. A second light source was used to illuminate the bride's back. More about fill lighting later.

**Figure 7.15**
Light and wind were combined to make this interesting study of the bride and her veil.
(Photograph by TriCoast Photography.)

It's easy to see why Mike and Cody are in demand as photographers and mentors from their use of light and color in Figure 7.16. Here, backlighting was used to light the subject and create highlights and shadows that impart a message of their own. The Bible was adjusted at an angle so that the ring produced a heart-shaped shadow, and the highlight became a cross. The depth of field was very shallow due to the close proximity of the camera to the ring, and the focus point was centered on the shadow. The color was accentuated during processing, growing more intense as it moved to the top of the picture.

**Figure 7.16**

This image combines light, shadow, color, and depth of field to expertly tell a story in symbols. (Photograph by TriCoast Photography.)

# Working with Light: Modifiers and Filters

LIGHT TRAVELS FROM ITS SOURCE to the subject and then to your sensor. Along the way, it can be modified in ways than help or hinder your composition. We've looked at several pictures that show how the angle of the sun changes the color of its light, and how fog and haze can scatter it. The strength of sunlight changes throughout the day. All of those conditions affect the amount of light reaching the sensor, requiring a change in exposure and often a shift in color balance.

The river scene in Figure 7.17 was taken in late afternoon, and the light was coming in at an angle that caused it to rim the crew's shoulders. The sun was about to go behind the hills, and was starting to cast a shadow on the slope across from the camera position, and on the water on the other side of the boat. The day was humid, and the haze scattered the light, making the distant trees look soft. The vertical position of the sun determined both the location of the highlights on the rowers and the placement and intensity of the shadows. The sun's position and the haze were both light modifiers.

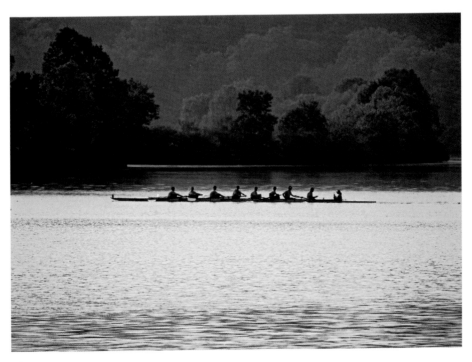

**Figure 7.17**
Bright sun illuminates the rowers in this picture, but a humid haze mutes and softens the trees in the background. (Photograph by James Karney.)

The picture of the large fish in Figure 7.18 was taken on a bright sunny day, but 50 feet underwater! Air and water are both light modifiers. Water is denser, so some effects are easier to see in underwater shots. I used a strobe unit on a long arm attached to the camera as the light source. The side of the fish toward the flash shows its true color. The side in shadow has a noticeable green cast. And the rest of the picture is bathed in a blue cast. That's due to the way water absorbs light, starting with the red portion of the spectrum. The particles in water also scatter light and reduce sharpness.

## Optical Filters

Once upon a time, when we used film, serious photographers carried a pouch full of glass filters they could screw onto the front a lens to modify the light as it entered the camera. Some were used to change the color balance. Color films were designed to be used under daylight or tungsten conditions, and these corrected the existing light to match the film's preferences.

**Figure 7.18**
The blue cast in the background is due to the light-absorbing characteristics of water. (Photograph by James Karney.)

A light yellow filter improved skin tones with black and white film. With a DSLR, many of the tasks handed by filters can be done in an editing program like Photoshop. As a result, few photographers carry filters, and many don't even know about them. There are some types that still come in handy.

## Polarizers

If you have ever used polarized sunglasses, you know how they can make the sky look bluer and reduce glare on water and glass. A *polarizing filter* does just that with a camera, both digital and film. Figure 7.19 shows just the kind of scene that makes me reach for the filter kit.

**Figure 7.19**
Polarizers can darken the blue in the sky and reduce glare on water. (Photograph by Joe McBroom.)

Polarizers work sort of like a gate that only lets in light rays in that line up a certain way. The ones that don't are blocked. You rotate the filter until you get the desired effect (or the best available). You can also use one to add glare or reduce the blue in the sky. The angle of the sun and the reflective surface make a difference in just how much effect you see. Under the right conditions, the change can be dramatic. Most DSLRs require a circular polarizer. That's so the filter won't confuse the auto-focus system.

There will be a change in exposure when you use a polarizer, because part of the light is being blocked from reaching the sensor. The exact amount varies with the strength of the effect.

### Neutral Density and Graduated Filters

Sometimes you want to be able to use a slower shutter speed to blur the motion, or a wide f/stop to reduce depth of field, but the light is too bright. A neutral density (ND) filter is a dark sheet of glass designed to reduce exposure without adding any color to the light reaching the sensor. They come in different strengths, and are labeled in stops. A 2x ND filter cuts the light in half, or one stop; 4x by two stops; etc.

Graduated filters come in different flavors. A graduated neutral density filter is lighter at one edge and slowly gets darker as it moves toward the other. There are graduated color filters that let you blend a color to scene. Some are combined with a graduated neutral density layer.

These can be very handy for intensifying the warm orange of a sunset or increasing the dark blue in the sky, without changing the overall color balance or exposure of the main point of interest. Figure 7.20 shows this effect with a darkened sky in the upper-left portion of the picture.

**Figure 7.20**
Graduated color filters can be used to add extra color to part of a picture during exposure. (Photograph by TriCoast Photography.)

## Infrared Filters

There are portions of the light spectrum that we can't see. Ultraviolet lies beyond the blue portion of the visible spectrum, while infrared extends beyond the red, and both are invisible to the human eye. Some DSLRs can be used to take pictures using ultraviolet (UV) or infrared light (IR)—with the right modifications and filters.

Both UV and IR images are labeled *false color*, because the shift in spectrum alters the way colors are recorded, in both black-and-white and color. There are several programs, like Alien Skin Exposure 2, that can mimic false color photography (with varying degrees of success). Figure 7.21 shows what an infrared image looks like. Notice how dark the sky is and the way green is rendered very light to white.

**Figure 7.21**
Infrared photography produces very dark skies, and greens are rendered white.
(Photograph by TriCoast Photography.)

# Controlling Light: How Many and How Much

S O FAR WE HAVE CENTERED on understanding and working with a single light source—the main light—and we have mostly considered available light. We'll concentrate the remainder of this chapter on manipulating light by adding light to the scene rather than just working with what is already there. This dramatically improves our ability to control contrast, adjust shadows, and manipulate texture. It gives more options in setting exposure. Multiple lighting can be as simple as the sun and a sandy beach, or a studio with banks of lighting equipment. Most multiple lighting applications only use two or three sources.

Complex studio lighting is beyond the scope of this book, and priced beyond the budget of the average amateur. We can borrow concepts and methods that the pros use without high-powered strobes—if we know how to use multiple sources. The good news is that simple reflectors and advances in small flash units can produce similar results, with far less cost and bother.

## The Naming of Names

There are some terms to define. When there was only one light in the picture we could just say "the light," or "the source." Photographers identify multiple light sources by what they do, as well as how bright they are and the source. That makes it easier to manage what effect the light is supposed to have, and how to set its intensity.

One common way to name lights by function is borrowed from motion pictures. In this system, the primary light source is usually called the *main light* or the *key light*. This is the light that is used to *key*—or *index*—the exposure setting and provide the majority of the illumination on the subject. That does not mean it is the brightest light source in the picture, or that it has to light up the entire scene. (Of course it will be the brightest light if there is only one light. Even then, the main light may not light the entire image.) The picture in Figure 7.22 was made using what filmmakers call a *key spot*. The main light is tightly centered on the subject and much of the scene is in shadow or even totally black.

*Background lights* are placed behind the subject to cast light back onto the background. Novices think that the color of a background is determined by its color. That's only true if light falling on it is close enough to the exposure when the picture is taken. If the light falling on the background light blasts enough light, the background is recorded as pure white—just like a very bright light is recorded as white in a picture. If the background is in shadow, or too far away from the light source, it will be recorded as black. The image in Figure 7.23 was taken with a carefully-controlled exposure. The cake is lit from one side, and the background from a source hidden behind it. The levels were set to let the candles form a bright ring and just illuminate the tablecloth.

**Figure 7.22**
This photograph has only one light source, so it is the key light used to set the exposure. (Photograph by TriCoast Photography)

A *fill light* does just that. It fills in or reduces the darkness of shadows. It is never as bright as the main light, and is not usually calculated into the exposure setting. The most basic multiple-lighting setup consists of the key light and a fill light.

**Figure 7.23**
The lighting in this picture was crafted to hold the texture of the icing on the cake and highlight the silver tray. The backlight adds color contrast, in addition to adding depth to the scene. The candles are a ring of accent lights. (Photograph by TriCoast Photography.)

*Accent lights* are used to add highlights to provide more exposure to a specific area of the picture than the key light, or to illuminate part of the composition that is not fully lit by the main light. They are often named by what they light. For example, a *hair light* is usually placed above and behind a subject to add highlights and sheen to the hair, and possibility to add light to visually separate the subject's head from the background.

A *rim light* works the same way as a hair light, but isn't focused on hair. Gary Todoroff's picture of Capetown sheep in Figure 7.24 uses the sun as a rim light to outline a mother and her kid. He set his exposure so that the open sky served as the main light, and positioned the camera so that rim light, combined with the morning haze and a shallow depth of field, separated the animals from their background.

**Figure 7.24**
The sheep are rim-lit by the sun, and the exposure is based on their shaded bodies. (Photograph by Gary Todoroff.)

*Bounce light* casts indirect lighting off a surface like a ceiling, a wall, or a reflector. It can be a natural occurrence, or placed deliberately by the photographer. Bounce lighting is usually diffuse, unless it is reflected off a very shiny surface held close to the subject. News photographers often raise a flash close to the ceiling, creating a bounce effect that combines with existing overhead lighting. This approach produces soft shadows and allows for exposures with better depth of field.

There are two more definitions needed before we start using multiple lights, *continuous* and *transitory*. A continuous light source is one that stays on and can be seen while determining the exposure, like the sun or a light bulb. With a continuous light source, the longer the shutter is open, the more it adds to the exposure.

A transitory source is only on during the exposure. Examples include flash units, lightning, and fireworks. With flash, the light duration is so short that f/stop is the only real control over exposure when flash units are the only light source. That's because the light does all its work in less time than the shutter is open. Be sure to check your camera's manual for information on its *flash sync speed*. The shutters in DSLR cameras are only fully open all at once, below a certain specified speed. Below that specified flash sync speed, which ranges from 1/60th to 1/250th of a second, part of the image area will be covered by the shutter and not be recorded. Some flash units have the ability to fire several rapid bursts to overcome this limitation.

# It's All Relative to Intensity

THE KEY (PARDON THE PUN) to mastering controlled lighting is in understanding the concept of *lighting ratios*. The main light source is always used to determine the exposure. Fill lights are placed and adjusted to reduce the shadows, and are always less bright than the main. The difference, expressed in exposure f/stops, is the lighting ratio. For example, a 1:2 ratio means that there is a one-stop difference, and the light falling on the darker side is one stop less than the main light.

Here's a simple example. You are in open sunlight and want to reduce the harsh shadows. If you use your on-camera flash as a fill, step the flash's intensity to one stop less than the daylight exposure used for the picture. Your camera or flash probably has a feature that can be set in f/stops—that's easy. If the sunlight exposure is 1/200th of a second at f/11, then the fill needs to generate the amount of light needed for an exposure of 1/200th of a second at f/8. That's a lighting ratio of 1:2. The first number is the main light, and the second is half of that.

A quick recap before we cover some lighting setups in detail. The main light is whichever light source is used to determine the exposure. That's why it is called the key light. A fill light is used to make the shadows light and reveal more detail. Accent lights put more exposure on a specific portion of the image than the main light to create a highlight. The relative intensity of one light to another determines how they interact in the composition.

# Adding a Fill Light the Easy Way

CONTINUAL LIGHT SOURCES are easier to use than transitory sources, because we can see their impact in the viewfinder. Normally a reflector is used as a fill light, because they draw their "power" from a brighter light. But that depends on location. Figure 7.25 is a case in point. The subject is sitting on a trail in a wooded area. The Sweet-16 condition is open shade. There is some bright sun filtering through the leaves. The sun is shining brightly in an open area nearby. Study the picture before reading the next paragraph and see if you can identify the three light sources used in the picture and their relative intensities.

This portrait is a nice example of how choosing the right location and the use of a second light source can transform a picture. I had one of my daughters stand in open sun and hold a flexible reflector so that the light fell into the scene from almost a 45-degree angle on her sister's right. She moved her position and the angle of the reflector until we had the desired level of lighting. She is standing just outside the picture, and the reflected sunlight is about a stop and a half brighter than the shade, making the reflected light the main source.

**Figure 7.25**
The main light in this picture is the sun bounced off a reflector. (Photograph by James Karney.)

I had the subject sit so that a little area of bright sun passing through the leaves caught her pony-tail, creating a hairlight. The open shade was used as the fill. I measured the main exposure (the reflected light) using my camera's spot-meter mode on her face, and selected a shutter-speed and f/stop combination that created a shallow depth of field to blur the of boards and gravel in the background. The point of focus was my daughter's eyes.

Figure 7.26 shows Brian Wagner holding the same collapsible mylar reflector I used to make the picture in Figure 7.25. These are really handy gadgets that can be twisted into a small circle for easy carrying. They are flexible, which lets you bend the shape to focus or feather the light as needed. This one has one side that is silver, and the other is golden in color. The silver casts light the same color that falls on it, while the gold material warms the light. Some discs come in translucent material. That casts a softer light, and can be used as a diffuser or scrim to soften the light even more by actually placing it in the path of the light falling onto the subject.

# Bounce Light—a Reflector by Another Name

You can turn almost any nearby surface into a reflector by aiming a light source at it and bouncing the light onto the scene. That's the basic principle behind most ceiling lights. We can use the same technique by placing additional sources close to the ceiling (or a wall). The most common use of this technique is firing a flash unit at the ceiling. While you can simply aim a camera-mounted strobe up (most have heads that swivel just for that purpose), the effect is stronger if you place the light closer to the surface. That requires an accessory cord. Many DSLR cameras have the ability to control flash output and will automatically adjust the exposure and flash intensity to produce a soft fill. That's what I used to take the picture in Figure 7.27.

**Figure 7.26**
Collapsible reflectors are easy to carry and fold to a compact size.

**Figure 7.27**
Bounce flash is often used to create a soft, natural-looking fill light. (Photograph by James Karney.)

There are some things to keep in mind when working with bounce flash and reflectors. First, the color of the reflecting surface will be carried to the subject. It's usually best to stick to white or neutral tones when choosing a surface.

Light loses intensity as it travels. When you are bouncing light, it has to move to the reflector, and then on to the subject. If the distance is too great, the bounced light may not have enough power to properly do its job. Many strobes and/or DSLRs have an indicator, either a beep or flashing light, that warns when the burst was inadequate.

## Wrap-Around Light

The bigger the source, the softer the light. That's why studio photographers buy *soft boxes*. These are large enclosures that surround a light source with white walls, usually angled to focus the light through a translucent diffusion panel. Two-by-three feet is common, and some are eight feet across. The same effect can be obtained by placing the subject near a broad expanse of windows that are not in direct sun. Artists and some photographers build a picture window (no pun intended) on their studio's north wall.

The back of the chapel where I took the picture in Figure 7.28 had a series of five windows facing north, arranged in a semi-circle. The exposure was set to hold the detail in the back of the gown, and let the windows panes go totally white. The wrap-around fill effect allowed enough light to keep the bride from showing as a true silhouette. The exposure was 1/25th of a second at f/4 with an ISO of 200.

**Figure 7.28**
A series of five tall windows acted like a giant soft box in this bridal portrait. (Photograph by James Karney.)

# Using Flash as a Main Light Source

Some DSLRs have built-in flash units, which are notorious for causing *red-eye*–the effect caused by light reflecting off the back of the eye into the camera. Even shoe-mounted strobes are prone to the problem. Fancy flash brackets can eliminate the problem (for several hundred dollars), but most new DSLRs and dedicated flash units offer a better solution. They can communicate wirelessly. That let's us move the strobe just like a fancy studio strobe, even if it isn't as powerful.

The picture in Figure 7.29 was taken with a single flash in a large room with just a table lamp in the corner, out of the picture as the available light. The flash I used comes with a small stand. I used it to place the flash on the floor and located at a 45-degree angle to the child from the camera position. During the shoot I stayed down at the boy's level. I set the f/stop to f/2.8 for a shallow depth of field, and took some test shots to see how the light illumined the boy and the floor. Then I simply let him play and moved the light as needed to keep the angle adjusted to model his face.

**Figure 7.29**
The single flash used to light this portrait was used off-camera, triggered by a built-in wireless connection. The light, the subject, and the photographer were all at floor level. (Photograph by James Karney.)

# Using Flash and the Sun as a Fill Light

REMEMBER THE POINT about how the key light determines the role of all the light sources in the picture, no matter their intensity? The picture in Figure 7.30 has bright early-afternoon sunlight streaming in behind the musician. That's the rim light. The key light was the flash. The flash output was adjusted to give a proper exposure to the face, the sheet music, and his instrument. The final exposure was 1/90th of a second at f/5 with an ISO of 200.

You may have to underexpose a bit when using a very bright light as an accent light to hold detail and tone in the lighter areas of the picture. I did that here by about a half-stop, and adjusted light levels during processing. We'll cover that topic later in the book.

**Figure 7.30**
A flash was the main light in this picture and the sun acted as a rim light. (Photograph by James Karney.)

## Is the Flash a Fill Light, or the Sun a Background Light?

The sun is shining brightly in the background and the main subjects are in shade in the TriCoast photo in Figure 731. The shade cuts down on the contrast, just as it did in my portrait in Figure 7.25. But the background is a lot brighter than under the arch were the couple is standing. Without a second light, the choice would be between washing out the building or leaving the couple in shadow.

This picture is a subtle composition, well worthy of study. First, the flash exposure was carefully balanced to be just a little less bright than the sun. If it was an equal, or a little greater, amount of exposure, the result would look unnatural. We are used to seeing objects in shade as slightly darker than those in bright sun. Second, the photographer balanced both lights to bring out the blue in the sky. The final image is both natural-looking and colorful.

**Figure 7.31**

The sun lights the background, while the flash is powered to light the couple—but not too much. (Photograph by TriCoast Photography.)

# Give Me Just a Little More Time: Dragging the Shutter

FLASH EXPOSURES ARE MEASURED in a fraction of a second. Those images of water droplets frozen in mid-air as ice drops into a glass are taken using only flash, with a special trigger that fires both the strobes and the cameras. In that situation, the flash is the main light and the total basis for the exposure. But when you have other objects in the scene that need a longer exposure, you have to do a balancing act with the f/stop and shutter speed, known as *dragging the shutter*, to get everything into the picture. It is a very powerful technique, and here's how it works.

It's what Gary Todoroff used to capture both the interior of the cockpit and the city lights in Figure 7.32. The subdued light in the plane's cabin was not very bright, so he used an *angled bounced flash* to illuminate the pilots and the instrument panel. Angled light casts some light forward and bounces the rest upward. That results in deeper shadows, because the fill is reduced. If Gary had relied on the camera's computer to judge the exposure, the view out the windows would have been black. It would have chosen an exposure with a shutter speed too fast to record the lights.

Instead, he used a slow shutter speed (1/4th of a second), opened the lens aperture wide (f/4), and chose a high ISO (1600) to record the lights. The shutter speed was set to capture the lights in the window. The strobe's light output was powered to properly record the cockpit at that f/stop. That's the trick to dragging the shutter. The brief burst of light froze the action in the cockpit, the long shutter speed gathered enough light match the exposure required outside. One press of the button, one setting, two functional exposures, due to durations of the light sources.

**Figure 7.32**
The cockpit of the aircraft was lit by a flash, with an exposure balanced to not overpower the nighttime lights of the city as the flight approached the airport. (Photograph by Gary Todoroff.)

# It's Always about Seeing the Light

THIS CHAPTER IS AN introduction, a glimpse into the real secret of photography. Some people devote careers to lighting. There are bookshelves full of all kinds of charts, tables, diagrams, and rules about the subject. But it all comes down to one thing: seeing the light and being able to see the picture it contains. The image is sometimes obvious, other times it requires processing to reveal. But it all requires the vision of the person with the camera, and the skill to create that *something* that makes people look and see what they, until then, missed in the world.

The picture in Figure 7.33 is not socially dramatic; it does not record a pivotal moment in human history. Those, thankfully, are few and far between. This is a quiet moment on a calm body of water. The boat and its occupant appear as serene as the setting and the light that filters through the trees. The man's movements look unhurried.

The technology he is using is simple compared to the busy world of the cockpit in the preceding figure. There are three light sources in this picture, but Gary only had to choose a simple exposure and know how to balance them. The skill is his ability to see. Most people would have driven by and not been aware of the image.

**Figure 7.33**
There are three light sources in this picture, all provided by the sun, but only available to a photographer with the ability to see it and the skill to record it. (Photograph by Gary Todoroff.)

The main light is the light on the river, which, reflected, casts the man and the boat into silhouette. The slightly darker shade frames the scene, and the brighter sunlight filtered through the distant trees is the background light.

We've covered all the terms and basic skills now. The next chapter takes the process one step farther. We'll look at more pictures and uncover the way they were seen, and the techniques used to bring them to the viewer.

**Figure 8.1a** This picture is all about pattern and texture. (Photograph by Joe McBroom.)

# Crafting Compositions: Putting It All Together

**8**

THIS CHAPTER IS ABOUT THE MOST elusive, and engaging, parts of the photographic process—actually seeing potential pictures and turning them into photographs. The DSLR has made the technical side of photography much easier. We can see the results instantly. Moreover, the computer handles tasks that once required knowing, and being able to use, formulas with arcane terms like hyperfocal distance, D/Max, and the "circle of confusion."

They are still part of the process. But your camera, like a calculator, lets you skip the math as long as you know the concepts. We still have to bring the "vision thing" part of photography, and know how to apply the concepts to obtain the desired result. Composition is more than the way a picture is framed. It involves the choice of lens and exposure, picking (or taking advantage of) the right time, light, and camera position. All those topics in the preceding chapters—lens selection, depth of field, tonal range, shutter stop, etc.—are tools in crafting the look of the photograph.

**Figure 8.1b**
This picture uses pattern and color to draw the viewer to the tiger's gaze. (Photograph by Joe McBroom.)

# Self-Assignment: Looking at Pictures

ONE WAY TO GET THE CREATIVE juices going is by really *looking* at photographs and figuring out how they were done, and why they work well at drawing the eye. That lets us consider the art of composition and review the skills presented in the earlier chapters. Then, use the ideas to spark your own ideas for pictures. As we go through the images, consider scenes and subjects that would be good topics for you to use as personal self-assignments.

## Perspective: A Personal Point of View and a Sense of Timing

Let's start with the two pictures by Joe McBroom seen in Figures 8.1a and 8.1b. The first is a study in pattern, texture, light, and shadow. The eye is not drawn by action, human interest, or bright color. The natural light created relatively soft shadows, so the texture of the bricks is even soft, not rough. That approach centers the visual attention on the pattern of the brick arches.

Joe used a 45mm lens with a 29-degree angle of view (AOV) on his Nikon D300. That's at the lower range of telephoto. It provided a workable depth of field, while producing a bit of the visual compression of space (objects in the distance look closer together) that a long lens produces. The point of focus was a few arches back from the front. The depth of field (DOF) was adjusted to leave the closest arch acceptably sharp, and let even the most distant ones retain a clean edge. (The distance was too great for the DOF to cover the total range.) That softening actually adds to the sense of distance in the composition. The picture was taken just after mid-day, so the shadows on the pavement are short and do not distract from the lines of the arches.

Joe's picture in Figure 8.1b uses color contrast and depth of field in his study of a white tiger. The animal's light tone stands out from the blurred green and yellow of the fronds. The plants are still distinct enough to create a series of lined shapes that visually repeat the theme presented by the tiger's stripes. Joe frames its body to fill the lower portion of the frame, accentuating the color contrast and the curve of the tail and the body, drawing the viewer's eye across the picture to meet the direct gaze of the face, and a pair of very alert blue eyes.

The picture was taken using a long telephoto with a 4.6-degree AOV, equal to a 300mm lens on a full-frame sensor, opened to f/3.5 to produce a shallow depth of field and separate the tiger from the background.

In the wild or in a zoo, animals don't usually take direction that well, and helpfully assume a pose. Wildlife photography, even of captive wildlife, requires waiting and a sense of timing.

That's true of any animate subject. Facial expressions, body language, and interactions happen on their own schedule. Joe used the same long lens, and patience, to get the image in Figure 8.2., of two primates interacting. The crop is close, and the visual center of the action is slightly off-center. The angle of the faces, the line of the arm on the right, and the limited tonal range all serve to focus the composition on the interaction.

**Figure 8.2**
Timing was the key to capturing the interaction between the two animals in this picture.
(Photograph by Joe McBroom.)

# People-Watching and Watching People

A SENSE OF TIMING AND knowing when to press the shutter is equally important when photographing people. Even in posed portraits, we want a natural expression, rather than a forced smile. My approach is to be as unobtrusive as possible, keep a ready finger on the shutter, and not press it until the subjects relax. All of the other details—lighting, exposure, focus, and composition—should be already in place. Nikki McLeod's timing was perfect when she captured the couple in Figure 8.3. The picture was taken during a quiet moment on their wedding day. Nikki used available light and a telephoto lens to record the scene. Her processing of the image punched up the color and contrast, but retained a soft look with some selective Gaussian blur during processing.

Nikki chose to let the dark-colored ("coloured" for Nikki's UK benefit!) elements tend toward black, contrasting with the warm skin tones and rich creamy texture of the bride's dress. The picture in Figure 8.4 also centers on two people, and relies on timing rather than posing for its allure. Nikki was shooting with her lens wide open and using an ISO of 1000 with a 70mm lens. (The same as a 105mm moderate telephoto on a full frame sensor.) The tight framing, a blurred background, and way the woman is facing the child, bring the viewer's attention to the baby's expression. The low-contrast lighting, with its dominant gray tones, matches the baby's expression.

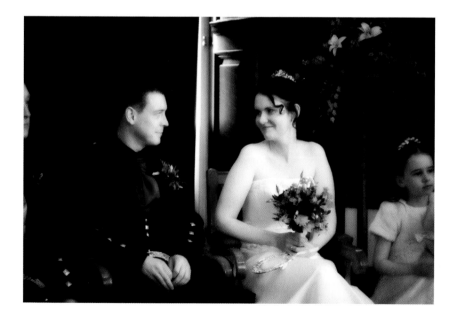

**Figure 8.3**
The combination of high contrast, the locations of light and dark areas, and the couple's expressions complement each other in this charming look at a couple on their wedding day. (Photograph by Nikki McLeod.)

**Figure 8.4**
The faces tell the story, and the photographer cropped close to remove any distractions. (Photograph by Nikki McLeod.)

The situation in Figure 8.5 was a bit more contrived. I suggested the whittling activity (in fact, it's my knife). We were in open shade, with a little light coming in from the right side of the picture. Giving your subjects something else to do takes their minds off the camera. That results in a more natural expression. It's easier if they can engage in their own conversation as well.

**Figure 8.5**
Having something to do besides pose makes it easier for your subjects to relax and forget about the camera. (Photograph by James Karney.)

The whittling gave them both something to look at, which was part of the plan. The natural pose fell into place, with the couple facing into the picture and toward each other. The visual triangle created by the matching three-quarter pose of the faces and the hands balances the central composition. I used a normal lens wide open at f/2.8 to blur the background slightly, and stood about two feet higher than the couple, so that the camera's perspective looked down at the man's hands.

There is nothing indirect about the gaze of the subject in Figure 8.6. Grame Ewart used high contrast and a camera angle at the same level as the subject to create a simple, strong character study. The bright skin tones of the face float in the center of the picture, framed by the hood and the dark shadows. He used a telephoto lens with a narrow 15-degree angle of view and an exposure of 1/30th of a second at f/9.

The picture makes use of local color contrast in the center of the image, with light skin tones offset by the eyes and lips. Coupled with the gaze, the viewer is immediately visually engaged with the subject.

**Figure 8.6**
The direct gaze of the subject and high color contrast add impact to this portrait. (Photograph by Grame Ewart.)

# Perspective as a Point of View

L ET'S LOOK A BIT CLOSER at how lens selection, combined with the camera angle and position, affects composition. We'll compare three landscapes by Gary Todoroff. The first scene is a wide-angle view, with the camera aligned to place the visual horizon (the place where the sky and ground come together) near the middle of the frame.

The cloudy sky, dark river, white snow, and dark trees in Figure 8.7 form alternating triangular shapes pointing toward each other in the center of the picture. (Depending on the angle of the sun, a Polaroid filter would provide outstanding control over the reflections in the water and how deep the blue in the sky appeared.) Gary used color contrast and the intersection of the lines to make this picture an exception to the rule that calls a balanced horizon "static." The exposure was set to hold tone in the snow, and to allow the river to go dark.

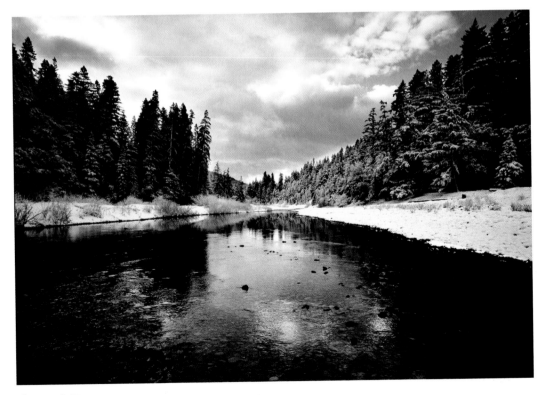

**Figure 8.7**
All of the angles in this picture converge in the center of the frame. (Photograph by Gary Todoroff.)

The emphasis is on the vertical in Figure 8.8. It too uses a wide-angle perspective, angled up to take in all of the flowers, and to imply the height of the redwood that serves as the backdrop to the flowering rhododendron. Gary also chose the vertical camera position to place the plant into shade, boosting the saturation of its colors, and to use the dappled sunlight on the right side of the tree as an accent light.

The seascape in Figure 8.9 combines camera angle and exposure to impart both mood and motion to the composition. Here the camera was also positioned low, but tilted to place the horizon close to the top of the frame and include more of the ocean in the picture. The exposure is indexed to keep the hazy look of the day and leave the rock in the distance slightly obscured.

A slow shutter speed was used to blur the waves and add a sense of motion and softness to the surface. The blue cast, with a touch of sunlight filtering through the clouds, gives the image a wintery mood.

**Figure 8.8**
The low camera angle and a vertical tilt work to capture the flowers and indicate the height of the redwood tree. (Photograph by Gary Todoroff.)

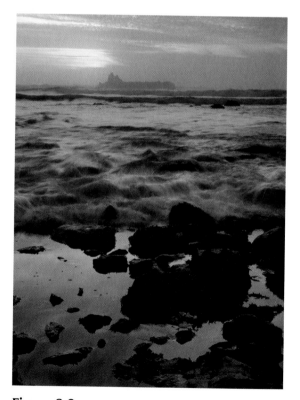

**Figure 8.9**
The high horizon and a slow shutter speed emphasize the sense of the sea in this picture. (Photograph by Gary Todoroff.)

# Low Key, High Key, and Points In-Between

PICTURES ARE TAKEN, photographs are made. The distinction lies in the ability of the person capturing the image to control the process, and so the results. The exposure settings we choose and the way we use light give us control over the relationship between light and dark tones. Figure 8.10 is a picture that looks like a still from a *film noir* mystery movie. It's dark, with rich blacks and high contrast—at the lower end of the tonal scale. The skin tones are well-defined, but there are few, if any, highlights. That's a very traditional low-key result. There is one light source and the exposure was indexed (keyed) on the lower range of the scale.

The exposure was f/2.8 at 1/20th of a second at ISO 800. That's about the level for a 75-watt light bulb in a typical room. The source was narrow and aimed to fall on the woman's face, while brushing the side of her companion, a spotlight effect. There is a highlight on her forehead, indicating the primary aiming point. The lighting was designed to leave the walls totally in shadow.

**Figure 8.10**
A single light source and a low-key exposure were used to create this dark, high-contrast effect. (Photograph by TriCoast Photography.)

High-key produces bright low-contrast images with little or no shadows. Care has to be taken to avoid washing out the upper end of the highlights when choosing an exposure. Broad light sources and light-colored clothing tend to work best with this technique, The TriCoast photo in Figure 8.11 was taken on the beach, with lots of fill from the light-colored sand. The couple was wearing white and khaki clothing.

The picture in Figure 8.12 was taken indoors. I used a room with white walls and ceiling, plus a large white reflector panel and white floor covering to create a "tent" effect. Then I bounced the lights off those surfaces to create an even, soft light. The color image was reduced to black and white and sepia-toned in Photoshop, after masking the eyes to retain their blue color.

**Figure 8.11**
High-key photos are brightly-lit, with low contrast. (Photograph by TriCoast Photography.)

**Figure 8.12**
This high-key portrait was lit by surrounding the girl with light bounced off white surfaces to produce soft, almost shadowless light. (Photograph by James Karney.)

## Not Quite So Extreme

We don't have to push high-key and low-key effects to the limit. Exposure and lighting in photography are like heat and spices in cooking. The results are adjusted to taste, and are almost infinitely variable. Figure 8.13 uses an exposure and lighting combination that approaches high key, but that retains some shadows. The scene is composed of predominantly light-colored objects, and plenty of light. White walls can be used to reflect light into the shadows, as can fill flash. The exposure was set high enough to turn the lightest portions of the man's shirt pure white.

When working close to the edge of tonal range, high or low key, it's a good idea to check the results in your camera's preview and make sure that the picture holds enough detail in important highlights. Notice how the couple was positioned against the background and in relation to the pillars. The colors shift in perspective as the walkway recedes, and the colored panels in the ceiling all to the composition.

**Figure 8.13**
This scene uses the basics of high-key technique, but the selected exposure allows some shadows to remain. (Photograph by TriCoast Photography.)

## Controlling Shadows and Contrast

High key and low key are fine, but most of the time we want good tonal range in our pictures. Moderate contrast, and detail in most of the shadows, look more natural. Available light conditions don't always cooperate, and that's when we turn to fill light. I keep a flash unit in my bag, and often on my camera, in bright sun as well as indoors. It comes in handy, even for "grab shots" on vacation, as the following examples show.

The pictures in Figures 8.14 and 8.15 were taken from the same camera position, one minute apart, as my daughters and I waited for a cave tour to begin. Figure 8.14 shows two of them reading in front of a window. The sky outside is bright, and the alcove we were in was lit only by the window. They were backlit, with their faces and the booklet shadowed in deep shade.

I used a slightly wide-angle lens (38mm on a full frame) and brought the camera close to their eye level. The exposure was set to 1/180th of a second at f/11 with an ISO of 100. That's close to the outdoor setting; I set my flash about one stop less. The fill flash brightens up the scene to eliminate almost all the shadows, but also enough to keep the brighter highlights on the dark wood and keep the picture from having the harsh shadows of direct flash.

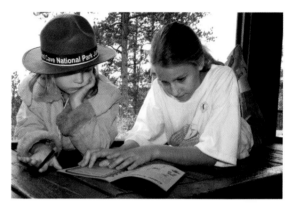

**Figure 8.14**
Balanced fill flash gives a much more natural look with better shadow detail than direct flash. (Photograph by James Karney.)

My other daughter was standing next to me, with her face turned toward the window at almost a 45-degree angle. The light was much softer. I turned off the flash and adjusted the exposure to 1/90th of a second at f/5. The shadow on the side of her face in Figure 8.15 gives an idea of how much fill was required for the picture of her sisters. Without the flash, I would have had to open the f/stop and lose the depth of field, or slow the shutter and risk camera shake to capture the backlit image of them reading in the windowsill.

**Figure 8.15**
This picture was taken next to the window in Figure 8.14, without the use of flash. (Photograph by James Karney.)

I dropped down to line up the spotlight and to bring the camera to the subject's eye level for a more natural perspective. This also ensured a dark background. The exposure was 1/40th of a second at f/3.5 with an ISO of 500.

Balancing multiple light sources may sound complicated, but with a little practice and observation it becomes easy. The improvement in your pictures will be very noticeable. The human eye can distinguish a one-stop difference in light levels, and that's close enough for the job of evaluating relative exposures. For this picture, there was originally too much shadow on the actor's face, and the spotlight was too bright. I keep a flash on the camera at all times when shooting theater work on or backstage. So all I had to do was turn it on and choose the output values and exposure. My DSLR has a control that lets me set the flash level without taking my eye off the viewfinder. That makes adjusting the exposure really quick. I did have to tweak the white balance later, since the spot, the stage light, and my flash didn't have the same color temperature. When shooting in mixed light I always capture in RAW format.

Direct flash doesn't have to produce harsh shadows if you carefully set the exposure and have a reasonable level of available light to work with. The picture in Figure 8.16 was taken during rehearsals and set-build for a play. I used a combination of flash, two available light sources, and camera angle to model the subject against the dark unlit theater. The exposure was set to keep the spotlight angling down brighter than the flash—an instant hair light! The flash is the main light, about one stop below the intensity of the spot. The remaining stage light, including the bounce from the spot on the floor, served as a fill.

**Figure 8.16**
Balancing flash with available light avoids dark shadows and improves contrast. (Photograph by James Karney.)

## Another Three-Point Lighting Example

Three-point lighting dramatically improves the ability to produce visually appealing images. This is because you can use the secondary lights to modify the darkness of shadows (fill lighting) and/or add highlights by including a light stronger than the light used to index the exposure.

Creatively mixing available light and flash is easier when you can choose the location and position your subject. That's exactly what was done in Figure 8.17, by Mike Fulton and Cody Clinton, to create similar lighting during a portrait session.

The key light in this picture was the flash. It is called the key light because it is the one used to determine the exposure, not because it is the brightest light. There may be other light sources in the scene that are brighter or darker. In this case it was set to be less powerful than the late afternoon sun, which accents the veil and does double duty as a rim light on the side of the gown. The indirect sky light serves as the fill. If your camera has a spot-meter function, it can be used to speed the process of finding the right exposure. Meter the existing light level of something in the scene that is receiving average light—like the woman's face. Then measure the highlight area. (Allow for the difference in color if one object is darker than the other.) Use an exposure between the two for your main exposure. The closer the exposure is to shade (the fill) the more faint the shadows will be, and the closer to the highlights, the darker the shadows will be.

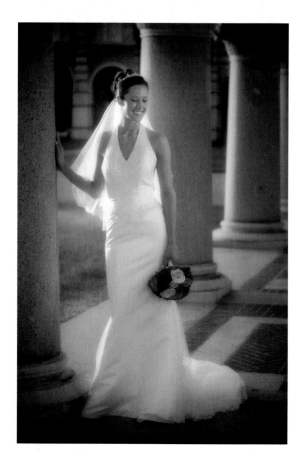

**Figure 8.17**
Three-point lighting, with sun, shade, and flash, combined with careful positioning and exposure, produced this dramatic result. (Photograph by TriCoast Photography.)

# Working in Available Dark

AVAILABLE DARK IS THE TERM many photographers use for a scene that is on the edge of the ability to record any image at all. At its extreme, you need a slow shutter speed, wide-open lens, a steady brace or tripod, and all the ISO the camera provides. That usually means a range beyond the normal ISO. Some manufacturers call it high and don't provide an actual number, because it is beyond the ability of the sensor to record an image without excessive sensor noise. That can erode fine detail and produce poor (or nonexistent) shadow and highlight detail. Not to mention that low light levels tend to produce black shadows and high-contrast images.

Newer high-end DSLRs have incredibly powerful sensors, able to go far beyond the light-gathering ability of film or of the DLSRs of a few years ago. Figure 8.18a shows a picture from a dance program taken in dim, very reddish light. It was a test to see just how far the sensor could be pushed in low light. The exposure was 1/3rd of a second at f/2.8 with a metered ISO speed of 6400 on a camera with a top ISO number of 1600, and two additional steps (about 6400) in its special modes. The original color image showed large clusters of grain, even after using noise-reduction software; an enlarged section of the results are shown as Figure 8.15b. The lower-left portion is part of the dancer's costume and her raised knee.

**Figures 8.18a and 8.18b**
The black-and-white photograph on the left was taken in low light at an extreme ISO setting. It has been converted to black and white and subjected to noise reduction. The color section is an enlarged part of the color image after the primary noise reduction. (Photograph by James Karney.)

New cameras offer much faster ISO ratings and have much better noise control than early models. If you plan on doing a lot of low-level-light photography, one might be a good investment, as well as fast lenses. Even with the advanced models, reciprocity is still a factor that has to be considered. As the light level goes down, we have to increase the shutter speed and/or increase the lens opening to provide a longer exposure.

The sensor is designed to work optimally through a typical range of shutter speeds. At very slow speeds, the sensor does get the full benefit of the additional time. It's sort like a person doing pull-ups. At some point the arms tire and efficiency drops. Long shutter speeds may require an extra percentage added to the time to get the same practical exposure. You may want to run some tests (that's what I was doing when the picture in Figure 8.15a was made) before taking pictures of an important event that requires exposures of over one second. Your manual might suggest compensation factors.

David Edmondson's night skyline of Edinburgh, Scotland (see Figure 8.19) was taken with a Nikon D200, the replacement model to the Nikon D100 I used for the dance performance. There is some noise in the shadows, but the results show the improving quality of DSLR sensor technology, and indicate how different subjects and light levels produce different results. The exposure was 30 seconds at f/22 with an ISO of 200. The lower ISO number was also a factor in the improved resolution seen in his image. I needed a faster shutter speed to record the dancers in Figure 8.18a.

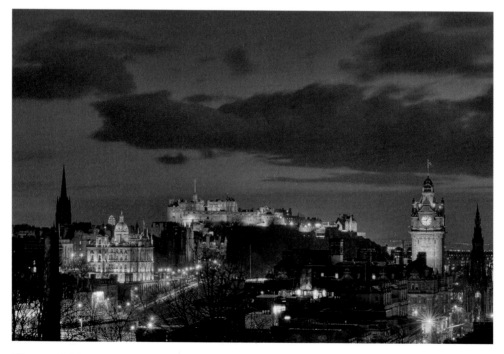

**Figure 8.19**
This night skyline was taken with an exposure of 30 seconds at f/22. (Photograph by David Edmondson.)

## Low-Light Exposure Guidelines

There are interesting subjects in the world of available dark—fireworks, moon-lit landscapes, stars through a telescope, meteor showers, etc. With a long shutter speed you can turn car lights and roads at night into ribbons of light, and make firework displays (like the one in the photograph by by Bob Cieszenski in Figure 8.20) fill the sky. The full moon turns night into noon with a 10-minute exposure. A shorter interval can make for interesting pictures of the moon shining on snow.

Bob chose his location carefully, and left the shutter open long enough to record several fireworks bursts. You can see how the slow speed allowed some of the smoke from other explosions to be visible. Fireworks and street lights are bright. If either of those are your subjects, the f/stop can be used to determine the exposure. For fireworks, f/8 with an ISO of 400 is a good starting point. Fine-tune as needed.

Street lights vary in intensity and number. The Las Vegas strip at 2 AM will be a lot different from a small town at 9 PM. Either way, it's a good idea to follow David Edmondson's example. Use the lowest ISO possible for the shutter speed you need to stop the motion, and adjust the ISO accordingly. He wasn't worried about speed, and the f/stop with a 30-second shutter opening. allowed him to close the lens down for maximum depth of field.

Keep in mind that light pollution with longer exposures may make the sky look brighter. That may require adjustments. A few trial shots are a good idea.

Robert McCabe (www.fotosharp.com) offers a collection of very-well-done laminated cards covering low-light exposure settings and a host of other photography "cheat sheets." If you plan of going out in inclement weather, check out his inexpensive rain covers, too.

**Figure 8.20**
Fireworks can be made to fill the sky with the right combination of long exposure and camera location. (Photograph by Robert Cieszenski.)

# The Art and Practice of Self-Assignment

THE BEST WAY TO NOT ONLY learn but to improve your picture-taking ability is by taking photographs. While you can just carry a camera and look for good subjects, developing a habit of regular self-assignments is a great tool. You don't have to travel far or find dramatic scenes. In fact, sometimes focusing on one lens or focal length and finding 10 pictures in a single room or your yard is very worthwhile.

When I was a medical photographer, I carried a small 35mm rangefinder on my belt and looked for street scenes. When I was a newspaper photographer, I trekked the woods with a large-format camera, an SLR, and a tripod. Each trip had a theme—waterfalls, flowers, close-ups, etc.

I'd like to close with a look at five images by Geoff Cronje that show what a good self-assignment can generate. They show how vision and a sense of discovery are important parts of the photographer's arsenal. Figure 8.21 sets the stage. We're in a rail yard in the morning and Geoff's first subjects are a worker, a train, and the yard itself. The low camera angle with the direct line of tracks, the steam rising from the engine and the cars in the background, and the variable shade and sun for lighting all work to give the feeling of the steady bustle of the scene. There is just enough color contrast, combined with the color of man pushing the wheelbarrow's outfit and his being in sharp focus, to make him the center of the scene. The exposure was 1/80th of a second at f/2.0 with an ISO of 200. Geoff used a telephoto lens to help create the perspective and reduce the depth of field.

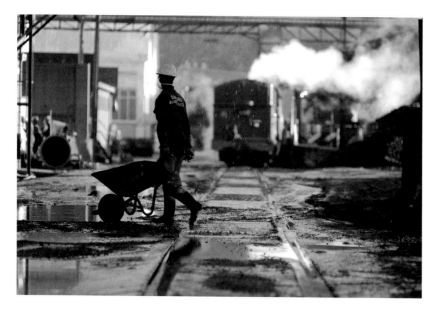

**Figure 8.21**
Focus, color contrast, movement, and lighting all combine to set the mood on this picture. (Photograph by Geoff Cronje.)

The sense of mood, place, and story being told continue with the second image, with a picture of a man, his machine, and a short break from the day's routine (see Figure 8.22). The sky is overcast; the cool tone matches the neutral colors of the engine, the smoke, and the personal isolation of the man. A normal lens and the somewhat lowered camera position increase the visual statement. The exposure was 1/25th of a second at f/5.6 with an ISO of 320.

The image in Figure 8.23 is very similar to one we saw in Figure 7.2, in the last chapter, of the same subject. The difference between the two is a slower shutter speed. Geoff closed down the lens and chose a speed that would blur the movements of the fire tender. The man held still for enough of the exposure interval to record his face clearly amongst the blur. He is rocking back and forth, and his legs are clear in sharp focus. The image is designed to show how quickly and intently the man is working.

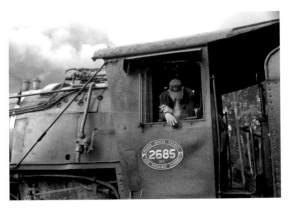

**Figure 8.22**
Good timing helped create this study of a quiet moment. (Photograph by Geoff Cronje.)

**Figure 8.23**
A slow shutter speed was used to underscore the motion of the man stoking the fire. (Photograph by Geoff Cronje.)

The next image, shown in Figure 8.24, is in the same location, on the same day, but without any people. This is a study in shapes, light, and shadow, and the effective use of slight color contrast and of working with deep shadow. The picture was taken with a moderate telephoto and a narrow aperture.

The angle of the subject to the lens allows the entire scene to stay in an acceptable focus, while causing a slight reduction in visual size as the wheels recede from the camera. The center of focus is the brake of the closest wheel, and the soft light combines with color and shadow to emphasize the texture and rough surface of the metal. The repeating lines and alternating patterns of light and dark balance the composition.

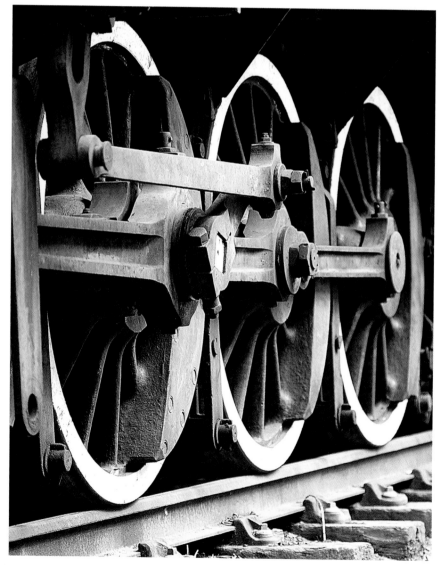

**Figure 8.24**

This picture is a simple, yet effective study of light and dark, texture, and straight and angled lines. (Photograph by Geoff Cronje.)

The final picture, shown in Figure 8.25, was taken on another day by the same photographer. It is another simple study in contrast. Note the straight and unbroken lines of the window frame, the broken pebbled glass, the patterns of light and shadow, and the black and colored sections of the wall in the back. A different sky, a different time of day, and the picture would have not looked the same. It relies on the pattern and angle of the light to reveal the tone and texture we see.

It also required the ability of the photographer to see the lines, understand the light, craft the composition, and choose the camera technique to create it. Every time we use our cameras with the intention of really making a photograph, not simply taking a picture, we improve our ability to see and record the world around us with a photographer's vision and a style we can call our own.

**Figure 8.25**
This still life offers a study in texture, and the interplay of lines, light, and shadow. (Photograph by Geoff Cronje)

**Figure 9.1a** A symbolic detail of an important day. (Exposure 1/30th of a second at f/2.8, ISO 100. Photograph by James Karney.)

# A Day in the Life: Telling Stories with Pictures

**9**

W E PRIZE PICTURES FOR THE MEMORIES they let us preserve and share. Most photography is of an event; examples range in duration from a child's play session to an around-the-world trip. The right collection of pictures can be woven into a slideshow, an album, or a scrapbook that truly captures the spirit of an event. Thus far in this book, we've focused our attention on technical photographic skills, the "how" of taking individual pictures; now we turn to the camera as a story-teller.

This chapter examines how to plan your session and photograph an event—how to work with your subject and adapt to changing situations. The same basic approach can be used for any situation—for example, a play, graduation day, school activities, work, vacation, or a team's sports season—the events of our lives. This kind of picture-taking is called *photojournalism*. Its ever-changing demands make it one of the most challenging and rewarding uses of the camera. The resulting pictures can be transformed into an album or a multimedia slideshow and shared.

**Figure 9.1b**
The precise moment of exposure and the right point of view are important tools when telling a story in pictures. (Exposure 1/20th of a second at f/4, ISO 320)

# A Wealth of Picture Possibilities

WE'LL FOLLOW A PHOTOGRAPHER (me) and his subjects though a very full wedding day that started at 7:30 in the morning and lasted until 11 P.M. that night. (Since I took all the images, let's skip the photo credits for this chapter.) Weddings are one of the most challenging photographic events, and provide an excellent topic for reviewing all the camera skills presented in earlier chapters. This one was an outdoor wedding with an indoor reception, and the event lasted from morning till almost midnight. Along the way I'll explain how each situation was managed, discuss the way the pictures were chosen, and offer tips on technique. You should already understand the basics of camera handling, exposure, using flash, and working with different lenses to get the most from the material.

The first two pictures are a good example of the range of photographic possibilities at almost any event. Figures 9.1a and 9.1b were taken just a few minutes apart, as the bride was getting ready. The same camera was used, but with two very different approaches. The gown in the window is a still life, and the camera was mounted on a tripod. Time was taken to carefully adjust the composition, and set up the lighting conditions. I bracketed the exposure, taking several pictures with varying shutter speeds at the same f/stop. I wanted the gown to be translucent, framed in the dark drapes, and the toned rendition was planned from the very beginning.

The picture of the bride donning her gown was planned—but not posed. As with most of the day's events, there was only one chance to get the picture. I'd already manually adjusted the exposure and had carefully chosen where to stand. My total concentration was devoted to pressing the shutter at the precise moment that the composition and her expression were just right. We'll come back to both pictures in more detail later. First we need to talk about preparation.

# Getting Ready (Photographer and Subject)

PHOTOJOURNALISM HAS ALWAYS been my favorite photographic discipline. To really succeed, it demands a dual focus. Part of your attention is tuned to the unfolding event; and another part evaluates and takes advantage of the photographic possibilities it presents. To succeed, you (and your equipment) have to be ready. The image in Figure 9.2 was taken while following the bride to the chapel. It was an unexpected opportunity.

It's always a good idea to plan and prepare before any photographic adventure. That's even more important when the subject is a fleeting event that cannot be repeated. Packing your gear is more than just putting items into the bag. In many ways recording an event for a photo-essay is a lot like writing a story. You want to make sure that all of the important activities are covered, and that the important people (or pets, places, etc.) and their roles are fully explored.

If you know your subject well—say, it's one of your children, or an event you regularly attend—then personal understanding may suffice. If the situation, location, or primary subjects are new to you, then some research is in order. I've photographed weddings for several decades, so the basics are second nature; even so, getting to know the specific details for each event is still important.

It's always important to look over your available equipment and consider the conditions you'll encounter. The type and amount of gear available will have an impact on how you take the pictures, but remember that every photograph ever made was created with just a camera and a single lens. Think about the lighting situations and the type of action you'll have to deal with during the project.

**Figure 9.2**
This image was not part of the planned set of images. It's wise to always be ready to take a picture at any time during an event.

Your DSLR is the basic item of photographic equipment. Be sure that it is working properly and that you have enough battery power and memory cards for it. I double-check the camera settings when packing, and again when unpacking on location. Locate the power sources for any gadgets that need them: camera, flash units, meters, wireless gadgets, etc. Is everything working?

## Warming-Up Exercises

This was an outdoor afternoon wedding with an indoor reception in the evening. The range of settings, coupled with a lively couple and their families and friends, provided lots of challenges —and opportunities for great pictures. An early arrival at breakfast time allowed taking pictures of the location, people getting ready, and putting them at ease with my presence and being photographed.

Figure 9.3 shows the wedding site at mid-morning. A cloudless sky and bright sun make for a high-contrast situation. Careful attention to exposure, and using fill flash, will be required to keep detail in the wedding gown—without the participants looking like raccoons because of shadows around their eyes. Right now (8 A.M.) the sun is coming from the back right (north east) of the scene. The ceremony will take place in mid-afternoon, and the sun will be in the south east.

Notice the blue sky; that's produced by manual exposure. The in-camera meter produced a washed-out sky, with blown highlights on the tops of the white chairs. Imagine what would have happened with a white bridal gown in full mid-day sun! Remember how a blue sky is 18 percent gray? I spot-metered the sky, then adjusted that result to obtain the desired effect. I used the 17mm lens wide open to render the lake and woods slightly out of focus. The final setting was f2.8 at 1/5000th of a second using ISO 100.

**Figure 9.3**
Photojournalism requires planning and adapting to the situation, much the same way the staff of the bed and breakfast had to prepare for this wedding.

Then I moved inside, examined the reception rooms, and determined the lighting and lenses needed for the reception. The dinner portion of the affair was going to be during daylight as well. Figure 9.4 shows part of the room. The condition was sort of open shade, but with some illumination from overhead lights. Again I had to deal with shadows, but the contrast was not as great. I planned to use fill flash again, but with less power. When the flash is too bright, it makes the pictures look unnatural. An Expodisc was used to set a custom light balance, which was stored in the camera's memory for later.

With preparations and planning complete, I joined the bride and her attendants and started taking people pictures.

The dancing portion of the program didn't start until after sunset, and required more light, a higher ISO value, and a faster shutter speed. So I planned to use flash as the dominant source. We'll save exploring the settings and shooting techniques for when we have live subjects in the pictures. Now, it's time to look at taking people pictures.

**Figure 9.4**
The reception was an indoor event, with different lighting conditions and space constraints, and so required additional planning.

# Never Say Smile!

HAIR-STYLING AND MAKEUP application were just starting at Whitestone Inn, a bed-and-breakfast dedicated to hosting weddings, when I joined the bridal party as they were getting ready. The dressing area included several rooms, and all were brightly lit with overhead fluorescent fixtures. The picture in Figure 9.5 was taken at about 8:15. (I'll include times so you can follow the flow of the day and lighting conditions.) I decided to use available light as the main illumination, with off-camera fill flash to reduce the shadows under the eyes without having to worry about red-eye. That required an accessory cable to connect the strobe to the DSLR's hot shoe.

A couple of quick test exposures showed that I could rely on the automatic functions on the advanced fill-flash system. The exposure info for the picture of the bride with her mother and sister was 1/30th of a second at f2.8, ISO 100, made with a 17-55mm zoom at 38mm. That's a normal angle of view, allowing me to crop close without any visible wide-angle distortion. I did have to adjust my white balance to compensate for mixing the somewhat green fluorescent lights with the sunlight-balanced flash unit. I used the Expodisc again. Another option is to place a color-compensating filter over the flash which adds a bit of green to match the strobe's color temperature to the overhead lighting.

**Figure 9.5**
The wise photographer lets his subjects have fun and avoids the word "smile," as in this casual portrait of sister, mother, and bride.

This picture was requested by the group. I asked them to get close, and then we chatted as I took the picture—avoiding the use of the word "smile." We joked a little bit as several exposures were made. Most people can't produce a natural smile on demand, and asking directly for one during a session usually results in a stiff grin. Not exactly what a photographer wants.

Allow some time, and take some pictures to warm up your subjects. Most people start out being self-conscious, but that usually fades as they get used to the camera. Casual discussion with a little direction works well. I often ask the subjects in group pictures to stand closer together, because the normal personal space between people looks large in the pictures. In Figure 9.6 the family was cutting up, so a request for a hug and a quick joke produced the desired result.

Some people are very shy, and will continue to avoid the lens or look stiff. The best approach with them is often to be as unobtrusive as possible, or make it seem that someone else is the focus of your attentions. In some cases, playing especially with them, and taking time to warm them up—even letting them photograph you—works well.

The two pictures shown in Figures 9.6 and 9.7 were both taken in the mirror. Once again, an off-camera flash was used to boost the light level and reduce shadows. The only change in the camera settings was zooming in from 38mm to 55mm, producing a slight telephoto effect. Both pictures were framed, and my position was chosen, to reduce the depth of field and render the non-essential parts of the composition slightly out of focus.

The first picture is cropped tightly, focusing on the subject's face. I moved my shooting position to eliminate the sight of anyone else in the picture. The second image shows more of the room and the other people getting ready. An on-going dialog with the bridesmaid produced an active expression.

**Figure 9.6**
Using a mirror to get more direct a point of view.

Direct flash doesn't get along well with mirrors; it usually produces a washed-out reflection, and often casts unusual shadows. I shifted to bounce flash for the mirror pictures, holding the unit close to the ceiling to boost the light in the room. My strobe comes with a plastic dome accessory to diffuse the beam and soften shadows. I placed that on the unit before taking these images. Be very careful around mirrors and windows that can add reflections of your flash to the picture. Repositioning the flash is a lot easier than editing the image later.

It's easy to get tunnel vision when photographing people. We are shooting and closely watching only the subject. The background is easy to ignore. The key is to check the viewfinder and move around. Just a slight shift in angle or position can make a major difference in the composition and the angle of light. Since there isn't any cost (unless you are short on memory space) to making several exposures, it's a good idea to experiment. Also watch out for placing your own reflection or the flash in the picture. See Figure 9.7.

The printed image of Figure 9.7 in the book may not show the slight warm color cast compared to the preceding two figures. It's obvious on my monitor. The cause is a tungsten make-up light near the mirror. That makes three light sources (tungsten, fluorescent, and flash). It was easy to adjust in editing, and not really very noticeable unless compared to an image with proper color balance. The unedited version shows us that we need to keep an eye on changing lighting conditions and adjust settings to avoid extra work (and sometimes, we can't later remove color casts completely from mixed-source environments).

**Figure 9.7**
Your subject can see you in the mirror and interact. Keep an eye on the background; it's part of the composition.

# Details, Details, Details

**M**OST OF THE ACTION at an event tends to be focused on the people, but don't overlook inanimate objects and details that can add to your story-telling when it comes time to craft an album or slide show. The make-up collection in Figure 9.8 is one example of an image taken with slide usage in mind. This image was made while the women were getting ready. The subject has color, is easily identified as a part of the event, and lends itself to use as a title slide just by adding captions.

Most human activities offer similar iconic elements for "detail pictures." What comes to mind with bats, balls, and gloves lined up; dance shoes; theatrical props; or ice cream, cake, and candles? Keep an eye out for such items, and consider shooting them by themselves or with a portion of a person in the image. Hands lacing shoes, working a ball into a catcher's mitt, or wrapping presents can add flavor to your show or scrapbook collection.

When an event has several stages, look for "detail pictures" that can serve as markers for a transition from one phase to another. Figure 9.9 features part of the dinner setting for the bride and groom. Here we have an element that not only has recognizable items, but has items that are also personalized for the couple and the day.

**Figure 9.8**
Small details can help tell the big picture, especially if you are planning an album or slide show.

**Figure 9.9**
This black-and-white composition uses a blend of tones and textures to make its point.

This picture was taken with a 105mm macro lens, making it easy to keep the drapes behind the setting out of focus. The camera was angled a bit to get both the glasses and the placeholders sharply in focus. The exposure was 1/80th of a second at f/4, with an ISO of 100. The exposure was manually set to hold good detail in the white linen, and let the medium-colored fabric behind "go dark." I used a small amount of fill flash to put some sparkle on the glasses. The settings had been placed the evening before by the B&B staff, and the picture was taken early in the morning. When people start arriving, your ability to take this type of picture quickly fades.

At first glance Figure 9.10 looks like a monochrome image, but it's really in full color. Notice the purple sheen on the ribbon and the colors in the stems in the background. These were gift decorations placed on a table near the entry to the reception area. This image was also made early in the day.

**Figure 9.10**
Tight depth of field and just a bit of color makes this shot a good candidate for an album background image.

This composition lends itself to serving as a page background for several images in an album, or a title slide in a multimedia show. The basic exposure was identical to the one used for Figure 9.9: 1/80th of a second at f/4, ISO 100: (again with a manual setting). Here the strobe was brought around and to the back to create the highlights seen in the sheer ribbon. The 105mm macro lens let me close in on the composition, but made for a very shallow depth of field. I made several exposures to obtain one that had just the right pleasing highlights and sharp areas.

There is another lesson to learn from this discussion. Mentally editing your work, and looking for new story elements, are just as much keys to success as are your photographic skills when you are creating a photographic essay. There are certain moments that are "must-haves." At a wedding, these include the arrival of the bride, the exchange of vows and rings, the first kiss, cutting the cake, the bouquet toss, and the grand exit. There are other touchstones not as easy to define, but that the photographer has to be sensitive enough to capture, and that require thought and attention to what is going on in every moment.

At one wedding I photographed, the bride had just finished getting ready, and a white-haired gentleman was ushered in. This was her mentor from years before. Being ready, I quickly captured both of their expressions as she recognized him and they hugged. Being ready also requires a firm knowledge of your equipment and the proper configurations to meet changing conditions. Adjusting your camera settings while you walk from one set of lighting conditions to another is a very useful habit. Knowing when to trust the meter, and when it is likely to fool you is another. Basic skills coupled with attention to details are the keys to getting good pictures.

# A Matter of Perspective: The Guys Getting Ready

AFTER THE BRIDAL PARTY finished hair and make-up, I crossed the hallway to the men's dressing rooms. The guys had only to don tuxes, so I concentrated on interactions and expressions. The light was a bit brighter here, and I continued to use an off-camera fill flash. You can see a slight shadow to right of the groom in Figure 9.11. Once again the automatic fill-flash system was used to set the flash levels, but I double-checked the results several times. When working off-camera flash, keep an eye on the angle of shadows the unit casts. The plus side is not having to worry about red-eye.

Compare the field of view used by adjusting the zoom lens and the distance from the subject between Figures 9.11 and 9.12, taken as the men were getting ready. The basic exposures are the same, the coverage is not. While working I varied the angle of view to obtain a mix of wide-angle, normal, and close-up images. Wide-angle shots give the viewer the "big picture." Figure 9.11 shows a slightly wide view, and the simple setting of the men with the rack of clothing. Figure 9.12 is a moderate angle shot of the groom. Just a hint of the other men in the group, visible in the mirror, lets the viewer see that the groom is surrounded by friends—underscoring the laughter shown in his expression.

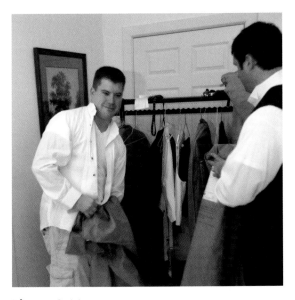

**Figure 9.11**
The groom's party getting ready offered a different set of picture possibilities.

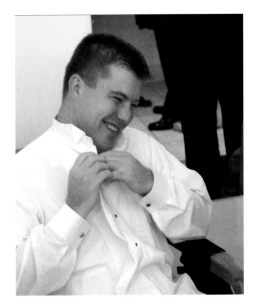

**Figure 9.12**
Some of the best expressions come when you are not part of the conversation and can become an unobtrusive observer.

## Not Quite Posed

Creativity with a camera centers on seeing possibilities and then taking advantage of opportunities as they arise. Figure 9.13 is a good example. The groomsman was looking around the door as I walked into the hallway. By the time I raised the camera he had straightened up out the door. "Do that again," I said, and pressed the shutter as his head moved into just the right position. The angle of his body, the location of the sign, and the direction he is looking are perfect for the upper right-hand corner of an album page containing pictures of the men getting ready.

This raises the issue (and the definition) of posing. Most of the pictures I take at an event are made without any direction, or even talking, on my part. That generally is the way to get the real "look" of the event and natural expressions. When needed, however, be willing to ask your subjects for assistance.

This picture was a "re-enactment." It had already happened, and I directed the subject to repeat it. In effect, it was staged. It was also totally true to the day's events. The natural look on his face is due to his being comfortable with my presence and the camera. It doesn't look forced or phony. When you are taking posed group shots, the entire scene has to be arranged. We'll cover that topic shortly.

**Figure 9.13**
Keep an eye open for interesting juxtapositions, like a groomsman under the sign saying "Men."

# Thinking in Scenes

**M**OST EVENTS CAN BE BROKEN into segments as defined by the actions of the participants, much like the scenes in a movie. Each scene tells its own story. As the event progresses, each of the scenes builds on the ones before and leads into those that follow. Good photo-essays provide a shot that visually establishes the topic and sets the stage for the remaining images, which carry the "action" in detail. The final picture in each series acts as a segue, drawing the audience into the next segment.

That was the approach I used to capture the bride donning the wedding dress, and the attention of her attendants during the process. It was one scene, and the pictures were planned to provide a sense of continuity with the rest of the day. When designing an essay it helps to consider the different elements in your story, and how they progress over time and in importance. That's why this chapter's lead picture (the edited version is shown in Figure 9.1a, and the unedited one here) was of the gown alone. It's waiting, the time not quite ready.

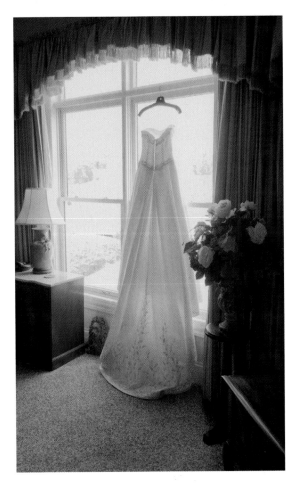

**Figure 9.14**
The unedited picture of the gown in the window shows the extreme variation in light levels between the room and the outdoors. In the final print, I removed the over-exposed area visible through the window.

Only natural light was used for this image. The exposure (f/2.8 at 1/30th of a second, ISO 100) was based on the fabric of the gown. The room had several windows, and all of the drapes were opened to provide fill light. I used a low-contrast setting to hold as much detail in the shadows as possible. Almost all the objects lit by full sun outside the window were totally washed out. The outdoor exposure was f/16 at 1/100th of second, which would have preserved all the detail seen through the windows, but left the room in shadow and made the gown too dark. During editing, I removed all of the outside objects and raised the overall contrast before I toned the image.

The image in Figure 9.1b, all the way back at the beginning of this chapter, is the pivotal moment of this part of the day. Her expression, the bridesmaids helping on both sides, and the way she emerges from the fabric, tell the essence of the story. I used a wide-angle, 12mm lens to include the two bridesmaids in the scene. Most of these pictures were taken without directing the actions of the participants in any way. The goal was to capture the natural expressions and the mood of the group as they prepared.

Available light conditions can change quickly as your subjects move. This room had three large windows on three sides. During this session I opened and closed drapes to control the amount and direction of the light. I closed the drapes on one window in Figure 9.15, the one to the camera's right. You can see that side is a bit darker than the left side of the picture, and light from the window in the back left (the window itself not visible) acts as a fill light.

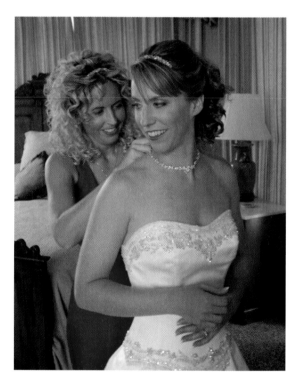

**Figure 9.15**
When the activity is moving naturally, the most important skill is being poised and ready to press the shutter. You must be aware of any need to adjust exposure and focal length.

All of the photos of the bride getting dressed were made with available light. Adding flash would have ruined the effect of the soft, even light coming in from the windows. I upped the ISO setting to 320 to obtain a workable shutter speed for the interior shots.

The image in Figure 9.15 was taken at 1/20th of a second at f/4 (the widest opening on my 12mm-24mm zoom, which was set to 28mm). As a rule of thumb, try to keep the shutter-speed value at least as fast as the focal length of the lens, unless the lens is equipped with some form of vibration reduction. (For example use at least 1/50th of a second with a 50mm lens.) With practice—when necessary—you can usually exceed that limit by one or two stops without excessive camera-shake problems.

Figure 9.16 is a group picture of the attendants behind the bride as her sister arranges the veil. The curtains on all three windows were open. Compare the illumination to that in Figure 9.14. The light falling on the women to the back of the image was brighter than the light on the bride and her sister. I had to adjust the exposure to achieve the "correct" exposure for the middle bridesmaid, and then fine-tune the image during editing.

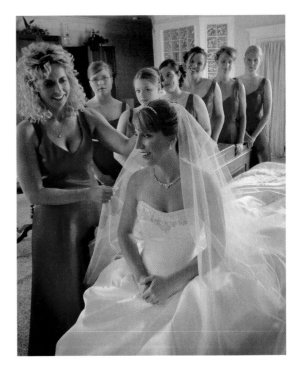

**Figure 9.16**

This image was taken from an elevated position, to arrange the heads of the attendants around the bride.

# Working All the Angles

NOW COMPARE THE CAMERA'S viewpoint in Figures 9.17 and 9.18. I was standing on a small ladder for Figure 9.16. The higher point of view raised the visual placement of the attendants' heads in the frame, so they could all be seen. I stepped down and moved in closer for the black-and-white picture in Figure 9.17. Then I adjusted my position to place the bridesmaids' faces behind the bride. I wanted the other women slightly out of focus and used the veil to frame the right side of the picture. The exposure (1/40th of a second at f/4) was indexed on the gown and the bride's face, with the main light coming in from the window to her left.

The angle that the lighting falls on your subjects is an important creative tool. The window was closer to the women in the background than to the bride. This slightly overexposed them in relation to her. That's what I wanted. That effect, combined with a shallow depth of field, makes the bride and her expression the central theme of the picture. Pointing the camera straight at the bright window also produced a bit of lens flare, softening the lighting and reducing overall contrast.

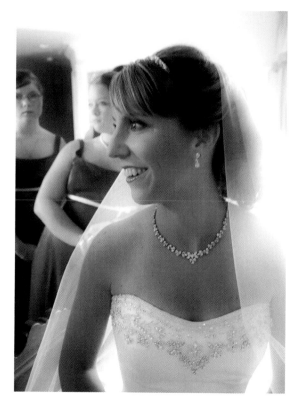

**Figure 9.17**
Moving in closer and seeing in black and white.

The bride is sitting in the same position in Figures 9.17 and 9.18, but the lighting effect is radically different between the two images. The window is a fixed source. Moving the camera changes the lighting effect because it changes the relative angle of the light on the subject, as seen from the camera's position. In Figure 9.17 the bright window light is falling on the bride's back, and is not seen on her face by the camera. When I moved to my left, the light from the open window falling on her right side becomes brighter than the available room light on her left.

The exposure (30th of a second at f/2.8) was set to just hold detail in the highlights on her left side. The zoom was set to 44mm so that the pillows in the background appeared slightly out of focus. There is also more contrast in Figure 9.18 because of the lighting ratios between the left and right sides.

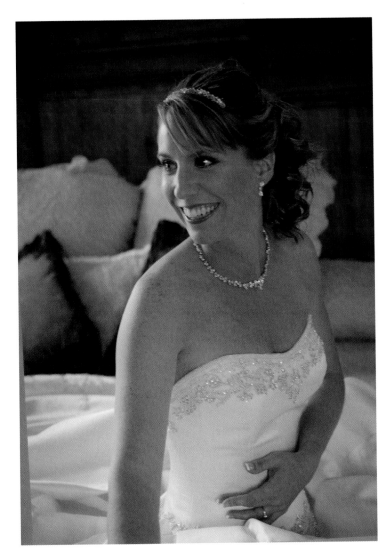

**Figure 9.18**
Simply changing the lighting angle and exposure produces a much different portrait of the bride.

# The Artful Segue

THE BRIDE IS READY, and we are on the move. I'm the first out the door, followed by the flower girl. As she walks down the stairs, I take the picture seen in Figure 9.19. This is the first of two images that segue the "getting ready" part of the event into the ceremony. This is another available-light photo, with no time to fuss with exposure, and the position and composition being dictated by the stairs and speed of the little girl. Giving her any direction would ruin her expression and natural movement.

**Figure 9.19**
The first half of our segue is a "grab-shot" taken on the stairs.

The light was coming in from the front door of the hallway, so the color balance was the same as in the open shade of the dressing room we had just left. I took a quick spot-meter reading of the little girl's face and used that (f/4 at 1/10th of a second) as my exposure and a 12mm setting on the zoom lens. The slow speed produced a bit of motion blur, most noticeable in her foot and dress. Not ideal in a formal portrait, but in keeping with the mood of a little girl on her way to an important role in the ceremony. The motion and the dress are major expressions of the segue theme, from readiness to ceremony.

Figure 9.20 is the second half of our segue. It carries the theme of motion and the dress. The picture shows the bride and her father traveling by golf cart to meet the horse-drawn carriage used for the grand entrance. She is holding on to the moving cart with one hand, and her bouquet with the other. I quickly changed the white balance to sun and adjusted my camera settings for outdoor work.

Bright sun has always been a good news/bad news situation for photographers. It provides plenty of light, but with high contrast. I wanted to hold detail in the wedding gown, so I overexposed slightly (f/20 at 1/250th of a second with an ISO of 200) to hold color and detail in the fabric, letting the shadows record totally black. That setting also allowed the sky to hold its blue color.

**Figure 9.20**
The change from indoors to full sun required a radical change in ISO, exposure, and light balance.

I used a strobe unit for fill flash. The flash was set to automatically work at an output 1 and 2/3 stops lower than the primary exposure. That ratio is a good starting point for producing natural-looking, but not dark, shadows that still have color and detail inside. Of course, that only works when you are reasonably close to your subject. You should check the results as you work.

Compare the shadows in Figures 9.20 and 9.21 to see what I mean. The flash fired in both pictures, providing fill light. The shadows under the golf cart, where the strobe couldn't reach, are black. I was standing much closer when Figure 9.21 was taken. A good thing, because a tree was casting dark shadows on the left side of the carriage and the bride. Both images were taken with the same settings. The difference is due to distance of the subject from the flash and the area of coverage.

Let's take a moment to consider composition and the art of story-telling. Composition is more than just the arrangement of objects within the picture. It is also their relevance, and relationship to each other and to the overall story. Figure 9.21 shows the bride facing the step she is about to take—literally and metaphorically. She and her father are both looking toward the waiting groom, the minister, and the rest of the wedding party. The image shows them poised on the moment of imminent action, the step of commitment into one of life's most important choices.

**Figure 9.21**
The arrival of the bride, with shadows softened with fill flash.

# Follow the Action

O F COURSE, DETAILING all the action would be worthy of a book of its own. We are just doing a survey to consider major points and highlight different techniques. At this point in the event, the focus is on the flow of the action and the emotions which come with it. As I worked to record them, the angle of the light changed. I quickly moved around to be in front of the bride and her father. The flower girl and the ring-bearer were preparing the way with rose petals. The following sequence of pictures, from Figure 9.22 to 9.24, was taken close to the subjects with a wide-angle lens (19mm) to ensure the effectiveness of the fill flash. The exposure and flash settings varied a bit as I moved closer or farther from the main subjects, but the camera's ISO setting remained at 200.

The first image in the sequence has three subjects: the little boy and girl, plus a delighted guest. The f/16 at 1/250th exposure was slightly underexposed to retain detail in the girl's dress and hold some color in the sky. I boosted the flash output to soften the shadows, even on the face of the guest, as well as the ones cast by the little couple. The direct sun was still stronger and creates highlights on my subjects' hair.

The three pictures are all centered on the intensity of the little girl in performing her task and the concern of her companion. While exposure is important, other critical elements of success in this type of picture are timing the press of the shutter, and the camera angle.

**Figure 9.22**
The intense expressions of the children make this image a winner.

Getting really good event pictures requires anticipating action and being in the right place at the right time. This sequence demanded walking backward while keeping the camera focused on the subjects and ready to take pictures.

**Figure 9.23**
The action continues as the perfect petals are selected.

**Figure 9.24**
This picture was taken 10 seconds after the preceding image. The little girl's face is now slightly shaded by the boy.

Most DSLRs have a continuous exposure mode (and sometimes more than one) that will automatically trigger the shutter at a set rate as long as the button is pressed. I keep my camera in that mode during events, and practice pressing the button to get one shot at a time. That lets me keep control, while having the camera able to respond quickly to my next request. Sometimes the action is moving fast, and I squeeze off two or three shots to ensure capturing a good expression.

The flower girl selected the petals and then started moving faster. I took three more pictures in about eight seconds. The one in Figure 9.24 had the best expression for both the children and the guests as she scattered the flowers.

Notice how her face is a bit darker than in the previous pictures. Her companion moved, casting a shadow over her face. The action was close enough to allow the fill flash to keep the overall exposure in an acceptable range. Without the extra light, the little girl's face would have been in very dark shadow—and the picture unusable. With too much fill light, the pictures would have looked artificial compared to the other images in the sequence.

When the pace picks up, the pictures come faster. Your DSLR has an internal memory buffer that can only store a limited number of frames before it is full. Then the camera will have to finishing writing the data to the storage media (CF card, etc) before it can take another picture. Be careful to keep enough buffer space available when an important activity is about to occur.

# Working with (Changing) Light

CONSIDER THE PICTURE in Figure 9.25. Working with sunlight can present challenges, even when there are no clouds in the sky. During the actual ceremony I moved several times to get a good camera position as the couple exchanged vows, took the first kiss, released doves, and made their grand exit in the carriage. The relative angle of the sun changed with each new position, and that called for dealing with changes in the lighting configuration. All of these pictures, from Figure 9.25 to Figure 9.30, were taken within 15 minutes of each other.

The sun was coming into the scene high and from the front right of the subjects at 45 degrees. That's a good angle, but produced a high-contrast situation. The ceremony was too far away and in too wide an area for the flash to cover. The available-light exposure was set to hold detail in the gown. The trade-off was dark shadows and the loss of detail in the dark clothing of the groom's party and several guests. There is also a slight blue cast in the shadow area on the bride's gown. That could theoretically have been minimized with fill-flash, but that was not possible here. I underexposed the image about a stop and a half (f/18 at 1/250th second at ISO 200).

**Figure 9.25**
Fill flash only works when your strobe unit has the power to overcome the distance to your subject and the shadows being cast. Here, distance exceeds its capability, and we see darker shadows.

The sun is at 45 degrees to the back right of the couple in Figure 9.26. That produced shadows on the faces of the bride and groom, which was reduced with fill flash. I used the camera's spot-meter function on the dress and set the exposure to f/9 at 1/250th of a second. That overexposed the groomsmen in the background and slightly washed out the blue sky, but let me hold detail in the veil. The amount of fill was adjusted to keep detail in the dress. The overall exposure was corrected during processing. (More on that topic later in the book.) There is some flare visible near the groom's right arm that was removed in the final print.

**Figure 9.26**
Moderate backlighting combined with fill flash improves shadow detail and eliminates color cast when used properly.

I moved again when it came time for the ring exchange (see Figure 9.27), and the sun was coming in at a 45-degree angle to the bride's right. I increased the amount of fill flash (using the automatic-exposure capability of the flash unit) to reduce the shadows, and at the same time dropped the overall camera exposure to avoid washing out the detail in the gown.

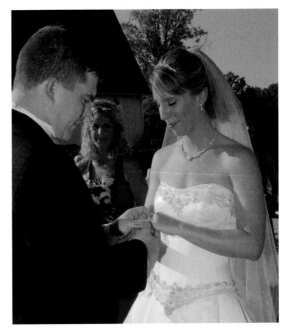

**Figure 9.27**
The ring exchange required another change in position and in the exposure settings.

You can gauge the effect of the fill light by comparing the shadow on the bride's left shoulder with how evenly her face is illuminated, and by the detail in the fabric of the groom's tuxedo. See how the shadow of her right arm grows fainter as it moves closer to the camera position? Just to be safe, I bracketed, taking several exposures for insurance. Some cameras allow you to automatically bracket your exposure and flash settings. That can be a handy feature. I use manual adjustments to prevent accidentally leaving that function enabled.

# More About Angles

CAMERA ANGLE HAS A MAJOR impact on how your primary subjects look in relation to the rest of the scene, and the viewer's sense of perspective. I actually lowered my body position for most of the pictures at the ceremony. The amount varied with the desired effect and overall conditions. In the photograph of the kiss (see Figure 9.28), I positioned myself waist-high and slightly to the left of the couple. That makes them appear taller in the frame, and raises the relative position of the best man into the upper right corner.

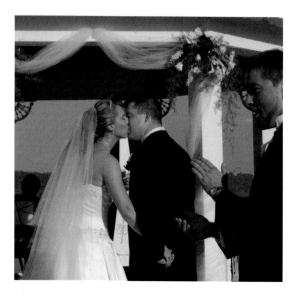

**Figure 9.28**
Kissing the bride and more changes in position and exposure.

When you change camera angles and distance, lighting and exposure change with them. Figure 9.28 has the sun in the same position as Figure 9.25—and the same primary exposure settings. The shadows are greatly reduced because the camera position was close enough to effectively use fill flash. I reduced the power of the strobe from the preceding shot of the ring exchange so that the flash would not overexpose the best man and his applause.

That was a risk, because the best man was closer to the camera than the couple. It's the same effect we saw when I pointed out the shadow of the bride's arm on her torso in the ring picture. Outdoor fill flash is an incredibility powerful tool. As such it requires practice to master. Moving around your subjects, the way I did in these pictures, is a great exercise to gain experience in using flash outdoors. Vary the distance and get a sense for the power of your light and how well the built-in metering tools work under various conditions.

Figure 9.29 was taken at f/11 at 1/250th of a second at ISO 200, about one stop more than the camera's meter reading. I used fill flash to reduce the dark shadows the "correct" exposure would have cast over the couple and the doves. That required moving in close and using a wide-angle lens to include the proud parents of the groom. Again, I lowered my position relative to the couple, but not so much that the people in the back of the audience were hidden behind the guests in the front row. The fact that the area sloped down slightly toward the front helped.

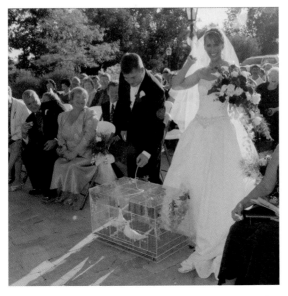

**Figure 9.29**
The combination of a wide-angle lens and backlighting from the sun often produces the lens flare seen in this picture.

The combination of bright backlighting and a wide-angle lens—especially when flash is used—is an invitation for flare. Watch for it when your light source is pointing toward the camera. You can see it in this picture in the open sky, on the groom's arm and leg, and at the bride's raised elbow. Sometimes a carefully placed hand, or shooting from a shaded position, shields the lens and solves the problem. In this case there was no avoiding it while still getting the picture. I'll show you how to edit out flare later in the book.

The picture of the couple exiting the ceremony in Figure 9.30 was framed to include the entire wedding party in the background. I used a wide-angle lens to keep the other members of the wedding party in reasonable focus. The camera position was adjusted to make the couple appear taller, and so that the bride's sister would be behind them. Otherwise she would have been hidden from view. The exposure of f/22 at 1/250th of a second was chosen to hold detail in the highlights (once again, the white gown was the determining factor).

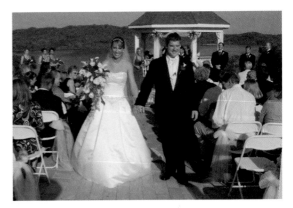

**Figure 9.30**
The grand exit, and more walking backward for the photographer.

The ceremony only lasted for about 20 minutes. During that time, about 128 "primary" pictures were taken. They are the images that were selected for processing and possible use. I actually took quite a few more. Some were bracketed copies to ensure I got a workable exposure. Others were taken to experiment with angles, and provide extras of a pose in case somebody blinked.

# Moving Indoors Presents New Challenges

T HE FINAL PORTION OF THE EVENT was the indoor reception. The challenges are the ones common to indoor photography. The rooms were well-lit for an interior setting, but much darker than daylight. The average available light reading with an ISO setting of 200 was about 1/15th of a second at f/4. That's not fast enough to freeze motion for activities like dancing and bouquet tosses. The options are to raise the ISO value (and have more noise in the pictures) or use flash. Direct flash produces harsh shadows. The ceiling was too high for bounce flash.

Examining Figure 9.31 provides insights into both the technique itself, and some of the challenges, of using flash with available-light fill. The picture shows the bride dancing with several other women (f/5 at 1/60th of a second at ISO 200). The flash is casting shadows from the dancers' arms, seen on the bride's gown and on the wall in the background. If the flash is too powerful in relation to the available light, the shadows will be very dark.

The solution was to use flash as the primary light source, but raise the ISO value to allow the available light in the room to act as a fill. It's the reverse of the exposure strategy I used when the women were doing make-up and hair. There the flash was the fill, and the room light was the primary source.

**Figure 9.31**
For most of the reception, the flash unit was the dominant light source, and the overhead lights served as fill.

Reducing shadows with flash photography requires increasing the ISO setting and/or slowing the shutter speed. Here the room light was bright enough to allow boosting the shutter speed without having to raise the ISO very much. Lighting is almost always a balancing act.

Now look at the background area. The near wall to the left side of the picture is brighter than the back of the room. That's because it is about 20 feet closer. If I'd relied more on the flash to light the scene, most of the room would have gone very dark. I wanted to show detail in these areas, and that required a wider f/stop and a slightly slower shutter speed.

Most advanced DSLRs and the dedicated flash units do an excellent job of determining a "workable" exposure. Figure 9.31 was taken using the automatic setting, with some modification. The system offered a setting that would have washed out the detail and color in the wedding dress. I took a couple of pictures and quickly checked the results. Adjusting the flash output slightly (about 2/3 stop) produced an image with good detail in the highlights, without darkening the background of the scene too much.

## Sometimes Two Heads Are Better than One

A single flash has limitations. It may not be able to put out enough light for a large room, or when the subjects are farther away from the camera. Many DSLRs today offer wireless control of multiple dedicated flash units. (Third-party products are available if your camera doesn't have that feature.) Figure 9.32 was taken with two flashes. One was on the camera, and another was set up as a remote unit on a monopod near the camera. It was extended close to the ceiling and bounced to add more overall light to the room. You can see the reflections in the windows. (Because of the angle, one light cast a reflection on two places. I was standing on a small ladder to get a higher camera position.)

**Figure 9.32**
Using two flash units can evenly light larger areas without producing harsh shadows. This unretouched image shows the output of both flash units reflected in the central pair of windows.

Compare the lighting between Figures 9.31 and 9.32 and it's easy to see how the extra light brightened up the large room. The result looks more like a flash picture because the strobes added more light to the scene than the available light in the room. The second light added about 2/3 of a stop to the overall light levels. It would have been more if the strobe had been pointed at the subjects rather than bounced. That approach would have created a second set of shadows and made it even more obvious that flash was used.

Figure 9.33 was taken using the same ladder, in the same spot, as Figure 9.32. The mood and the lighting are quite different because only the on-camera flash was used, and there are no other lights visible in the picture. The total focus is on the dancing couple and the expression of the bride as she dances with her husband.

The picture in Figure 9.34 was taken during the same dance, with identical exposure and flash settings. The only difference was the angle. I stepped off the ladder and adjusted my position to line up with level of the couple's heads. The wide-angle zoom let me get close, and still have the people in the background reasonably in focus.

Study all three of the preceding images. The color balance of Figure 9.32 is cooler than the next two figures. They have a warm glow in the background. That's due to the color temperature of the tungsten lights. In both Figures 9.33 and 9.34 the couple was very close to the flash. I had to adjust the white balance slightly during editing. (We'll cover that topic in the next chapter.)

**Figure 9.33**
This picture was taken from the same position in the room with a single flash unit. The subjects were closer. Notice how much darker the background and shadows created by the flash are in this image.

The important point is: Remember that in any mixed lighting situation, the effect of each different type of source will vary based on how close it is to the subject and how powerful it is. When using flash, the closer it (and usually you) is to a subject, the more the flash will dominate the exposure. The farther away the flash is, the less. The people to the left of the bride and groom in Figure 9.34 have a noticeable color cast. This would not be acceptable if they were the primary subjects in the pictures. Since they are part of the background, the color cast actually helps the overall composition and helps makes the wedding couple stand out visually from the crowd.

**Figure 9.34**
It was the same song, with the same couple; just a different point of view.

The reception lasted for several hours after these pictures, but we are going to take our leave now. The variations in lighting, the need for different exposures, and the range of poses varied greatly during the day. You may be thinking, "but this amount of variety isn't typical of my kind of picture-taking." Actually, perhaps it is; maybe it has more often been the case than you have realized in the past.

Consider a sports event, family-reunion picnic, or a vacation that takes place on a sunny day. Would fill flash help improve your exposures? Do the subjects move in and out of the shade?

Does a shift in location mean you change the white balance or the most suitable ISO setting? A change in activities might be better served with a faster shutter speed. To get really interesting pictures, we should always be looking for better camera angles, anticipating the next possibility, and watching for the peak moment to press the shutter.

The real goal of this chapter was to spark you to refine the skills from the preceding chapters and reinforce the need to look for places to apply them every time you use the camera. Now it's time to turn our attention to processing the images we take.

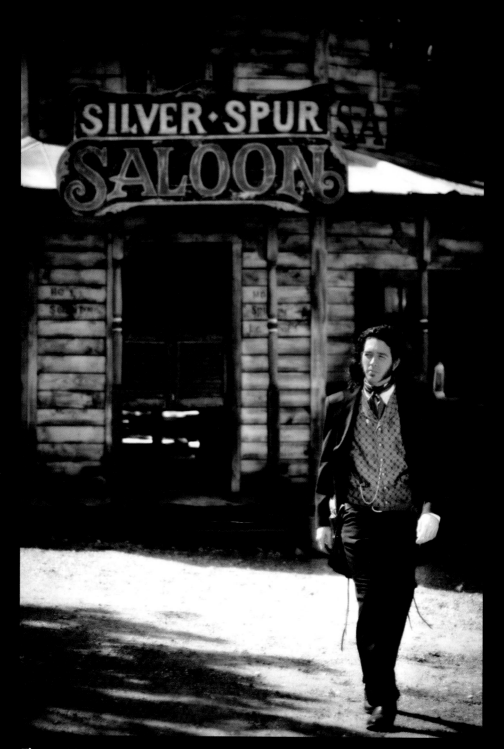

**Figure 10.1a** This image was digitally processed to give it the look of an old black-and-white photo to match its Old West setting. It was taken with a Canon EOD DSLR and edited in Adobe Photoshop. (Photograph by Mike Fulton.)

# Images into Pictures: Processing and Printing Your Files

# 10

WE USE OUR CAMERAS TO TAKE PICTURES. Processing and editing are how we turn the image files into photographs. In the days of film photography, processing required chemicals and a darkroom, and retouching was a skill practiced with dyes and special pencils. Today the computer has replaced the darkroom; chemicals and retouching tools have given way to software. It is possible to get printable images right out of the camera, but the best pictures are still the result of good processing and loving post-exposure attention. Figures 10.1b and 10.2 are the same image; 10.1b has been treated to skilled processing and editing.

Every time you take a digital picture, the camera creates a RAW image file. This file contains the unmodified data scan made by the sensor, along with the shooting information saved about the exposure. RAW files are stored in a proprietary format. Processing transforms the RAW file into a standard image format (like JPEG or TIFF), which can then be edited. Your camera can probably generate a JPEG, maybe even a TIFF file, of an image automatically. It still starts with a RAW file. The camera is doing the processing on autopilot. You have the equivalent of a digital Polaroid. The result may be acceptable, but never as refined as custom processing.

**Figure 10.1b**
Skilled editing produced the vivid colors and finely placed accents in this picture, adding impact and drawing the viewer's attention to the principal subject. (Photograph by Mike Fulton.)

# From RAW to Refined: Processing and Editing

I BREAK UP THE POST-EXPOSURE image handling into two phases: processing and editing. During *processing* we adjust the overall appearance of the image—tune the exposure; adjust brightness, contrast, and color balance; reduce signal noise and lens aberrations; and resize the image for the desired output. Of course, just how much we can actually accomplish varies with the quality of the image file and the capabilities of the processing software.

*Editing* is when we work with parts of the image, manipulating the appearance of individual pixels, their relationship to each other and to the overall composition. We can do things like boost the blue in the sky (without adjusting the other colors), darken or lighten areas or portions of the picture to draw the eye to a particular region, and remove or blur unwanted elements. Many image-manipulation programs offer a combination of processing and editing tools.

**Figure 10.2**
Compare this unedited version of the picture with the version seen in Figure 10.1b (enlarged at right).

Under ideal lighting conditions, and with good exposure, the basics of processing are simple and can be done very quickly. If you have images with deep shadows, washed out highlights, or other problems, the process will take longer. With practice and good software come speed and better skills.

This chapter is an introduction to processing and editing and an introduction to some of my favorite tools and techniques. It is not a detailed tutorial on the programs used. There is no one perfect editing program for all photographers, because we each have different styles and use different techniques. Before making a purchase it's a good idea to do a little research and make use of trial versions. Mastering the various

programs and techniques takes time and practice; basic skills are easy to develop with the right software, and to refine with practice.

The companion disc in the back of this book has fully functional trial versions (both Windows and Macintosh versions) of Bibble Pro and LightZone, plus user manuals, and learning aids that you can use to improve your skills and expand your knowledge. There are other programs mentioned that are not on the CD; trial versions of these can be obtained via the Internet. I've included image files you can use to follow along with the text. (They are copyrighted and only to be used for that purpose.) First let's define some terms and the steps used to transform a camera capture into a finished photograph.

# First Steps First

THE COMPLETE POST-EXPOSURE sequence of events (capture, processing, editing, displaying) is called *workflow*. Before a captured image can be opened and manipulated, it first has to be transferred to the computer. You can use your operating system's Copy command, the software that came with your camera, a card reader, or a third-party program like a RAW processor or editor. Which one works best is often a matter of personal preference. We'll use the Copy command for our exercises. Start by locating the Exercise Images folder inside the Chapter 10 folder on the companion disc and copying it to your hard drive.

## Working with RAW Images

Now it's time to install our RAW processor, Bibble Pro. This is my favorite processor for its wide range of features, reasonable cost, and powerful batch-handling features that make quick work of repetitive tasks. Other popular programs in this category are Adobe's Lightroom, LightZone (which we will look at for its editing tools later), and DxO (which excels in its ability to adjust for lens distortion).

We have arranged a special extension to the trial period for Bibble Pro and a discount on the purchase of a full copy of the latest edition of the software. For more information, visit www.bibble-labs.com/karneydslr.

Open the Bibble Pro folder. Locate and open the subfolder with the name that matches your operating system (Mac or Windows). Double-click on the installer application in that folder to begin Setup. Accept the default settings for the program when they are offered. When the installation is complete, open Bibble Pro by clicking its program icon.

Figure 10.3 shows the Windows version of Bibble Pro at work, with the default layout, on a collection of images from a dressage competition. The top of the main area has a menu bar, and underneath that a toolbar with a row of icons. The program's design allows users to customize the panels and tools to suit individual work styles. (If you didn't modify any of the setup options, your window should look almost the same. I've made the panel with the shooting information visible. It is probably hidden right now on your screen. Click on the tool icon that looks like a yellow triangle with an exclamation point in the center, and the panel should appear. Clicking the icon a second time will toggle the panel off.)

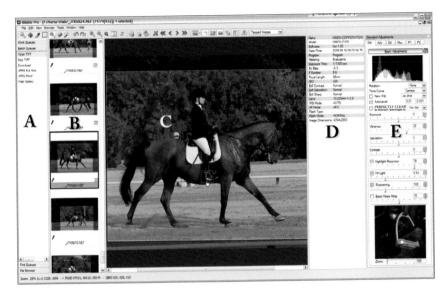

**Figure 10.3**
A labeled screen capture of Bibble Pro, open during an editing session.

I've labeled the four panels below the toolbar. We won't be working with the first two (marked A and B). The left-most panel (letter A) is the Folder View panel. It contains the tabs for the work queues, batch queues, print queues, and file browser. Click on one of the bars with a name label to change the mode. *Queues* are one of Bibble Pro's more powerful features, allowing you to automate image processing, file conversion and renaming, and a host of other common tasks. The *Thumbnail panel* (marked with the letter B), contains thumbnails of the images in current directory or of the images assigned to the active queue.

The large Image panel in the center (marked C) previews the currently selected image, and shows your modifications in real time. The Shooting Information panel (letter D) displays the file data collected by the camera and stored with the file (metadata). If the information has been stripped, you may not see much more than the file name and size. On the far right is the Tool Tab panel, marked with the letter E. It arranges all of the image processing and editing tools. You can customize them, and also undock any you frequently use and move them outside of the main workspace.

This is a special version of Bibble Pro that comes with an extended trial period. The Bibble Pro folder contains three videos and program reference guides. They are not required for the following exercises, but provide useful overviews of the program's interface and primary features. While we will use Bibble Pro to work with RAW images, the exercise is designed to show only how to process captures rather than to teach the full use of this program.

# Basic Image Processing

Open the File menu and select the Open command. When the file dialog box opens, navigate to the Exercise Images 10 folder, choose the Rider RAW file, and then click OK. The Bibble Pro interface will shift into Image mode with only the Image and Tool Tab panels open as seen in Figure 10.4 (minus the Open menu). Now we are ready to start processing.

This picture was taken on a sunny day with a very thin overcast. I used a slight underexposure to help hold the white elements in the rider's outfit and the horse's saddle-blanket. That made the shadow areas a bit dark, and there is still some *clipping* (totally white areas without detail)

in the highlights. We are going to fix both, and punch up the color and contrast a bit using just the tools on the Standard Tools tab (the one labeled Std at the top). It's already selected.

Before we start working, I want to point out a very important concept about how most RAW processors, including Bibble, work: *non-destructive editing*. The term refers to the fact that Bibble never makes any changes to the original image file. Instead, a companion file, called a *sidecar,* is created, which records all adjustments and applies them to the preview and to any output files or prints made from the picture. You don't have to save the adjustments; they are saved on-the-fly as you work.

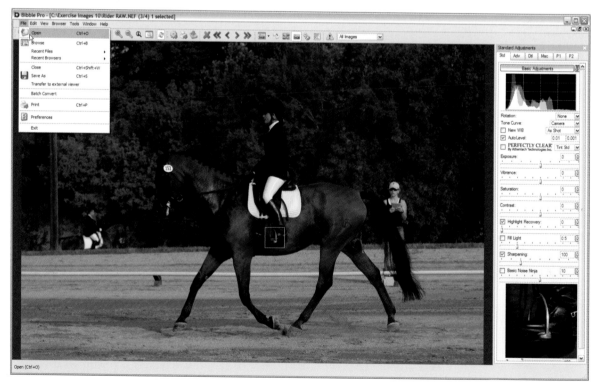

**Figure 10.4**
Loading an individual file for processing using the Open command from the File menu.

# Adjusting the White Balance

Digital cameras are much more sensitive to white balance than the human eye. We adjust our visual awareness of "white" when we move indoors from outside, or from a room with tungsten lighting to one with fluorescent. In digital photography we have to adjust the *white balance* (sometimes referred to as *color balance*) to match the lighting conditions when the picture was taken. Your camera probably has an Auto feature that does a reasonable, but not perfect, job of adjusting the white balance for changes in lighting conditions at the time of exposure. If you shoot RAW images, the white balance can easily be adjusted during processing.

I usually start working with an image by assessing and fine-tuning its white balance. You can't accurately evaluate an exposure's fine detail until the white balance is set. Here, the camera's white balance was set to Auto and the color looks OK, but it can be improved. The sun was shining, but there was a thin layer of clouds most of the day, so the conditions don't exactly match a standard pre-set for daylight. To my eye, on my color-calibrated monitor, the image looks just a little blue. While it is within an acceptable range, let's tweak it a bit and explore Bibble's controls.

We'll use the Eyedropper tool to make the adjustment, and then I'll suggest some other ways to experiment with this setting to help you understand the concept of white balance. Let's enable the Highlight/Shadow Warning feature by clicking on the yellow triangle on the right side of the toolbar under the menus. Areas of yellow will appear on the rider's pant leg and the back of the blanket. These are areas in the image that have lost highlight detail and are approaching toneless white.

**Most professional photographers, and some amateurs, calibrate their monitors and printers using tools like the ColorVision SpyderPro. Without calibration, there is no way to be sure that two monitors will show colors the same way as each other or as your camera (or even the same monitor over time, because color output will drift), or to be reasonably sure that the colors you see on the monitor will be what you get from the printer.**

**Most users are not as critical in their demands for proper color balance. As long as skin tones look normal, and there is not a noticeable color cast in the print, they are happy. Before investing in another piece of hardware, see if your prints are acceptable to you.**

Now open the View menu and choose the Zoom Actual Pixels command. Then click to enable the Eyedropper tool. It's the third tool icon from the left. Place it over the yellow line as shown in Figure 10.5a. On the status bar at the bottom of the image area is a read-out that shows the colors as RGB (red/green/blue) values. The section that starts with—(8-bit) and then has three sets of three numbers separated by commas is the area we want to watch. Move the Eyedropper pointer and look for a spot that is close to 255, 255, 255. That exact number is pure white, and has no detail.

**Figure 10.5a**

The Eyedropper in place to make the selection.

**Figure 10.5b**

The image after setting the new white balance.

We want to find a place where the value is just a little less than that to click and set the new value for white. I used a point that read 238, 244, 252. Anywhere in that range will work. As soon as the change is made there should be a dramatic shift in the yellow areas. You will see much of it turn to red and blue as seen in Figure 10.5b. The areas at the extreme bright end of the exposure range are washing out, and the point where you clicked now reads 255, 255, 255. The program indexed that point as pure white when you clicked on it with the Eyedropper pointer. If you don't like the first result, select another point and click again, until you like the result. Figure 10.5b shows my image after setting the white balance.

## A Little Experimenting

The change in the highlights came when we adjusted the white balance by setting an index point with the Eyedropper. Before we do the rest of our processing, let's see what happens to both the highlights and overall color when the white balance is *really* modified. Most RAW image processors offer a standard set of white balance settings: sunlight, cloudy, shade, tungsten, etc. The names and values may vary a bit, but work basically the same way. For example, if a shot was taken on a cloudy day, but the camera white balance was set to daylight or sunny, Bibble can correct the colors by applying the Fluorescent white-balance setting.

Just underneath the histogram (the full-color graph at the top of the right-hand panel—more on it shortly), in the Std Tool tab, are three drop-down menus. The top one adjusts the image's rotation in 90-degree increments. The second one provides a collection of pre-defined tonal curves, and the third lists white-balance presets. Change the latter menu setting to Fluorescent as shown in Figure 10.6.

With the Highlight Shadow Warning feature enabled, most of the white portions of the picture are now covered in yellow. Turn off the warning and you can see how the new balance radically changes the overall color of the image. Now look closely at the area ringed by arrows in Figure 10.6 and observe the loss of detail in the fabric.

Try the other presets and watch how the overall color changes, as well as highlight and shadow detail. The Daylight option will be very close to the Click White option. That's because the lighting conditions were very close to full sun— or daylight. Choose the Click White option from the menu to restore the first correction. Remember that the final choice as to any setting and the appearance of the image is up to you. For example, I often warm the white balance in portraits just a little, because (to me) that improves skin tone.

**Figure 10.6**
Changing the white-balance setting in both color and highlight detail.

# Cropping and Adjusting the Picture

THERE IS EXTRA SPACE in this picture, so let's crop the picture before continuing with our processing adjustments. Bibble never actually removes any of the image. It notes the selected area and only outputs that portion of the image to a file or printer when told to do so. You can re-crop at any time. There are preset crops for common print sizes, but we'll just do a free-form crop of our picture.

Open the View menu and choose the Fit to Window option. (Feel free to note and use Bibble Pro's keyboard shortcuts and toolbar icons to perform an action. I'm using the menus to avoid having to give options for the differences in operating system commands.) The fourth icon from the left on the toolbar under the menus launches the Crop tool. Click on it to make it active, and then place the cursor in the position of the upper-left corner of the cropped area shown in Figure 10.7.

Now drag the cursor diagonally down to the right to crop the image. The active area will show the guidelines to help in composition. After you release the Crop tool you can use the mouse to drag the crop area by placing the hand-shaped cursor inside the crop rectangle. Placing the pointer on the edge will change the cursor into a line with two arrows facing out. Use it to adjust the size of the crop area. Once you have it looking right, open the View menu and choose the Zoom to Crop selection. It's time make the rest of our adjustments.

**Figure 10.7**
The Crop tool does not actually remove any portion of the original image; it simply defines the area that will be included in the final output.

# Adjustments: A Bit of This and a Little of That

Now comes the intuitive part. Look at the white-balanced and cropped image (Figure 10.7) and see what (if anything) needs to be done. No two images are exactly alike, and there is also the matter of personal preference and style. Are the shadows too dark and/or the highlights washed out? Are the colors too bright or too dull? Such changes can be made with the Basic Adjustments tool stack (see Figure 10.8).

Sometimes simply adjusting the overall exposure or contrast setting is all that's needed. Making small adjustments is usually the quickest way to work. We are blessed with a variety of tools, and the image-tweaking process often resembles grandmother's cooking—adding a pinch of this and a smidgen of that. One adjustment often will only slightly modify any others that have been already made. Remember that the edits don't really change the image, just the way it looks. The basic data stays the same.

The following explanations of the effect of the basic controls, and the order in which they are applied, are general guidelines. Some images require very little work, others more. Before actually making adjustments, let's define the Tools in the order they appear in the stack. (We are only using the Standard tools in this exercise, and we will save Noise Ninja for later.) Clicking a checkbox turns a tool on or off, a drop-down menu provides pre-set options, and sliders let you gradually adjust settings. The Edit/Settings menu at the top of the window has options for restoring settings to the original camera values. (See the videos on the disc for more information on the user interface.)

**Figure 10.8**
RAW processing is often an iterative process, as one setting may modify others. This screenshot shows the basic tool stack with my final settings for the horse and rider in place.

## The Histogram

The histogram, at the top of the tool stack, works much like the one that is on most DSLRs. Look at Figure 10.8. It is a read-only graph, showing how the pixels in the image are distributed. The horizontal axis reports the pixel density across the tonal range, with the darkest areas (the shadows) on the left side, to the brightest (the highlights) on the right. When the graph has higher levels of pixels in the left portion of the horizontal axis, then the image has more intensity in the shadows. If they are higher in the middle, there is more intensity in the mid-tones, and if they are on the right, then more in the highlights. The vertical axis represents the total number of pixels at a given point on the tonal scale. The higher the graph, the more pixels and the lighter the image will be in that point on the tonal curve. Figures 10.9a and 10.9b illustrate the dramatic differences a histogram can display.

The primary colors each have their own plot on the graph. As you work, the histogram will change as the image is modified. When a portion of the graph is pushed all the way to the top, that area is so bright that highlight detail is lost. The shadows will be black with no detail at points on the graph where the histogram is empty.

The two histograms that comprise Figure 10.9 are from two different pictures. The one on the left (10.9a) is from our current file, with the horse and rider. The blue spike in the shadows is from the dark jackets and black helmets. The pixels extend across the full width of the chart, thanks to Bibble's Auto-Level feature, explained below. The one on the right (10.9b) is from the image of seagull in flight, seen in Figure 10.10. The RAW file is in the Exercise Images folder. There is a narrower range of colors and fewer shadows and highlights in this picture, and the Auto-Level feature was disabled.

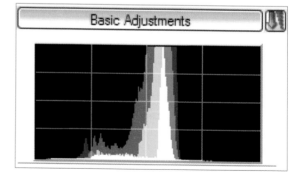

### Figures 10.9a and 10.9b

Histograms are guides. These two histograms are from two different images, with dramatically different subjects and pixel distributions. Both pictures printed well.

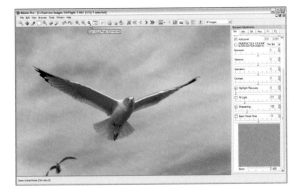

**Figure 10.10**
The seagull image that generated the histogram in Figure 10.9b.

## Tone Curves, Auto Level, and Perfectly Clear

The *tone* of an image is a combination of the hue, saturation, and brightness of the colors within it. Hue measures the color reflected from objects in the image, saturation measures the strength of those colors, and brightness measures the lightness of the image. The pre-set tonal curves available in the drop-down menu adjust the tonal range by modifying the relationship between highlights, shadows, and mid-tones all at once; The Camera setting uses the curve obtained from the RAW file. Setting the tone curve to High, Low, Not So High, Really High, Really Low, or Normal changes the relationships. The Low settings preserves highlight detail and reduces overall contrast. The High settings boost contrast at the expense of shadow and highlight detail.

Auto-Level adjusts the distribution of the image's pixels to fill the full tonal range of the histogram. Perfectly Clear® is a tool designed by Athentech Technologies to automatically optimize lighting, contrast, and sharpening while removing abnormal tint. When Perfectly Clear is enabled, AutoLevel is automatically disabled. The best way to understand what each of these tools does is by turning one on and off with several pictures.

## Exposure

The actual exposure is defined by the amount of light recorded by your digital camera's sensor when the shutter is opened and the image created. If an image is overexposed, the image appears washed out. If the image is underexposed, the image appears too dark. The Exposure tool adjusts the way that the recording is read by the processing engine. The results will vary based on the quality of the capture and the original exposure. Detail that is totally lost due to extreme under- or overexposure cannot be regained.

## Vibrance and Saturation

Vibrance and Saturation settings are used to enhance or diminish the intensity of the colors in an image. The Saturation control acts on the entire image, adding or removing saturation and making colors more vivid. Vibrance is more selective and has a more noticeable effect in the less-saturated areas of the image.

## Contrast, Highlight Recovery, and Fill Light

Highlight Recovery restores detail and color to overexposed highlights without changing the overall exposure or color balance. Fill Light softens the shadows in the image, while causing little or no shift in the highlights. If one or more color channels in your image are blown out, Bibble analyzes the remaining data and uses it to restore detail. This often allows recovery for up to $\frac{1}{2}$ of the overexposure or underexposure. The effect varies depending on the camera used, and how accurately the white balance is set. (That's one reason I usually shoot RAW and fine-tune the white balance as I first begin processing an image.)

## Sharpening

Sharpening can make an already sharp picture look sharper. This tool finds areas of pixels that differ in color value from their surroundings, and increases the local contrast at the margins. It's sort of like adding an outline or drop shadow to text. Too much sharpening can make a picture look artificial, and it can't make an out of focus picture look in-focus. This tool is best saved for the finishing touch after other adjustments have been made.

## Look First and Don't Over-do

I begin by looking at the exposure and the level of detail in the highlights and shadows, and note the overall contrast and saturation. Is the image noticeably too dark or light? Then adjusting the exposure may be in order. If there are dark shadows, then adding some fill light might help. If the whites are washed out, Highlight Recovery is in order. In most cases, I can process an image in less than a minute, assuming a good original exposure and white balance.

How do you want the subject portrayed? A sunset might benefit from increased saturation, a slight warm cast, and reducing the detail in the shadows on the ground to increase the dominance of the sky and sun. A portrait of a woman is often treated to reduce contrasts and limited sharpening in order to, to enhance skin tone and reduce the appearance of wrinkles. A portrait of a man is traditionally treated with a bit more contrast to bring out strength in the facial structure.

Play with the image of the rider and become familiar with the tools. Open some of your own pictures with different types of subjects. Learn how much detail can be recovered in the highlights and shadows. Examine the way the histogram looks, and try out Perfectly Clear. Then move on to the next exercise and some advanced tips and tricks.

# Overcoming the Limits of Technology

THE MODERN DSLR and its computer-designed lenses are amazing devices, but not perfect. Use a high ISO, and your images will probably exhibit flecks of random color that rob the picture of detail and sharpness. Lens construction always involves optical trade-offs between speed, sharpness, distortion, and color fidelity—especially when the aperture is wide open. Digital processing lets us reduce and sometimes even overcome these limits, by applying sophisticated analysis and enhancement filters to our pictures. Refer to Figure 10.11 and I'll demonstrate.

**Figure 10.11**

The low light level in this street scene required a high ISO setting, resulting in signal noise throughout the image.

Open the venice.nef file in Bibble Pro using the File/Open command and I'll introduce you to the enhancement technology that that comes with the program. This image was a "grab shot" taken under marginal conditions. I liked the mood, the light, and the sense of the city at dusk. I knew the quality of final picture would suffer due to noise, slow shutter speed, and extreme lighting and exposure conditions. A plus side is that it is a perfect file for showing the advanced clean-up tools a good RAW processing program offers.

The picture may load sideways. If so, click on the Rotate icon (under the mouse pointer in Figure 10.11). This picture was taken on a soft early autumn evening in Venice as I was walking. The ISO 800 setting, combined with a 2/3 stop underexposure to keep the lights from blowing out too dramatically, resulted in signal noise. The wide-open lens set things up for distortion and chromatic aberration.

Check the Perfectly Clear box to process the image, and set the white balance to Click White. Place the Eye-dropper over the window curtain above the left-most light in the picture. Then adjust the Sharpening setting to 100. The Highlight Recovery setting should read about 55. Use the image in Figure 11.12 for reference. I've added a red arrow to make it easy to find the Eyedropper (in the upper-left corner).

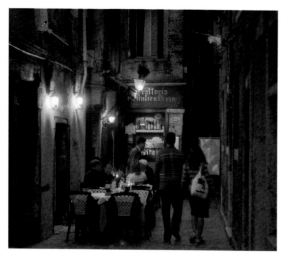

**Figure 10.12**
The image after applying Perfectly Clear and adjusting the white balance, with the Eyedropper still in place.

**Figure 10.13**
The Focus Window cursor lets you choose an area to enlarge for detailed observation in the Zoom window at the bottom of the tool stack.

## Noise Abatement

Let's look closely at the image and examine the noise pattern. The editing technique worked, but there is significant noise due to the low light levels in the scene and the high ISO used to take the picture. Click on the fifth icon from the left. It's the one for the Focus Window cursor. The tool tip is visible under the menu bar in Figure 10.13. A square gold-colored outline appears in the preview window while it is active. Place your mouse pointer over the pavement tiles where several join. Noise is often greatest in areas of a picture that are darker and/or of even color and tone. You can move the Focus window by dragging it with the mouse. The Zoom window is visible at the bottom of the tool stack and you can adjust the magnification slider to from 100 to 400 percent.

The Zoom feature is really handy for doing detail work, while still being able to see a full image in the main window. Examine the area in the Zoom window as you move the Focus Window cursor. There are spots of blue and a somewhat mottled appearance visible over the tiles. There is a different pattern in the brighter-lit area around the table area and the diners. That's all sensor noise. Noise often looks like dust, pock marks, or unusual patterns on the image. The glowing green objects in the picture are artifacts caused by lens flare. We'll deal with them later.

### Enter the Noise Ninjas

Now let's clean up the noise. Just above the Zoom window are the Basic Noise Ninja checkbox and slider. Noise Ninja is a plug-in, based on the stand-alone version of the product of the same name by PictureCode (www.picturecode.com). When enabled, it uses a complex mathematical formula to reduce the noise without losing detail. Select the checkbox and watch what happens to the noise. This basic edition does a pretty good job. The full program takes things further by adding custom profiles for specific camera and lens combinations. If you buy a license to the full product, it can work right inside of Bibble and other popular image-editing programs like Adobe Photoshop. See Figure 10.14.

**Figure 10.14**
The full version of Noise Ninja offers advanced controls and custom profiles for improved noise reduction.

Among the items on the third tab of the tool stack (labeled Dtl) is access to the full features of Noise Ninja. To enable them, you have to obtain a license for the product from PictureCode. Figure 10.14 shows the tool in action. It can read the file and generate a custom noise-reduction profile based on the camera, lens, ISO, and white-balance settings. You also get a stand-alone version of the program with more tools, camera and lens profiles, and plug-ins for other popular image-editing programs.

Your tool stack probably has the Noise Ninja registered tool closer to the bottom, under the other tools. Bibble lets us move the tools in the stack, or bring them out as a free-floating applet. To move a tool, click on its title bar and drag it to the new location.

## Correcting Lens Aberrations

Our final adjustments will be to reduce the file's optical problems caused by *lens distortion*. That term refers to any imperfection in the image caused by the lens design. Zoom lenses usually show more distortion than fixed-focal-length (prime) designs. That's because zooms are more complicated, with more glass and shifting elements. Refer to Figure 10.15.

Barrel and pin-cushion distortion are the two most common problems. *Barrel distortion* makes straight lines in the image look rounded, like a barrel. This is most noticeable in wide-angle and fisheye designs. *Pin-cushion distortion* makes an image look pinched or narrowed at the sides.

**Figure 10.15**
There is no such thing as a perfect lens. Full-featured processing programs use advanced algorithms to fine-tune optical appearance in the final image.

*Vignetting* is the darkening of corners of an image, due to light fall-off because of lens design. It also can happen when a filter or lens hood shades the edge of the lens and reduces its light-gathering ability.

Click on the Misc (Miscellaneous) tab of the tool stack and look for the Lens Correction tools seen in Figure 10.15. I've moved them in my stack from the default locations to bring them closer to the Zoom window. Make sure the drop-down menus show the right camera and lens combination. Adjust to show the Nikon D200 and the 80-200mm f/2.0 G-ED-IF AF-S DX lens (Good thing the barrel of the zoom is big enough to list the name). Sometimes the program can't identify the proper hardware from the file data.

Now click each of the options in the following order, and watch the main preview area as the correction is applied. It will take a few seconds for the display to adjust. There will be a very visible shift in the picture. Start by selecting the Enable Correction checkbox under the Lens Correction tab, then selecting the Enable CA Correction. Next, click to select the Resize Image to Fit and watch the edges of the image. Finally, select the Enable Vignetting check box.

I almost always select the Enable Lens, Resize Image to Fit, and Enable CA Correction checkboxes. Vignetting only gets occasional use, because my lens collection does not exhibit the flaw very much, and I tend to like having the edges of most pictures a little dark to draw attention to the center of the image.

*Chromatic aberration* (CA) is due to the way the light of different wavelengths travels through the glass, and is bent at slightly different angles. Again, this is most common in zoom lenses, particularly at their extreme apertures and zoom settings. CA appears most at an image's corners and in high-contrast areas, or around the details of an image. It often looks like a purple fringe or halo around smaller objects.

# Exporting Your Pictures

BIBBLE WILL LET YOU PRINT your pictures on a printer attached to your computer after editing, using the Print command located in the File menu. If you want to edit the finished image in another program, use it on a Web site, or send it to an external lab, then the file must be exported in a standard file format (JPEG, TIFF, or PNG). To export a single image, just use the File/Save As command. I've already exported a TIFF version of this picture and placed it in the Exercise Images 10 folder.

The workflow video on the disc in the Bibble folder covers the program's advanced batch-output features. They are powerful tools for handling large numbers of files, and you can also use batch commands to apply common processing to other files.

# Picture Perfect:
# The Art of Retouching—Part One, LightZone

PROCESSING APPLIES corrections to the entire image; editing is the detailed work of adjusting areas of the picture, even the individual pixels, and adding very potent special effects. My two editing favorites are LightZone and Adobe Photoshop (very powerful and very expensive). Photoshop Elements is less pricey—with reduced features. We don't have the space for a detailed tutorial of editors, but the following discussion will give you an understanding of how they work and what they can do.

Figure 10.16 shows the Venice scene being edited in LightZone. The two white outlines around the center portion of the picture define the region that is being manipulated. You define a region by clicking the mouse to set the boundary points (which appear as white dots). The space between the two outlines denotes the "feather zone." Any adjustments begin at the outer edge and slowly increase to full power at the inner. There is an Invert checkbox at the bottom of the tool in the stack that lets you invert the tool, so it acts on the area outside the region. If no region is defined, the adjustment affects the entire image.

The tools used here are darkening the edges and blurring the picture, while leaving the center of the region untouched. That's because the effect has been inverted using the Invert Mask checkbox in the lower-left hand corner of the tool's controls.

You may have heard of the zone system, developed by Ansel Adams in the 1930s and 40s. It offers a way to precisely control the tonal range and contrast within a picture to obtain incredibly rich detail, from the faintest highlights to the deepest shadows. His method requires complicated exposure calculations and careful

processing, and printing with lots of trial and error in the darkroom, to get the "perfect" result; the results are genuinely stunning when his methods are followed with care and artistic talent.

LightZone brings the same kind of control to digital photography. If you would like to experiment as I give the tour, load the trial version (found in the LightZone folder of the CD). Use the File/Open command to load the Venice.tif file from the Exercise Images folder. (You can also take advantage of a series of tutorial videos at http://www.lightcrafts.com/learning/.)

**Figure 10.16**

LightZone offers a unique set of editing tools for both RAW processing and fine-tuning areas within an image.

There are two LightZone Tools shown in Figure 10.17, separated by a row of icons, to the right of the work area. The one of top is the ZoneFinder, the one on the bottom is a ZoneMapper. The ZoneMapper is a gray-scale with 16 segments; each step represents a one-half f/stop change in density. Place the mouse cursor over a segment in the ZoneMapper and the corresponding tones in the image are highlighted in yellow on the ZoneFinder. The segments on the right side of the ZoneMapper can be independently adjusted to change exposure, contrast, and color.

You can have as many instances of a tool, each with its own regions and settings, as you want. In addition to the ZoneMapper are the Relight tool (which gives fine control over highlight and shadow recovery), a Gaussian Blur tool (selective out-of-focus), and Sharpening, Hue/Saturation, Color Balance, White Balance, Black and White, Clone, Spot, and Red-Eye Reduction tools. You can add a tool to the stack by clicking its icon in the toolbar right under the ZoneFinder. The tools can be repositioned within the stack to change the order in which they affect the image.

If you have installed LightZone and loaded the Venice.tif file, click on the Relight Tool icon. It is the second from the left and looks like a crescent moon. At once, the picture will change to look more like it was taken in the late afternoon, not at night.

In Figure 10.18, I've clicked on the Sharpen Tool icon, and the controls have been added to the top of the stack. A few clicks and the effect is constrained to the center of the picture. All editing done in LightZone is non-destructive. You can turn tools on and off to see how each one interacts with the others. Once the picture looks the way you want, it can be exported into a variety of common image file formats, and the LightZone edits saved as a separate file for reuse.

**Figure 10.17**
A close-up view of the ZoneFinder and ZoneMapper at work.

**Figure 10.18**
The Sharpen tool is being limited here to just the center of the image.

On the left side of the LightZone interface is a column titled Styles. These are saved customized tool stacks that can be applied to an image by clicking on the name of the desired combination. The tools are added to any you may have already set, and you can keep adding new ones and modify those already in the style to get just the right result.

Figure 10.19 shows the Venice scene with the Alien Infrared style applied. The top tool in the stack is actually a standard color balance that has been tuned and renamed. Clicking the name allows renaming at any time. If you have the LightZone program open, try some other styles to get a quick sense of just how flexible this editor is.

**Figure 10.19**
Styles let LightZone users quickly apply a set of saved tools to an image.
Here the picture has been converted into a simulated black-and-white infrared rendition.

# Retouching, Part Two: Adobe Photoshop, *et al*

YOU MAY HAVE NOTICED that while we selected regions, we didn't get down to actually modifying individual pixels. LightZone has some ability to do that kind of work, but Photoshop is the gold standard for powerful pixel editing. In addition to its own impressive array of brushes, filters, and support for pressure-sensitive tablets with pens and virtual air-brushes, third-party vendors offer a variety of really neat tools that extend Photoshop's abilities. Many of these products, like Photoshop itself, are available online in trial editions. A lot of the add-on products also work with Photoshop Elements. That combination is a lot easier on the wallet if you don't need all the high-end capability of Photoshop itself.

Photoshop is renowned for its ability to manipulate pixels and perform amazing special effects. It can process RAW images, but is really designed for detailed pixel editing and retouching. Figure 10.20 shows a portion of the Venice scene while I was removing the green artifacts caused by reflections from the bright lights. The tall narrow set of icons is the Photoshop Tools window. Many of them offer more than one option, and those can have a range of settings. Learning the basics in this program is easy enough, but real skill takes a lot of learning and practice.

**Figure 10.20**
Using the Clone Stamp tool to remove the green flare artifacts.

I used the Clone Stamp tool to copy pixels from one area and overwrite those in another. There is also a Healing Brush tool (with variations) that will blend the pixels from a source area with the existing one in the target location. The Clone Stamp tool is great for tasks like this, but you have to be careful not to make it look like a section is being duplicated. The Healing Brush tool is the weapon of choice for removing blemishes from skin.

The screenshot in Figure 10.21 shows the same picture after editing out the spots. This time the Brushes and History windows are open. Photoshop offers a wide range of brush styles, and you can make custom ones as well. Layers let you stack images on top of each other, and then blend the contents into a new composite. The History feature not only shows you what has been done, but enables some special effects as well. The History brush can paint previously revised material back into the current image. With two images open you can also transfer sections of one image into another.

Actions are a great time-saver in Photoshop, and a way to easily add professional polish to your pictures. I've placed two versions of a picture of a young baseball player side by side in Figure 10.22. She was sitting in open shade, resulting in a low-contrast picture (seen on the left), that was just a little cool in appearance. The image on the right has been modified with just one mouse click. I could have fixed both contrast and color balance in either Bibble Pro or LightZone, but wanted to show you how to add some "pop" with Photoshop actions.

**Figure 10.21**
The finished edit with the Photoshop Brushes and History windows in view. Removing the green spots took less than a minute.

**Figure 10.22**
Actions are collections of edits that are recorded for future use, like these from TriCoast Photography.

A Photoshop action is a series of Photoshop commands that are recorded, then named and saved for future use. The one I used here is from a collection by Mike Fulton and Cody Clinton. Mike took the picture in Figures 10.1b and 10.2; the first, like the current example, was treated with one of their actions, which can be purchased at www.findingcolor.com.

To the right of the pictures is the Action window. See the Play button at the bottom? When you click it, the currently selected action is played. It can be a simple adjustment, or one that invokes a complicated array of edits. Mike and Cody have some that can be fined-tuned, while others are totally automatic.

Our final "show and tell" for Photoshop is a filter. There are some that are offered by Adobe and come with the program. Others, from third-party vendors, are really programs within a program. Many actually open in a new window and then pass the edited image back to Photoshop after you have made your adjustments.

Nik Silver Efex Pro, shown in Figure 10.23, is one of several filters designed to perform black-and-white emulation/conversions. Photoshop has always had the ability to convert a color image to black and white using its saturation settings. The results were OK, but did not rival film for tonal range. Silver Efex Pro, and other filters like Alien Skin Exposure 2 and DxO Film Pack, actually are able to mimic specific films. They can be tweaked to add grain and modify contrast and tonal curve, based on the results of different chemical developers and printing papers. Combined with high-end inkjet printers, the results provide outstanding quality.

Other filters add new tools to streamline contrast adjustment without having to learn advanced curve manipulation, to correct color cast, etc. Many can be used with pressure-sensitive tablets or have control points that can be placed on a portion of the picture to limit the area being modified.

**Figure 10.23**
A Photoshop filter is a program within a program that extends the features of its host and gives us additional editing power.

# Output and Printing Options

ONCE THE EDITING IS DONE there is one more step required to share your pictures: output. Printing and output options vary from program to program, so a detailed discussion is beyond the scope of a book on DSLR photography. But we can look at some of the common issues and opportunities. The most traditional method is the paper print. An inkjet or dye-sublimation printer can be attached right to your computer and produce near-chemical photographic quality. All of the programs we examined can print using any printer supported by your operating system.

Figure 10.24 shows the Adobe Photoshop Print dialog box. This is a typical dialog box for sending one file to a printer. It can automatically scale your image to fit the printer's paper size. Most modern DSLRs generate files large enough to make prints over 8×10 inches without a problem. When the image has very low resolution (say, you made an extreme crop and are only using a small portion of the picture), scaling it up may result in poor quality. This is true for any image and any editing program. Check the program's documentation for instructions on how to adjust the image size (and so its resolution) to match the printer's requirements. High quality generally demands between 150 to 300 dpi (dots per inch). There are also plug-ins available that do a reasonable job of digitally enlarging a file so that larger prints can be made. I've managed to make a 36×48 inch print from a cropped (about ½ of the image area) section of a 10-megapixel file using Alien Skin's BlowUp (www.alienskin.com).

**Figure 10.24**

The final step is output. Options include your own printer, a pro or commercial lab, and sharing via the Internet or disc.

Some programs let you assemble picture packages that automatically divide the print job into areas, so that you can get a variety of smaller prints onto a single sheet of paper. This saves money and time. Figure 10.25 shows the Picture Package feature that is built into Adobe Photoshop. (It's located in the Automate section of the File menu.)

Picture Package has pre-defined combinations similar to those offered by school and sports team photographers (like two 5×7s, or four 4×5s, or one 5×7 and two 4×5s). You can also design your own packages and save the layout for future use.

**Figure 10.25**
Picture Package lets you combine several different-sized prints into a single composite print job.

Inkjet printing can get expensive, and the quality is usually not as good or durable as traditional chemical-based photographic prints. I said "usually" because quality still depends on the attention to detail and quality control of the printer. Your local drugstore and big-box store probably have a photo lab that can print your files. The images can be uploaded over the Internet or taken into the lab on a disc or thumb drive.

They will give you reasonable prints, but the results will not usually be up to professional-lab quality. Whites may not be true white and the tonal range may suffer. For the best results, you can use the same technology to send (or take) your files to a photo store or professional lab. Pro labs usually have two divisions, one for professional photographers and the other for the public. They have different names, but the prints come off the same machines.

Figure 10.26 shows the online lab Web site for Showcase Photographic in Atlanta (www.showcaseinc.com) a professional photography-supply store that also offers online and in-store printing to the general public. At the top of their page are tabs for the various services they offer. In addition to prints, you can store copies of your files in albums for future printing, and create a variety of custom picture products like calendars, mouse pads, coffee mugs, posters, etc.

**Figure 10.26**
Uploading a print job to the Showcase Photographic store's Web site.

Some stores offer a wide variety of novelty products, as well as coffee-table books, albums, etc. Another advantage is the ability to generate very large prints. For those kinds of prints, you may want to create a custom composite, and for albums and scrapbooks you'll want to incorporate eye-catching designs. That's the focus of the next chapter.

**Figure 11.1a** Collages, albums, and similar multi-image layouts are easy ways to combine and show your images—with the right software.

# The Digital Photo Album

# 11

THE PICTURES FOR THE OPENING IMAGE in this chapter (Figure 11.1a) were taken of my daughter during a cheerleading competition, combined into a collage, and printed as a glossy poster for her room. The ones in Figure 11.1b are from a high-school play. They were transformed into a collage for the cover and label of the DVD that the group sold at the ticket counter. Digital photography offers us many ways to share our images. While the vast majority of digital photographs end up as 4×6 prints, or stored a way on a CD, with a little creativity they can be transformed into projects like these two—or into photo scrapbooks, coffee table-style albums, or slideshows (which we'll save for the next chapter).

The collage design makes these pictures stand out and tell their story. The DSLR, combined with easy-to-use software and new printing technology, has made products formerly limited to professionals—from posters and CD covers to high-quality bound, full-color, coffee-table books—available to the amateur photographer.

**Figure 11.1b**
This is a collage for a DVD cover for a slide show of a high-school play. See also Figure 11.2.

# FotoFusion and Digital Album Design

T HE KEY TO DIGITAL COLLAGE design is the software. LumaPix's FotoFusion was designed specifically for photo-layout projects. It lets us quickly combine and position images; add design elements like drop-shadows, borders, and text to a page; and then send the results to a printer or lab or share them via email. The companion disc has a working trial version in the Chapter 11 folder, plus the user's manual in PDF form, and a collection of training videos. By all means, experiment with your own pictures as we tour FotoFusion's features.

There are three versions of FotoFusion, which work on all current Windows-based computers and Intel-based Macintosh computers with Windows emulation. Scrapbook Essentials ($39) is designed for scrapbookers who don't need advanced photographic and layout tools, and supports printing individual pages up to 12×12 inches at 300dpi. Enhanced ($119) supports single-page 300 dpi output up to 13×19 inches and has an expanded layout toolkit. Extreme ($299) includes more design tools and multi-page support with resolution only limited by the output device.

**Figure 11.2**
This is the same design seen in Figure 11.1b, open in LumaPix FotoFusion, just before being printed.

Our discussion will be a general introduction to digital-photo collages, and the layout software used to design them and obtain prints. A complete, detailed, step-by-step tutorial is beyond the scope of this chapter, but we will tour the FotoFusion program's features, and I'll use some prepared examples to show how it works. We won't be using any particular images, so gather some of your own pictures and experiment using FotoFusion's Tools.

When you load FotoFusion, it presents a wheel with options to create a new project, load an existing file, learn from a tutorial, or obtain a pre-designed layout from the LumaPix Marketplace. Choose New, and then click on the Custom square. A dialog box will open (see Figure 11.3). Choose a page size, either by entering the width and height in the upper-left corner of the box, or by clicking on the button to the left and selecting a standard size.

Notice the Safe Inset and Bleed settings. Printing presses and digital photo printers don't always line up exactly. If these devices aren't lined up correctly (or if the source file and the photo printer aren't using the same number of dots per inch), there may be a white line, or part of page may be cropped. *Bleed* is a printing-press term: The ink is allowed to "bleed" over the edge of the page past the margins. For photographic prints, all you usually need to do is set a small "safe zone." Check with your print shop for bleed information on the output made with your collage files if you want to run them on a printing press.

**Figure 11.3**

After opening the program, your first step in creating a new design is to set the page size.

# Pictures and Pages First

WE NEED TO HAVE THE PICTURES ready before starting a collage project. First, I sort out the likely images and place them into a new folder, ready for the layout phase. Their resolution needs to be reasonable for the size of the finished product. For most inkjet, dye sublimation, or photo lab output, 300 dpi should be fine. FotoFusion will resize and fine-tune, sharpening automatically (within reason). Ask your printer about the best resolution for specialty products like posters and banners from a quick-print shop.

Figure 11.4 shows a proof sheet created by Michael Sheasby in FotoFusion with 12 images of children at play. He adjusted the safe area to make sure that there is a reasonable amount of black background around the pictures, and that the text looks balanced in the final print.

**Figure 11.4**
FotoFusion comes with a collection of pre-designed layouts, templates, and an auto-collage feature, which makes it easy to start a design. (Photos by Michael Sheasby.)

# Then the Layered Look

FOTOFUSION PAGES START with a blank page to which we add a background, and then place the other design elements over that. Backgrounds can be an image, a graphic fill, or a pattern. It's important to choose a background that visually complements the other pictures and the colors in your layout.

Locate and click the Images button to open the Images panel (seen in Figure 11.5). Drag the image you want to use as the background over the page. Right-click it and choose the Select as Canvas Background option. The picture will be resized and made the new background of the design. You can use the same method to quickly set any other image on the page as the background. The background can be resized and given different looks (more about that soon), but it can't be moved—it always is attached to the virtual page.

The Dropper (see Figure 11.6) automatically appears when you select several images (hold the Ctrl key and click on the desired files) and drag them into the work area. This is like an image tray that holds the unplaced files. The left-most item can be dropped into a new frame or an existing one by placing the triangular cursor in the desired location on the canvas.

**Figure 11.5**
Once the page is defined we can start adding images and arranging the layout.

**Figure 11.6**
The Dropper at work with a tray of pictures.

You can add as many pictures at a time as you want, and a picture can be placed in a layout more than once. Once an image is on the page it can be selected and manipulated. Images (other than the background image) are in frames. A selected frame has a green rectangle in its upper center. The transparent objects on its edges are handles that are used to adjust the frame and its picture. The little squares on the inside are dragged to adjust the picture inside the frame (crop, make larger, etc.). The angles on the out-side edge adjust the frame itself (border, drop-shadow, etc.). Drag the little circular symbol over the picture about half-way to the upper border of the frame to rotate it. Drag the sunburst-like object in the center to position the picture with-in the frame. The quickest way to learn how to adjust frames is to experiment. (See the videos on the disc for detailed tutorials.)

I've added a third picture in Figure 11.7 and opened some additional tools. Click on a picture and a small window like the one with the red frame in the figure will appear. See the large white border around the frame with the trophy? I adjusted it by dragging my mouse cursor on the border area of the frame icon at the top of the window. The same method can be used to adjust the drop-shadow by dragging its represen-tation. As an example, I've used that method with the new picture to shift the drop-shadow off the upper and left sides of the frame.

**Figure 11.7**
Frames are more than just picture containers; they also incorporate design elements like drop-shadows and borders.

Click on the Settings button, located on the edge of the work area. A tall tool window like the one shown on the left side of Figure 11.7 will open. This provides a complete set of con-trols with sliders, checkboxes, and data-entry boxes for making precise adjustments to the current object.

# Adjusting and Editing Pictures and Text

CLICK INSIDE THE FRAME and a window labeled Image will open. It has tools for adjusting the brightness, contrast, and gamma of a picture, as well as converting it to black and white, making it appear transparent. Figure 11.8 shows three frames over our background image. One is of the trophy, which has been made brighter than the original. The others are duplicate copies of one picture. The one on the lower right has been slightly modified. You can tell by the difference in the color of the stage the cheerleader is performing on. The version above it (on the right side) has been made quite transparent, and given a sepia tone.

FotoFusion has not modified the original image file in any way. The program "borrows" a copy, and renders a new version when the file is output. If you want to make a permanent change to a picture, it has to be edited in an external editor —which FotoFusion makes easy. Right-click on a picture and choose Edit from the pop-up menu. The first time, you will have to choose Manage from the new menu that appears, and tell FotoFusion which external editor(s) you want to use and where its program file is located. After that, choose an editor from the list, and the image will be opened in it, then returned to FotoFusion with your revisions after you have saved your modifications in the external editor.

### Figure 11.8

FotoFusion offers a variety of non-destructive tools for adjusting the appearance of images in a project.

The red-filled frames shown in Figure 11.9 are what you'll see if a source file is moved from its location after the FotoFusion document is saved or it is on an unavailable disk. If that happens, open the Tools menu and choose the Locate Missing Images option. Then use the dialog box that appears to select the proper folder. You don't have to identify each file, just the folder. Repeat the process if some files are in another folder.

**Figure 11.9**
You'll have to tell FotoFusion where to find images for a project if they are moved to a new location.

Collage designs use text both to provide information and as a design element. FotoFusion makes it easy to add text and adjust typestyles in your projects. Click on the T symbol in the bottom left of the Frame window. A new frame (see Figure 11.10) will appear, the Frame window will become the Text window, and the Font panel will open. Type in the desired text in the box at the top of the Font panel and it will appeal in the new Text frame. The rest of the panel offers a wide range of controls, from choosing the type face and letter/line spacing to color and opacity.

**Figure 11.10**
A Text object is a special type of frame with its own controls and settings.

You can see how text is a primary part of the design in the card shown in Figure 11.11. The headline reading "Brothers" provides an instant identification of the relationship between the two subjects. The block underneath the portrait provides details. Notice how the design lets the headline flow over both the picture and the descriptive text. The "paper" background and tabs "holding" the picture and card in place add to the three-dimensional, heirloom appearance of the layout.

The Text Content feature sets the characters that will appear on the canvas. Font attributes change the font, and add bold, italic, strikeout, and underline characteristics to the letters. Alignment and spacing options justify the text and alter the character and line spacing. Text and outline options change the color, opacity, and other attributes of the text's appearance. Matte options apply a matte effect to the text, or transform the text into a matte (Enhanced and Extreme versions only). These controls are all available in the floating Text window when a text object is selected.

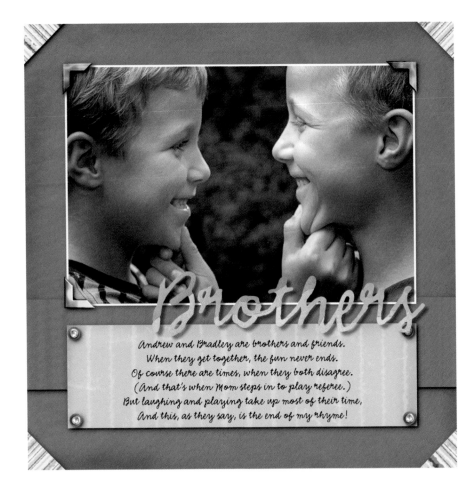

**Figure 11.11**
This is an example of a finished collage with a scrapbook theme, and with excellent use of text to indentify and explain the subject. It could be printed as a card, or combined with other designs into a book. (Photograph by Denis Germain.)

# The Proof Is in the Printing

I N THE TOP CENTER OF THE FotoFusion window are tabs (the exact number varies with the version). So far we have limited our activities to the Create section of the program. Click on the Output tab to print, or the Share tab to send your work via email. As mentioned before, FotoFusion limits the resolution with the Standard and Enhanced versions. There are also fewer options and file formats available with those editions.

Figure 11.12 shows the Share tab active with the Image Quality section open. Other tabs provide additional functions. Recipients are set using the Address features in the Envelope section. If you want to protect your file from improper sharing or printing, use the Watermark and Banners function to over-print the file. You can send a file either using your own server or through the LumaPix host by setting the host in the ISP Settings section.

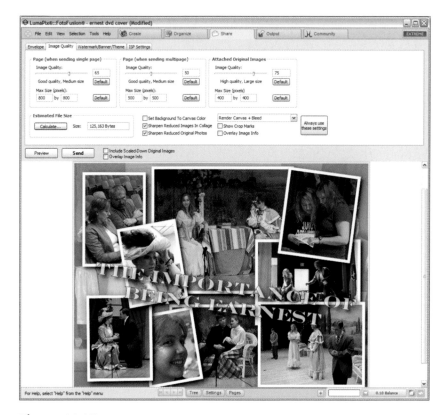

**Figure 11.12**
FotoFusion lets you adjust image size and quality when outputting a document, as here when sending a design via email.

The Output tab has three modes: To a File, To the Web, and To a Printer, which selected from a drop-down menu that appears when you click on the tab. Figure 11.13 shows the File option open, with a preview already generated. Previewing the job before clicking Render lets you examine it for flaws and check the quality of your chosen file formation and resolution. If you are sending the file for printing to a remote photographic printer or press, double-check both the proper resolution and safety zones/blends before sending the job—even if it looks great when printed on your local printer.

The Publish to a Website function builds a Web page that can be uploaded to a remote server from right inside FotoFusion. You can add watermarks and banners, just as with emails. Figure 11.14 shows the dialog box that appears if you choose to send the job to a local printer.
It offers fewer options, since the majority of the settings will be limited by your printer's resolution and paper size, and the controls offered by the operating system and printer.

**Figure 11.14**
The FotoFusion local printer dialog box.

**Figure 11.13**
Choosing an output file format from the Output tab.

## Some Final Suggestions When Outputting Collages

Consider the following when you output collages:

### Make Sure They Match

Viewing pictures taken of the same subject (even at almost the same time) side-by-side can accentuate slight differences in skin tone and color balance, due to changes in lighting or processing. I often make a final comparison before sending a print job off. First I save the design, and choose one picture to be the reference. Then I move each of the other images so that a white area and skin are next to each other. If I see a color cast, then I adjust that picture and re-examine the pair. When all of the images are ready, I close the file without saving, and print the actual finished version. Since FotoFusion loads the file to print each time the command is selected, all the changes will be included.

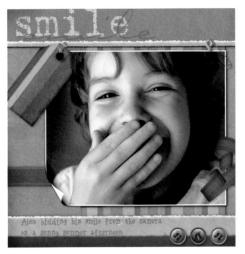

**Figure 11.15**

Make sure you know the proper settings for resolution and color space before sending a job to the printer. That helps ensure that details like the sepia tone and buttons in this charming card look exactly as intended. (Photograph by Denis Germain.)

If you are using an outside photo lab or printer, get the answers to the following questions before rendering the file. Use them to configure your output. (See the program's user manual for more information on what these settings do and how to adjust them.) You may want to send a small test job before sending an expensive large print, an album, or a printed book series. Here's what you need to know:

### Required Color Space

What is the color space that the printer uses? A *color space* is the reference system that tells the output device what a color is and how to render it. Most commercial labs and printers use the one named sRGB. If your files are output using a different color space from the printer, the colors won't look right. For example, the sepia tone in Figure 11.15 could look quite different if the wrong color space was used.

### Dots Per Inch

Do you really need the *exact* dpi setting of the remote printer? If you have a good safety margin and don't need an exact match, then close is good enough. It's imperative that the dpi of the output file exactly matches the dpi of the printer. Many lab techs tell their clients something like "Just use 300 dpi and send us a good looking JPEG, we can handle it." Enlarging or reducing a 300-dpi JPEG can crop the image area of a print, or leave an unprinted area on one side of the print.

### File Format and Compression

FotoFusion offers a variety of output file formats. Be sure to ask the vendor for their preferred file type, and if there are any size or resolution requirements. Most labs that print "as-is" will take either high-quality JPEG or TIFF files without a problem. That's because the image does not have to be modified in any way. (Of course, the source images have to be of good quality.)

### Submission Method

How are the files going to the lab? Most will be able to take the mass of files over the Internet (assuming you have a good, fast connection), but may have a preferred time to schedule very large jobs. Some may ask that you send in the files on a CD or DVD.

Figure 11.16 shows a two-page panoramic spread from a vacation trip by Michael Sheasby. The design is similar to that found in a traditional photo album. The Post-It-note–style text placed on the left page gives it an informal and personal feel.

**Figure 11.16**
Part of a vacation layout in panoramic book format. (Photographs by Michael Sheasby.)

Our final example is a 16-inch-wide poster of four girls by Kent Smith (see Figure 11.17). The primary background is a black fill, and inside that is a layer with a second copy of the main image that has been enlarged, blurred, and given a thin white border. The result is a striking and perfectly color-coordinated backdrop that makes the portrait really stand out, and works well with the text block that indentifies each child.

**Figure 11.17**
There are two copies of the portrait in this poster by Kent Smith.

## Just a Starting Point

This chapter was an introduction to creating collages. The range of uses is amazing. Check local photo labs (even in big-box stores) and the Internet for products that you can use as platforms for your pictures. Digital printing technology is transforming the market, allowing images to be easily and inexpensively placed on purses, canvas shopping bags, cut glass and stemware, buttons, and (of course) all manner of paper products.

**Figure 12.1a** The photographic print isn't dead, but paper is only one way for a DSLR owner to share images with family, friends, and the world. Multimedia shows and digital frames are

# Beyond Printing: Multimedia Photography Using Slide Shows

# 12

ONCE UPON A TIME (IN THE DAYS OF FILM) the paper photographic print was *the* way to share images, and slide shows were an exception. Today, image files can be emailed, placed on sharing Web sites, and converted into multimedia slide shows that are played on a computer, a wide-screen TV, a digital frame—even MP3 players and cell phones. In the past month I've created online proofs of a wedding, my daughter's school presentation, and a collection of soccer-game images. They have been shown via a projector, the Internet, on DVDs, and on MP3 players.

This chapter shows how to easily transform your images into a multimedia show with special effects and sound, and share it with family and friends. A trial edition of the program used here, Photodex ProShow, is on the companion CD. It lets you use all the program's features, but places a banner noting the trial status over a show when it is viewed. I'll admit to a bias for this software. It is fun, powerful, and a regular part of my photography. I also authored *The Official Photodex Guide to ProShow*. This chapter is really only an introduction to the powerful features this really neat program offers.

**Figure 12.1b**
This travel photo from a British church isn't a typical vacation picture. It is an example of an image that can add detail and flavor to a multimedia travel show. (Photograph by James Karney.)

# The Multimedia Environment

WHILE WE CAN'T EXPLORE all of ProShow's features in a single chapter, we can create a slide show compete with soundtrack and some interesting effects. The program interface (see Figure 12.2) is simple to use. Most operations are done with a mouse, using interactive tools that provide immediate visual feedback.

The book's companion Web site at www.pro-showexpert.com has more information on the program. You'll need a Windows PC or a Macintosh computer that can run a Windows emulator. (This is the only program we use in the book that is PC-only.) To load ProShow, simply open the ProShow folder on the CD, click on the Setup icon, and follow the prompts.

**Figure 12.2**
The ProShow interface offers everything needed to easily create polished slide shows, both for display and to share your DSLR images.

The left side of the main window contains a folder list and thumbnails of the images in the currently selected folder. The right side is the preview area, where we can test our show as we work. Adding slides to a show and moving them around is as simple as dragging and dropping thumbnails into the slide list at the bottom of the window.

ProShow comes in three versions: Standard, Gold, and Producer. Standard is very basic. Gold offers multiple layers, motion, soundtracks, and image-editing and enhancement tools. Producer is powerful enough to handle almost any multi-media challenge, adding keyframing, transparency, masking, and support for HDTV output.

There is a second part of the program that we can't see—the rendering engine. This is where ProShow weaves all the content into the appro-priate video format and creates the final output. It does all the work. All we have to do is choose the output type, add any desired menu items, and provide the destination media. We can create a variety of formats including a DVD, an MP3 file, or a Web show. Figure 12.3 shows the Output dialog box for the Producer version of the program. Figure 12.4 shows how a show looks when played over the Internet.

**Figure 12.3**
ProShow offers many output options for sharing your work.

**Figure 12.4**
A ProShow production being played over the Internet.

# Assembling Images and Creating a Basic Slide Show

T O FOLLOW ALONG, COLLECT A SET of pictures you'd like to use in the slide show. Don't worry about them being altered. ProShow only "borrows" images. It does not actually modify the source files. I usually start by choosing the pictures for a show, placing copies into a new folder, and giving the show a name.

Shows can be of any size; we'll keep this one short. I've chosen 21 image files from a Harry Potter book party my daughters and I attended. Your selection is up to you. I'd suggest no more than about 20 images, since this is just for practice. Feel free to use any images you like.

The Producer version included on the CD can take most common file formats, including JPEG, TIFF, Photoshop PSD, and most forms of RAW. I'll use JPEGs because they load and render quickly.

Launch the ProShow program and use the browser in the upper-left portion of the window to locate the folder with your images. Click it, and the thumbnails will appear in the section below the folders. Now right-click in the thumbnail area, as shown in Figure 12.5, and choose the Add All Files to Show option when the context-sensitive menu appears. An information window will open and mark the progress as the slides are generated. ProShow automatically assembles a basic show based on the existing defaults, with three seconds allowed for each slide and a three-second transition between each pair.

**Figure 12.5**

Adding slides to the show using the context-sensitive menu.

Once the process is finished, all the thumbnails will have green checkmarks in their lower-right corners, and the new slides will be visible in the slide list. That is the row of images visible in the lower portion of the ProShow window. Look in the upper-right corner of the program's window and see the results. Mine says that I have 22 slides, and that the show will play for 2 minutes and 12 seconds.

Figure 12.6 shows my slide timeline after adding the files. The slide timeline is where we are going to work with both arranging the images and setting transitions. *Transitions* are the effects that occur as one slide changes into another when the show is played. Let's explore the slide list before we begin using it. The name of the file is displayed above each slide image.

ProShow makes it easy to tweak times and effects. Look at slide 2. On the left side, underneath the picture, is the slide's number in the show. On the right side is the play time in seconds for that slide in the show. I've clicked on the play time. That changes it to an interactive data box, allowing the user to adjust the time interval in seconds. Use a decimal point to enter fractions of a second. For example, 5.5 is five and one-half seconds.

It's important to make sure that a slide stays on the screen long enough to make its own visual statement. The program default is set to a standard three seconds. That's usually a good starting point. More important pictures and special effects may call for a longer time on screen. We'll hold off on adjustments until we get the basic design completed.

**Figure 12.6**
The slide timeline after adding images to the show.

Because we added all of the slides to the show at one time, ProShow placed the files in order based on file names. If your camera assigned the names automatically as they were taken, the images will be arranged in the list in the order they were taken. You may want to move some slides. That's easy. You can drag and drop individual Slides to a new position in the slide list. Just place your mouse over the desired slide, then drag and drop it in the desired position on the list.

There is another way to arrange slides if you want to make more extensive edits. Figure 12.7 shows the program with the Lightbox panel in place of the preview area. To do that, open the Window/Show menu and choose Lightbox to enable it, and then open the same menu again and choose Preview Area to hide it. You can drag and drop slides inside the Lightbox. The Show menu options are toggles. Repeat the procedure to regain the original settings and fill that part of the window with the preview area.

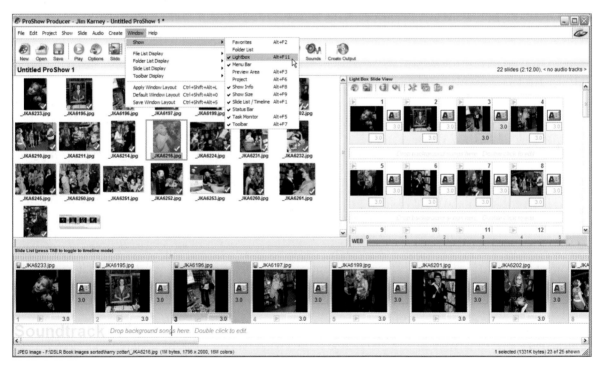

**Figure 12.7**
The ProShow interface with the Lightbox panel enabled.

# Setting Transitions, Timing, and Previewing the Show

ONCE YOUR SLIDES ARE in the desired order, it's time to design the transitions. In between each pair of slides is an icon with the letters A and B. This is the transition marker for an A/B fade. This is the default transition, and works very well as a simple effect.

Click on a transition icon and a new window opens, as seen in Figure 12.8. This is the Choose Transition window, with over 280 different styles. Hover over an icon, and the small preview area in the window's lower-left corner shows you how that transition will look with the slide. Click an icon and it becomes active between that pair of slides. You set a transition's time the same way as a slide's. Click the number below the transition's icon and set the value in seconds.

**Figure 12.8**
The Choose Transition window.

Choosing the right transition and matching it with the images on either side is more art than science. In general, it's best not to use too many different transitions. Too many variations tend to confuse viewers. Be sure to allow enough time for the transition as well. It's also important to make sure that the way a transition enters and leaves the show works well with the composition of the images it lies between. Go ahead and modify some of the transitions.

ProShow provides a really neat tool for testing how a transition works with its images. See the mouse pointer between slides 14 and 15 in Figure 12.9? Dragging it on the ribbed bar that runs across the top of the slide list can move the gray marker under the pointer. It is always the active point in the show that is displayed in the preview area. This is called "scrubbing the timeline."

See how the Preview Area shows the star-shaped Transition opening up to reveal the person in the mask? Try it now with your slide show. Drag the gray marker both forward and back on the line. It can really help you see just how a transition or an effect will look. If you want to see the play in real-time, click the Play button, located in the lower-left corner of the preview area.

**Figure 12.9**
Scrubbing the timeline provides an interactive preview that works both forward and backward through the show.

# Adding and Editing Soundtracks

I T'S BEEN SAID THAT THE difference between real life and life in the movies is that movies come with a soundtrack. So can your slide shows. ProShow provides all the tools needed to add audio clips and fit them to your slides. The Chapter 12 folder on the CD includes an MP3 file. Let's add it to the show.

Press the Ctrl and F4 keys at the same time to open the Show Soundtrack window. (You can also access this window by selecting the Manage Soundtrack option from the Audio menu.)

Once it opens, click the green Add button and a context-sensitive menu will open. Choose Add Sound File and your screen will look similar to the one in Figure 12.10. Navigate to the Chapter 12 folder, select the Larry_Allen_Brown_Shennandoah.mp3 file, then click the Open button. ProShow will load the soundtrack. After a short pause, a green soundtrack graphic will appear underneath the slide list. Play the preview again and you'll hear the music as the show plays. (The soundtrack will not be heard when scrubbing the timeline.)

**Figure 12.10**
Adding a soundtrack to a slide show.

The music will stop as soon as the last slide is finished if the show is shorter than the sound-track. You probably want to have the music last just as long as the slides. ProShow offers several tools for getting the timing just right. You can repeat one already in the show, or add another to the list. You can also adjust the timing and/or the slides and the sound in relation to each other.

Let's use my current show as an example. The soundtrack is a little over four minutes long, and the slides last 2 minutes and 12 seconds. The Audio menu has options to Sync Show to Audio and Sync Selected Slides to Track. Those are great if the total time for the slides and the length of track are close. If I were to use the Sync Show option, all of my slides and transitions would be adjusted to about six seconds, exactly matching the Show's total time to that of the soundtrack.

If you don't want to extend the length of your show, ProShow offers a really slick tool for editing your soundtrack to match the desired show time. Press the Ctrl and F4 keys again to reopen the Show Soundtrack window. Now click on the Edit Fades and Timing button. The window shown in Figure 12.11 will open.

**Figure 12.11**
The Edit Fades and Timing window.

See the hand-shaped mouse cursor between the two vertical lines on the left side of the sound-track graphic? The solid left line marks the point where the audio will start playing. Moving this line adjusts the point in the track where it begins playing. The dashed line marks where it will be playing at full volume, and can be moved with the mouse. If the two lines are at the same place, the track begins at full volume. Move the lines apart to create a fade-in effect (the music slowly increases in volume). The two lines at the right side of the soundtrack work the same way; positioning the end point of the sound track and controlling the fade-out effect.

# Adding Motion and Special Effects to Your Slides

WE NOW HAVE A BASIC SLIDE show. Click the Play button in the preview area and all of the images will appear, separated by their transitions. Nice, but not very exciting. Double-click on any slide in your show. When the Slide Options window appears, click on the Motion icon on the left side of the window. It will resemble the screen shown in Figure 12.12.

I said "resemble" because it's a composite image that includes several elements that don't normally appear at the same time. (Not to mention the fact that your picture is different from mine.) We'll discuss the menus and tools and tips in a moment. Let's focus on the basic purpose of this window first. It's designed for setting motion effects.

**Figure 12.12**
Setting motion effects using the mouse in ProShow is easy and fun.

There are two preview areas at the bottom. The one on the left shows the way the slide looks at the beginning of its play, and the one on the right how it will appear at the end of its time. As you begin, both of your previews should look the same, because you have not set any special effects.

Mine differ because I've already set up a zoom effect in this slide. It makes the picture grow larger in the frame during its time on the screen. Notice how the face of the young lady moves toward the center of the area. Here's the fun part: All of these kinds of effects can be done with a mouse—if you have a one with a wheel. If not, it's just a matter of adjusting sliders.

## Creating a Simple Motion Effect

Examine the portion of the Slide Options window shown in Figure 12.13. The sliders on the left side are used to set the way the image looks at the beginning of playback, and ones on the right control the effect at the end. The Zoom X and Zoom Y sliders adjust the size as a percentage. 100 is full-size. My image is full-size at the start, and just over 2.5 times larger at the end of play.

The Zoom X and Y sliders are normally linked together. Click on the Link button and the sliders can be moved individually. The Rotate slider rotates the picture on its center. The Smoothing control and the four Smooth drop-downs are used to fine-tune the way a picture behaves, and are beyond the scope of this very basic tutorial.

Experiment a bit with adding motion effects to your slides. As you do, try using the Copy menu options shown back in Figure 12.12. Click on the word Copy between the two previews to open it. The Copy Start to End command is a handy way to get a picture looking the same from start to finish—and so undo an effect you don't like.

**Figure 12.13**
The Motion Effects sliders.

# Visual Magic with ProShow Producer's Adjustment Effects

Now click on the Effects icon, located on the left side of the Slide Options window. It's the one at the top-left of Figure 12.14. This window is very similar to the Motion Effects window we just left. The only visible difference is that the tools above the two previews have changed.

Once again, the preview on the left side shows how the slide looks at the start of its play, and the one on the right, at the end. You'll see any existing effects applied to the Slide, including those (like motion effects) managed in other windows.

The controls include White and Black Point, Contrast, Brightness, Opacity, Hue, and Sharpening sliders, plus a Colorize feature. I've applied the latter to make a color change to the end of my slide. The checkmark at the top left of the Colorize End dialog box turns it on. Then, clicking on the Set Color button opens the Color Selection pane, as seen in the figure. As the slide plays, the image will shift from full-color to the brownish tone. The longer the slide plays, the slower the change will occur.

It's important to remember that ProShow does not actually change the picture when we apply adjustment effects. It only "borrows" a copy. Then it renders the versions needed to make the effect appear during playback.

**Figure 12.14**
"Toning" a picture as the slide plays using the Colorize Adjustment effect.

Let's use this slide as an example. If it plays for three seconds at 30 frames per second, there are ninety intermediate versions, each one showing slightly more of the effect. ProShow makes all of them by applying the settings you choose to the data obtained from the source picture. The original is never modified.

Take a little time and experiment with the settings. The same Copy menu can be used to restore the original values. If you exit the window and want to reset things, there is an Undo command located in the Edit menu.

## Working with Captions

ProShow uses a similar set of controls for adding and editing captions. Exit the Slide Options/ Adjustment Effects window and return to the main program interface. Right-click on the first slide in the slide list (the row of slides at the bottom of the main window). Choose the Insert command from the context-sensitive menu and then the Insert Blank Slide option as seen in Figure 12.15.

With the new slide selected, press the F5 key to open the Slide Options window in Caption mode. Click inside the box in the top-right portion of the window labeled Selected Caption and type a name for your show. The letters will appear in the captions list and on the slide as you type.

You can position the caption on the slide by placing your mouse cursor over the text and then dragging the caption when the cursor changes to a hand-shaped symbol. Dragging the caption's outline into the preview will resize the text. Use the controls in the area underneath the Selected Caption box to make precise size and position adjustments, set type features (size, font, etc.) and add effects like a drop shadow and outline.

If you want to add another caption, click on the green button with the plus symbol to the right of the captions list. Each caption can have its own set of effects and text settings. ProShow Producer also supports caption motion effects and Interactivity. The latter lets you use a caption to provide user controls, such as jumping to another slide, linking to a website, or pausing the show.

**Figure 12.15**
Adding a blank slide and caption to the show.

# Screening Your Shows

W E NOW HAVE A COMPLETE, basic
slide show. ProShow offers a wide
range of advanced features, including
using multiple pictures (and even video) on a
single slide. Each object rests on its own layer,
and can have its own special effects. You can
explore more on your own, and then continue
the chapter when you are ready to create the


## Choosing the Output Format

As you can see in Figure 12.16, ProShow offers a
variety of output formats. DVDs and video CDs
let you share and store physical copies of com-
plete movies inexpensively. You can also place
the actual picture files onto the disc. This is a
great way to archive a backup copy of your pic-
tures. The show can be designed to show the
image file names as each slide plays, making
it easy to indentify and file the picture in the
future.

**Figure 12.16**
The Create Output window offers a variety of output formats for your show.

The Executable and PC Autorun formats are self-contained slide shows with a built-in viewer that can play on any Windows PC. Output quality can be set for a variety of screen resolutions from basic monitor to HDTV. Just keep in mind that HDTV can take up a lot of disk space and requires high-performance equipment to display properly.

Web Show, YouTube, Device, and Email options let you port a copy of the production to almost anyone, anywhere. The program supports a wide range of MP3 players, iPods, and similar devices.

## Setting Options and Creating a Menu

Clicking on one of these output formats opens the appropriate Create window, which contains all the options for that type of show. Some options, like YouTube, let you upload the show from right inside ProShow. Others have options for designing menus. ProShow Producer lets you design projects, which can contain several individual shows.

Figure 12.17 shows the Menus window. The other tabs on the left side of the window vary, depending on the type of output selected. You can design simple or complex menus, choose the output resolution, and add branding extras like watermarks and introductory video clips, as well as set a custom color profile. The program's Help function and tutorials at www.Photodex.com and www.proshowexpert.com provide more information.

**Figure 12.17**
ProShow lets us create professional-looking menus for optical disc, Photodex Presenter, and Executable output formats.

## Photodex Online Sharing

Photodex offers another powerful feature very well worth mentioning. They provide free online high-resolution hosting and broadband streaming video play of shows created with either the Gold or Producer versions of the program. All you have to do is choose the Online Sharing option after creating a free account at Photodex.com/sharing. (See Figure 12.18.) This is a great service. You can upload high-quality shows to a fast Internet server and invite others to view them, with out any fees.

Playback is provided via the Photodex Presenter, a browser plug-in. It works within a Web page or in full-screen mode. This method does require that the computer used run the Windows operating system. However, ProShow can output in a variety of file formats, which can be used with other operating systems as well—just not via the Photodex Sharing Web site.

## A Closing Note

This brings us to the end of our mutual exploration of the digital single lens reflex. We started the first chapter with a quote from W. Eugene Smith. The technology has changed dramatically from his era of film, but the lure of photography's creative horizon is still the same. The works of the "Old Masters" of photography, like Smith, Ansel Adams, Robert Capa, Gordon Parks, and Richard Avedon (to name a few), are worth exploring and learning from. Consider visiting the online collection at the Library of Congress, or spending an afternoon browsing collections at a library or bookstore. There is a valuable and inspiring legacy available help you chart your personal journey with the camera.

**Figure 12.18**
Free online sharing is available for shows created with ProShow Gold and Producer on the Photodex Web site.

# Index

# License Agreement/Notice of Limited Warranty

By opening the sealed disc container in this book, you agree to the following terms and conditions. If, upon reading the following license agreement and notice of limited warranty, you cannot agree to the terms and conditions set forth, return the unused book with unopened disc to the place where you purchased it for a refund.

### License:
The enclosed software is copyrighted by the copyright holder(s) indicated on the software disc. You are licensed to copy the software onto a single computer for use by a single user and to a backup disc. You may not reproduce, make copies, or distribute copies or rent or lease the software in whole or in part, except with written permission of the copyright holder(s). You may transfer the enclosed disc only together with this license, and only if you destroy all other copies of the software and the transferee agrees to the terms of the license. You may not decompile, reverse assemble, or reverse engineer the software.

### Notice of Limited Warranty:
The enclosed disc is warranted by Course Technology to be free of physical defects in materials and workmanship for a period of sixty (60) days from end user's purchase of the book/disc combination. During the sixty-day term of the limited warranty, Course Technology will provide a replacement disc upon the return of a defective disc.

### Limited Liability:
THE SOLE REMEDY FOR BREACH OF THIS LIMITED WARRANTY SHALL CONSIST ENTIRELY OF REPLACEMENT OF THE DEFECTIVE DISC. IN NO EVENT SHALL COURSE TECHNOLOGY OR THE AUTHOR BE LIABLE FOR ANY OTHER DAMAGES, INCLUDING LOSS OR CORRUPTION OF DATA, CHANGES IN THE FUNCTIONAL CHARACTERISTICS OF THE HARDWARE OR OPERATING SYSTEM, DELETERIOUS INTERACTION WITH OTHER SOFTWARE, OR ANY OTHER SPECIAL, INCIDENTAL, OR CONSEQUENTIAL DAMAGES THAT MAY ARISE, EVEN IF COURSE TECHNOLOGY AND/OR THE AUTHOR HAS PREVIOUSLY BEEN NOTIFIED THAT THE POSSIBILITY OF SUCH DAMAGES EXISTS.

### Disclaimer of Warranties:
COURSE TECHNOLOGY AND THE AUTHOR SPECIFICALLY DISCLAIM ANY AND ALL OTHER WARRANTIES, EITHER EXPRESS OR IMPLIED, INCLUDING WARRANTIES OF MERCHANTABILITY, SUITABILITY TO A PARTICULAR TASK OR PURPOSE, OR FREEDOM FROM ERRORS. SOME STATES DO NOT ALLOW FOR EXCLUSION OF IMPLIED WARRANTIES OR LIMITATION OF INCIDENTAL OR CONSEQUENTIAL DAMAGES, SO THESE LIMITATIONS MIGHT NOT APPLY TO YOU.

### Other:
This Agreement is governed by the laws of the State of Massachusetts without regard to choice of law principles. The United Convention of Contracts for the International Sale of Goods is specifically disclaimed. This Agreement constitutes the entire agreement between you and Course Technology regarding use of the software.